■ 西北大学高水平教材建设项目（项目编号：XM05190564）

American Drama:
A Brief History, Selected Reading and Performance

美国戏剧
简史、选读和演出

主　编　李基亚
副主编　郭　瑛
参　编　张润文　王　娟

西北大学出版社
·西安·

图书在版编目(CIP)数据

美国戏剧简史、选读和演出 / 李基亚主编. —西安：西北大学出版社, 2021.11
ISBN 978-7-5604-4876-3

Ⅰ.①美… Ⅱ.①李… Ⅲ.①戏剧史—美国—高等学校—教材 Ⅳ.①J809.712

中国版本图书馆CIP数据核字(2021)第249359号

美国戏剧简史、选读和演出

主　　编	李基亚
出版发行	西北大学出版社
地　　址	西安市太白北路229号
邮　　编	710069
电　　话	029-88303042
经　　销	全国新华书店
印　　刷	西安日报社印务中心
开　　本	889 mm×1194 mm　1/16
印　　张	13.25
字　　数	270千
版　　次	2021年11月第1版　2024年3月第2次印刷
书　　号	ISBN 978-7-5604-4876-3
定　　价	49.00元

如有印装质量问题，请与本社联系调换，电话029-88302966。

Foreword 前 言

2017年教育部颁发的《大学英语教学指南》(以下简称《指南》)指出：要从学生需求出发，为高校大学生提供优质外语教育。为了提高教学质量，高校开设大学英语课程一方面需满足国家战略需求，为国家改革开放和经济社会发展服务，另一方面需满足学生专业学习、国际交流、继续深造、工作就业等方面的需要。大学英语课程对大学生的未来发展具有现实意义和长远影响，有助于学生树立世界眼光，培养国际意识，提高人文素养，并为知识创新、潜能发挥和全面发展提供一个基本工具，为迎接全球化时代的挑战和机遇做好准备。

为了顺应《指南》的要求，新一轮的大学英语教学改革在我国各高校开展起来。教学改革提出大学英语教学应贯彻分类指导、因材施教的原则，以适应个性化教学的实际。为了加快本科教学改革步伐，全面提升本科人才培养质量，西北大学外国语学院对非英语专业的学生实施了分层教学，制定了二年级学生选修课的科目和要求。英语选修课的改革之举有重大意义，对于非英语专业学生而言，大学英语并不仅仅等同于通过四、六级考试，更代表了严肃活泼、包罗万象的思考精神和创造精神。多门类的选修课不仅有助于拓宽学生们的眼界和强化他们的英语专项技能，还能进一步加深他们对于西方文化的理解。

目前我院为二年级非英语专业本科生开设的选修课共45门(第一学期开设22门，第二学期开设23门)。《美国戏剧简史、选读和演出》是第二学期的选修课。作为文学"四大样式"之一的戏剧具有丰富的文化底蕴和思想内涵，包含演讲、文学、哲学、社会、经济、心理等多层次内容，从而给观众提供了生动的表演形式和深刻的精神领悟，是高度审美的来源。申报这门课程的初衷是我个人对戏剧和电影的喜爱。我非常希望将这种喜爱传递给这一代的大学生们，希望他们能够通过学习这门课程，感受到语言和表演的魅力，体会超越年龄和时空的情感之重和生命之歌。

剧本具有口语化和故事性强的特点，很容易引起学生的学习兴趣，是理想的阅读材料。而戏剧表演能够有效促进学生语言技能的提高，对于培养他们的自信心、理解力、想象力、创造力和团队精神大有裨益。同时，作品创作的年代背景、作家的人生经历是作品产生的沃土，是民族文化的综合体现。一部戏剧作品的背后蕴藏着丰富的历史和人文知识，不仅有助于学生理解西方文化的发展历程，还能够深化同理心，拓宽情感维度。

总之，戏剧教育是一种有助于立体化、多方位地发展学生语言表达能力，增强同理心并深化思考的学习和认知方式。本教材将戏剧史、剧作选读和表演融为一体，有一定的创新意义。

一、《美国戏剧简史、选读和演出》的章节内容和特点

1. 开篇对西方戏剧史进行了简要的回顾

相比于历史悠久的欧洲，建国几百年的美国无疑是个"小兄弟"。美国戏剧自建国开始就是对欧洲戏剧的全方位模仿和借鉴，直到20世纪初小剧场运动兴起，才开始有了根植美国、享誉国际的优秀作品。因此，想要理解美国戏剧的发展历程，决不可不提它的老祖宗——古希腊戏剧的产生和发展。西方戏剧从古希腊到20世纪初，经历了不同的发展阶段，衍生出林林总总的戏剧风格和类型，这些都是美国戏剧产生和成长的养分来源。

本书第一章简要介绍了西方戏剧的发展过程和阶段，包括古希腊戏剧、古罗马戏剧、辉煌的文艺复兴和伊丽莎白一世时代的戏剧、沉闷古板的中世纪戏剧、人文思想伟大创新变革的19世纪和20世纪初戏剧的时代特点、戏剧类型和最知名的作家及代表作。这些作品对于后代的影响力非凡，可以说，直至今天，依旧方兴未艾。第一章通篇内容简洁、重点突出，生词和术语加注，方便学生课后复习。

2. 对美国戏剧史进行了简要的介绍和梳理

本书第二章和第三章对美国戏剧史进行了简要的介绍和梳理。内容涵盖建国之初、内战前后、20世纪和当代美国戏剧，完整介绍了戏剧在美国的启蒙和演变过程。该部分包括美国本土的戏剧萌芽、欧洲戏剧初登北美大陆、独立战争期间的戏剧反抗、西部大迁移和美国内战时期的戏剧遭遇、二战之后欧洲现实主义戏剧的广泛影响和当代戏剧的繁荣局面。

由于美国戏剧史内容丰富，人物众多，经过两轮教学实践，听取了学生的

学习心得并充分考虑到学期时长的因素,本书有针对性地对这部分内容进行了精简,保留了最重要的发展阶段、重大事件和历史转折点,对于剧作家和代表作品只是点到为止,不增加额外的学习负担。此外,文章加注丰富,生词、术语和部分难句都提供了汉语翻译,减少了学生查字典的时间,力求最大化降低阅读难度,保持阅读的连续性和乐趣。

3. 介绍了美国剧坛三大家的生平并选读经典作品

本书第四章、第五章和第六章分别介绍了美国剧坛三大家尤金·奥尼尔、田纳西·威廉斯和阿瑟·米勒的生平,同时也选取了他们最具特色的代表作品进行选读。

尤金·奥尼尔晚年写就的带有自传风格的《长夜漫漫路迢迢》是深获好评的作品,被认为是其职业生涯的巅峰之作。这部具有现实主义风格的悲剧感染力强,令人过目不忘。田纳西·威廉斯和阿瑟·米勒作为奥尼尔的继任者,是美国剧坛当之无愧的大家,他们的优秀作品众多,一时难以取舍。后来反复斟酌之后,将田纳西的《玻璃动物园》(具有自传风格的作品,可以和剧作家生平联系到一起学习)选为选读作品,同样颇负盛名的《欲望号街车》和《铁皮屋顶上的猫》则在作家生平中简要介绍背景和剧情。从米勒的作品中挑选了最负盛名的代表作《推销员之死》进行选读,而同样精彩的《都是我的孩子》和《炼狱》放在作家生平中简要介绍背景和剧情。剧本的选读部分同样进行了细致的加注和难句解释,每篇选读之后都附有全剧简介,帮助学生一窥全貌。

4. 实用的表演知识和有趣的课堂活动

本书第七章和第八章涉及表演。第七章介绍了如何成为一名好演员的诀窍,同时附有课堂表演实训的练习,生动有趣且操作方便。在两轮教学实践中,表演部分是最受学生们欢迎的内容。第八章介绍了如何进行表演前的角色分析,并附上了相关练习,既帮助学生深化对先前学过的剧本人物的理解,也给了他们一次完整演练的机会。

5. 相关戏剧术语的归纳和介绍

在教学中涉及了不少重要的戏剧术语,书末对此进行了归纳总结,罗列了100多个戏剧术语,以供所需。

二、使用本书的一些建议

本书的适用对象主要是高校非英语专业二年级本科生,也适用于英语专

业低年级选修课学生、通识课教学及所有热爱戏剧的英语学习者。使用方法根据使用对象的不同可做灵活处理。

教学模式不必拘泥于一种形式，可根据代课老师和学生的实际情况进行调整，以下列举三种教学方式，以供参考：

(1) 先教授简史和选读，然后进行表演练习，可谓"先静后动"。简史部分的知识考查以笔记为主，文后附有笔记格式，学完即刻总结复习。选读除了做笔记，还多了一项思考练习，目的是促进学生的自主思考能力。阅读学习完成后，便可以进行表演练习。

(2) 打乱章节顺序，按照"简史——表演1（第七章）——选读——表演2（第八章）"的方式进行教学，可谓"动静结合"。

(3) 打乱章节顺序，按照"表演1（第七章）——简史——选读——表演2（第八章）"的方式进行教学，这个方式是先让学生们体验表演的乐趣和感觉，借助对戏剧的直观感受，产生进一步学习的兴趣。

一般情况下，大学英语选修课每周两个课时，一个学期除去期中考试和期末总复习之外，通常都有18周左右的教学时间（没有删去法定节日时间）。以下所列的教学进度，仅供参考。具体情况可以具体处理。

第一周　课程介绍＋西方戏剧简史

第二周　美国戏剧简史（1）

第三周　美国戏剧简史（2）

第四周　课堂讨论

第五周　尤金·奥尼尔生平介绍

第六周　《长夜漫漫路迢迢》选读讲解

第七周　课堂讨论

第八周　田纳西·威廉斯生平介绍

第九周　《玻璃动物园》选读讲解

第十周　课堂讨论

第十一周　阿瑟·米勒生平介绍

第十二周　《推销员之死》选读讲解

第十三周　课堂讨论

第十四周　如何做个好演员（1）　理论学习

第十五周　如何做个好演员（2）　课堂活动

第十六周　角色分析(1)　理论学习

第十七周　角色分析(2)　小组剧本朗读和研讨

第十八周　角色分析(3)　小组作品观摩和评价

总而言之,对于喜欢戏剧的英语学习者和教师,本书提供了不错的阅读体验、表演实践和教学材料。读者不仅可以对美国戏剧有较为全面的认知,还可以近身接触美国剧坛三大家,走入他们的生活,了解他们的创作过程和作品,提高审美,丰富人生。

非常感谢参与本书编写的三位同事——郭瑛老师、张润文老师和王娟老师。郭瑛老师是我的教学搭档,在共同备课中,郭老师编撰了部分美国戏剧史及剧作家的资料,付出了辛勤的劳动。张润文老师和王娟老师给短剧本勘误及加注,虽然限于篇幅,短剧本最终未被纳入本书,但两位老师的辛苦和认真值得一书。

最后,要特别感谢西北大学出版社的大力支持和帮助。感谢陈英烨编辑的高效率和细心,感谢柴洁编辑的热情鼓励和帮助。本书由于新冠疫情的缘故,学院临时调整授课内容,中间一轮教学实践落空,只能推后时间,在完成了第二轮教学实践之后,综合各方面因素修改原教案,才得以成书。能获得出版,各位编辑功不可没。

希望以后随着更多的教学实践,可以对本书进行修订完善。编撰此书参考了不少资料,又根据教学实践不断修正教学方法,耗时两年多,限于水平,难免有失误不足之处,欢迎广大戏剧研究者及师生给予批评指正,以便后期再版时纠正。

李基亚

2021年6月于西北大学

CONTENTS

001 — **Chapter One** An Introduction to Western Drama

012 — **Chapter Two** A Brief History of American Drama (1)

021 — **Chapter Three** A Brief History of American Drama (2)

029 — **Chapter Four** Eugene O'Neill and *A Long Day's Journey into Night*

088 — **Chapter Five** Tennessee Williams and *The Glass Menagerie*

121 — **Chapter Six** Arthur Miller and *Death of a Salesman*

151 — **Chapter Seven** How to Be a Good Actor or Actress

167 — **Chapter Eight** Character Analysis

176 — **Glossary of Theatrical Terms**

200 — **Bibliography**

Chapter One
An Introduction to Western Drama

Greek Drama

The Greeks of the fifth century B. C. are credited with the first masterful dramatic age, which lasted from the birth of *Aeschylus*[1] to the death of *Aristophanes*[2]. Their theaters were supported by public funds, and the playwrights competed for prizes during the great feasts of *Dionysus*[3]. Sometimes as many as ten to fifteen thousand people sat in the theaters and watched with a sense of delight and *awe*[4] as the actors played out their tales.

Theater was extremely important to the Greeks as a way of interpreting their relationships with their gods and of reinforcing their sense of community. All classes enjoyed it; they came early in the morning and spent the entire day in the theater. Drama for the Greeks was not mere *escapism*[5] or entertainment, not a *frill*[6] or a luxury. Connected as it was with religious festivals, it was a cultural necessity.

Sophocles[7]' plays *Oedipus Rex*[8] and *Antigone*[9] are examples of the powerful tragedies that have *transfixed*[10] audiences for centuries. *Euripides*[11], who succeeded Sophocles, was also a prize-winning *tragedian*[12]. His *Trojan Women*[13], *Alcestis*[14], *Medea*[15], *Bacchae*[16], and *Elektra*[17] are still performed and still exert an influence on today's drama. The same is true of Aeschylus, who preceded both and whose *Agamemnon*[18], *The Libation Bearers*[19], *The Eumenides*[20], and *Prometheus Bound*[21] have

Notes:

1. 埃斯库罗斯(古希腊诗人、悲剧作家)
2. 阿里斯多芬尼斯(古希腊早期喜剧代表作家、诗人)
3. 狄俄尼索斯(古希腊神话中的酒神、丰产神和植物神)
4. awe: *n.* 敬畏
5. escapism: *n.* 逃避现实
6. frill: *n.* 装饰
7. 索福克勒斯(古希腊悲剧诗人、剧作家)
8. 《俄狄浦斯王》
9. 《安提戈涅》
10. transfix: *v.* 使……呆住
11. 欧里庇得斯(古希腊悲剧诗人、剧作家)
12. tragedian: *n.* 悲剧作家
13. 《特洛伊妇女》
14. 《阿尔刻提斯》
15. 《美狄亚》
16. 《酒神女信徒》
17. 《厄勒克特拉》
18. 《阿伽门农》
19. 《奠酒人》
20. 《报仇神》
21. 《被缚的普罗米修斯》

all been among the most lasting of plays.

In addition to such great tragedians, the Greeks also produced the important *comedians*[22] *Aristophanes*[23] and *Menander*[24], whose works have been *plundered*[25] for plays as diverse as a Shakespeare comedy and a Broadway musical. Aristophanes' *Lysistrata*[26], in which the *Athenian*[27] and *Spartan*[28] women agree to *withhold*[29] sex from their husbands until the men promise to stop making war, is a powerful social comedy. Menander produced a more *subtle*[30] type of comedy that made the culture laugh at itself. Both styles of comedy are the *staple*[31] of popular entertainment even today. Menander's social comedies were the basis of *the comedy of manners*[32], in which the society's ways of behavior are criticized. The comedy of manners is exemplified in *William Congreve*[33]'s eighteen-century *The Way of the World*[34] and even in *situation comedies*[35] on contemporary television.

Roman Drama

The Romans became aware of Greek drama in the third century B.C. and began to import Greek actors and playwrights. Because of many social and cultural differences between the societies, however, drama never took a central role in the life of the average Roman. *Seneca*[36], who is now viewed as Rome's most important tragedian, almost certainly wrote his plays to be read rather than to be seen onstage.

Roman comedy produced two great playwrights, *Plautus*[37] and *Terence*[38], who helped develop *the STOCK*

22. comedian: *n.* 喜剧作家
23. 阿里斯托芬(古希腊早期喜剧代表作家、诗人)
24. 米南德(雅典剧作家)
25. plunder: *v.* 剽窃
26. 《利西翠妲》
27. Athenian: *a.* 雅典的
28. Spartan: *a.* 斯巴达的
29. withhold: *v.* 拒绝,克制

30. subtle: *a.* 微妙的

31. staple: *n.* 主题
32. 风俗喜剧

33. 威廉·康格里夫(英国剧作家)
34. 《如此世道》
35. 情景喜剧

36. 塞涅卡(古罗马政治家、哲学家、悲剧作家)

37. 普劳图斯(古罗马剧作家)
38. 泰伦提乌斯(古罗马剧作家)

CHARACTER[39], such as the *skinflint*[40] or the *prude*[41], and used *the device of mix-ups*[42] involving identical twins in their plays. Plautus was the great Roman comedian in the tradition of Menander's comedy of manners. Plautus' best-known plays are *The Braggart Warrior*[43] and *The Twin Menaechmi*[44], and during the Renaissance, when all European schoolchildren read Latin, his works were favorites.

Terentius' work was praised during *the Renaissance*[45] as being smoother, more elegant, and more polished and refined than Plautus'. In his own age Terentius was less admired by the general *populace*[46] but more admired by *connoisseurs*[47] of drama. His best-known plays are rarely performed today: *The Woman of Andros*[48], *The Phormio*[49], and *The Brothers*[50].

Drama took its place beside many other forms of entertainment in Roman culture—sports events, spectacles, the slaughter of wild beasts, and mass sacrifices of Christians and others to animals. The Roman public, when it did attend plays, enjoyed *farces*[51] and relatively *coarse humor*[52]. The audiences for Plautus and Terentius, aristocratic in taste, did not represent the *cross section*[53] of the community that was typical of Greek audiences.

Medieval[54] Drama

After the fall of Rome and the spread of the *Goths*[55] and *Visigoths*[56] across southern Europe in the fifth century, Europe experienced a total breakdown of the strong central government Rome had provided. When

39. 固定化角色
40. skinflint: *n.* 吝啬鬼
41. prude: *n.* 假正经的女人
42. 认错人的情节(尤指搞混双胞胎)
43. 《吹牛军人》
44. 《孪生兄弟》
45. 文艺复兴
46. populace: *n.* 大众
47. connoisseurs: *n.* 鉴赏家
48. 《安德罗思女子》
49. 《福尔弥昂》
50. 《两兄弟》
51. farce: 闹剧
52. coarse humor: 粗俗幽默
53. cross section: 代表性作品
54. medieval: *a.* 中世纪的
55. Goth: *n.* 哥特人
56. Visigoth: *n.* 西哥特人

Rome fell, Greek and Roman culture virtually disappeared. The great classical texts went largely unread until the end of the medieval period in the fourteenth and fifteenth centuries. However, expressions of culture, including art forms such as drama, did not entirely disappear. During the medieval period the church's power and influence grew extensively and it tried to fill the gap left by the *demise*[57] of the Roman Empire. The church became a focus of both religious and secular activity for people all over Europe.

After almost five centuries of relative *inactivity*[58], European drama was reborn in religious ceremonies in the great stone churches that dominate most European towns. It moved out of the churches by the twelfth century perhaps because its own demands *outgrew*[59] its circumstances: It had become a competitor, not just an *adjunct*[60], of the religious ceremonies that had *spawned*[61] it.

One reason that the medieval European communities regarded their drama so highly is that it was a direct expression of many of their concerns and values. The age was highly religious; in addition, the people who produced the plays were members of *guilds*[62] whose personal pride was represented in their work. Their plays came to be called *mystery plays*[63] because the trade that each guild represented was a special skill—a mystery to the average person.

Many of these plays told stories drawn from the Bible. The tales of *Noah's Ark*[64], *Abraham and Isaac*[65], and *Samson and Delilah*[66] all had immense dramatic potential, and the mystery plays *capitalized*[67] on that

57. demise: *n.* 末期

58. inactivity: *n.* 休止状态

59. outgrow: *v.* 过大而不适于

60. adjunct: *n.* 附属品
61. spawn: *v.* 催生

62. guild: *n.* 行业协会

63. 神秘剧

64. (圣经故事)诺亚方舟
65. (圣经故事)亚伯拉罕和以撒
66. (圣经故事)参孙和达丽拉
67. capitalize: *v.* 利用

potential. Among them *The Second Shepherds' Play*[68] and *Abraham and Isaac* are still performed regularly.

Most mystery plays were gathered into groups of plays called *cycles*[69] *dramatizing*[70] incidents from the Bible, among other sources. They were usually performed outdoors, at times on movable wagons that doubled at stages. The audience either moved from wagon to wagon to see each play in a cycle, or the wagons moved among the audience. The interaction of the players and the audience was often taken for granted, and the distance between players and audience was often *collapsed*[71].

By the fifteenth and sixteenth centuries, another form of plays developed that was not associated with cycles or with the guilds. These were the *morality plays*[72], and their purpose was to touch on larger contemporary issues that had a moral *overtone*[73]. *Everyman*[74] is certainly the best known of the morality plays and was performed in many nations in translation.

Renaissance Drama

The *revival*[75] of learning in the Renaissance, beginning in the fourteenth century, had considerable effect on drama because classical Greek and Roman plays were discovered and studied.

Elizabethan[76] and Jacobean drama developed most fully during the fifty years from approximately 1590 to 1640. Audiences pored into the playhouses eager for plays about history and for the great tragedies of

68.《第二个牧羊人的故事》

69. cycles 即 mystery cycles 神秘剧
70. dramatize: v. 使戏剧化

71. collapse: v. 缩短

72. 道德剧

73. overtone: n. 寓意

74.《每个人》

75. revival: n. 复兴

76. Elizabethan: a. 伊丽莎白一世时期的

Christopher Marlowe[77], such as *Doctor Faustus*[78], and of *Shakespeare*[79], including *Macbeth*[80], *Hamlet*[81], *Othello*[82], *Julius Caesar*[83], and *King Lear*[84].

The great comedies of the age came mostly from the pen of William Shakespeare: *A Midsummer Night's Dream*[85], *The Comedy of Errors*[86], *As You Like it*[87], *Much ado About Nothing*[88], *The Taming of the Shrew*[89], and *Twelfth Night*[90]. Many of these comedies derived from Italian originals, usually novellas or popular poems and sometimes comedies. But Shakespeare, of course, elevated and vastly improved everything he borrowed. Ben Jonson[91], a playwright who was significantly influenced by classical writers, was also well represented on the Elizabethan stage. Jonson is also important for his contributions to the *masque*[92], an aristocratic entertainment that featured music, dance, and fantastic costuming.

The Elizabethan stage sometimes grew bloody, with playwrights and audiences showing a passion for tragedies that, like *Hamlet*, centered on revenge and often ended with most of the characters meeting a *premature*[93] death. Elizabethan plays also show considerable variety, with history of England. It was a theater of powerful effect, and contemporary diaries indicate that the audiences delighted in it.

Theaters in Shakespeare's day were built outside city limits in *seamy*[94] neighborhoods near *brothels*[95] and *bear-baiting pits*[96], where chained bears were set upon by large dogs for the crowd's amusement. Happily, the theater's business was good; the plays were constructed of remarkable language that seems to have fascinated all social

77. 克里斯托弗·马洛（英国诗人、剧作家）
78.《浮士德博士的悲剧》
79. 莎士比亚（英国诗人、剧作家）
80.《麦克白》
81.《哈姆莱特》
82.《奥赛罗》
83.《尤利乌斯·凯撒》
84.《李尔王》
85.《仲夏夜之梦》
86.《错误的喜剧》
87.《如你所愿》
88.《无事生非》
89.《驯悍记》
90.《第十二夜》
91. 本·琼森（英格兰文艺复兴剧作家、诗人和演员）

92. 假面剧

93. premature: a. 过早的

94. seamy: a. 污秽的
95. brothel: n. 妓院
96. bear-baiting pit: 逗熊场

classes. People flocked to the theater by the thousands.

Late Seventeenth and Eighteenth Century Drama

After the *puritan*[97] reign in England from 1649 to 1660, during which dramatic productions were almost nonexistent, the theater was suddenly revived. In 1660 Prince Charles was invited back from France to be king, thus beginning what was known in England as *the Restoration*[98]. It was a gay, exciting period *in stark contrast to*[99] the gray Puritan era. During the period new indoor theaters modeled on those in France were built, and a new generation of actors and actresses (women took part in plays for the first time in England) came forth to participate in the dramatic revival.

The eighteenth century saw the tradition of the comedy of manners continued in *Richard Brinsley Sheridan*[100]'s *School for Scandal*[101] and *Oliver Goldsmith*[102]'s *She Stoops to Conquer*[103]. The drama of this period focuses on an analysis of social manners, and much of it is *Satire*[104], that is, drama that offers mild criticism of society and holds society up to *comic ridicule*[105]. But underlying that ridicule is the relatively noble motive of reforming society.

During the eighteenth century, theater in France centered on the court and was in the control of *a small coterie*[106] of *snobbish*[107] people. The situation in England was not quite the same, although the audiences were snobbish and socially conscious. They went to the theater to be seen, and they often went in *claques*[108]—groups of

97. puritan: *n.* 清教徒
98. the Restoration: 王政复辟
99. in stark contrast to: 与……形成鲜明的对比
100. 理查德·布林斯利·谢里丹(英国社会风俗喜剧作家、政治家和演说家)
101. 《造谣学校》
102. 奥利弗·哥德史密斯(英国剧作家)
103. 《屈身求爱》
104. Satire: 讽刺文学
105. comic ridicule: 漫画式的嘲讽
106. a small coterie: 一小群
107. snobbish: *a.* 势利的
108. claque: *n.* 喝彩者

like-minded *patrons*[109] who applauded or *booed*[110] together to express their views. Theater was important, but attendance at it was like a material possession: something to be displayed for others to admire.

Nineteenth Century Drama to the Turn of the Century

English playwrights alone produced more than thirty thousand plays during the nineteenth century. Most of the plays were sentimental, *melodramatic*[111], and dominated by a few very powerful actors, stars who often overwhelmed the works written for them. The audiences were quite different from those of the seventeenth and eighteenth centuries. The upwardly mobile urban middle classes and the *moneyed*[112] factory and mill owners who had benefited economically from the industrial revolution demanded a drama that would entertain them.

The new audiences were not especially well educated, nor were they interested in plays that were intellectually demanding. Instead, they wanted *escapist*[113] and sentimental entertainment that was easy to respond to and did not challenge their basic values. Revivals of old plays and adaptations of Shakespeare were also common in the age, with great stars using the plays as platforms for overwhelming, and sometimes *overbearing*[114], performances. *Gothic thrillers*[115] were especially popular, as were *historical plays*[116] and *melodramatic plays*[117] featuring a helpless heroine.

As an *antidote*[118] to such a diet, the new *Realist*[119] movement in literature, marked by the achievements of French novelists *Émile Zola*[120] and *Gustave Flaubert*[121],

109. patron: *n.* 老顾客
110. boo: *v.* 发出嘘声

111. melodramatic: *a.* 夸张的，带有情节剧风格的

112. moneyed: *a.* 有钱的

113. escapist: *n.* 逃避现实者
114. overbearing: *a.* 压倒一切的
115. Gothic thriller: 哥特式惊悚小说
116. 历史剧
117. 情节剧
118. antidote: *n.* 解药；纠正方法
119. Realist: *n.* 现实主义者
120. 埃米尔·左拉（法国作家、自然主义创始人）
121. 古斯塔夫·福楼拜（法国小说家）

finally struck the stage in the 1870s in plays by *August Strindberg*[122] and *Henrik Ibsen*[123].

122. 奥古斯特·斯特林堡（瑞典戏剧家、小说家、诗人）
123. 亨利克·易卜生（挪威剧作家、现代现实主义戏剧的创始人）

Assignment

Review what you've learned from this chapter and complete the following note-taking with related information.

Ⅰ. **Playwrights and masterpieces**（各时代的知名剧作家及其代表作——自编序号总结）.

Western Drama	Playwrights	Masterpieces
Greek Drama	（示范）1. Aeschylus 埃斯库罗斯 Tragedian（悲剧作家）	*Agamemnon / The Libation Bearers / The Eumenides / Prometheus Bound* （代表作名可只写英文，也可双语）
Roman Drama		
Medieval Drama		
Renaissance Drama		
Late Seventeenth and Eighteenth Century Drama		
Nineteenth Century Drama to the Turn of the Century		

Ⅱ. **Main features of each period of Western Drama**（西方戏剧各个发展阶

段要点归纳).

Western Drama	Main Features
Greek Drama	(示范) 1. Drama probably evolved from ancient Egyptian and Greek rituals, ceremonies that were performed the same way again and again and were thought to have propitious effect on the relationship between the people and their gods.
Roman Drama	
Medieval Drama	
Renaissance Drama	
Late Seventeenth and Eighteenth Century Drama	
Nineteenth Century Drama to the Turn of the Century	

Further Reading

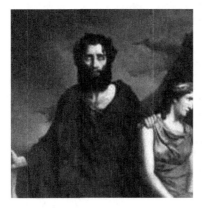

Oedipus

Oedipus was a mythical Greek king of Thebes(底比斯城). A tragic hero in Greek mythology, Oedipus accidentally fulfilled a prophecy that he would end up killing his father and marrying his mother, thereby bringing disaster to his city and family.

The story of Oedipus is the subject of Sophocles's tragedy *Oedipus the King*, which was followed by *Oedipus at Colonus*(科罗诺思城) and then *Antigone*. Together, these plays

make up Sophocles's three Theban plays(底比斯三部曲). Oedipus represents two enduring themes of Greek myth and drama: the flawed nature of humanity and an individual's role in the course of destiny in a harsh universe.(俄狄浦斯代表了希腊神话和戏剧中两个永恒的主题:人性的瑕疵和残酷世界里个人在命运进程中所扮演的角色。)

In the most well-known version of the myth, Oedipus was born to King Laius and Queen Jocasta. Laius wished to thwart(躲过) a prophecy, so he left Oedipus to die on a mountainside. However, the baby was found by shepherds and raised by King Polybus and Queen Merope as their own. Oedipus learned from the oracle at Delphi(特尔斐的祭司) of the prophecy that he would end up killing his father and marrying his mother but, unaware of his true parentage(出身), believed he was fated to murder Polybus and marry Merope, so left for Thebes. On his way he met an older man and quarreled, and Oedipus killed the stranger. Continuing on to Thebes, he found that the king of the city (Laius) had been recently killed, and that the city was at the mercy of the Sphinx(斯芬克斯). Oedipus answered the monster's riddle correctly, defeating it and winning the throne of the dead king and the hand in marriage of the king's widow, (and unbeknownst to him) his mother Jocasta.

Years later, to end a plague on Thebes, Oedipus searched to find who had killed Laius, and discovered that he himself was responsible. Jocasta, upon realizing that she had married both her own son, and her husband's murderer, hanged herself. Oedipus then seized two pins from her dress and blinded himself with them.

The legend of Oedipus has been retold in many versions, and was used by Sigmund Freud to name and give mythic precedent to *the Oedipus complex*(俄狄浦斯情结,即恋母情结).

Chapter Two

A Brief History of American Drama (1)

American drama is part of the European theatrical tradition that dates back to ancient Greek theatre and is heavily influenced by the British theatre. The central hub[1] of the US theater scene is New York City, with its divisions of *Broadway*, *Off-Broadway*, *and Off-Off-Broadway*[2]. Many movie and television stars got their big break working in New York productions. Outside New York, many cities have professional regional or resident theater companies that produce their own seasons, with some works being produced regionally with hopes of eventually moving to New York. US theater also has an active community theatre culture, which relies mainly on local volunteers who may not be actively pursuing a theatrical career.

Colonial Period

Before the first English colony was established in 1607, there were Spanish dramas and Native American tribes that performed theatrical events. Although a theater was built in *Williamsburg, Virginia*[3] in 1716, and the original *Dock Street Theatre*[4] opened in *Charleston, South Carolina*[5] in 1736, the birth of professional theater in America may have begun when *Lewis Hallam*[6] arrived with his theatrical company in Williamsburg in 1752. Lewis and his brother William, who arrived in 1754, were the first to organize a complete company of actors

Notes:

1. hub: *n.* 中心

2. 百老汇,外百老汇和外外百老汇

3. 弗吉尼亚州威廉斯堡市
4. 多克大街剧院
5. 南卡罗来纳州查尔斯顿市
6. 路易斯·哈勒姆(美国剧院经理人)

in Europe and bring them to the colonies. They brought a *repertoire*[7] of plays popular in London at the time, including *Hamlet*, *Othello*, *The Recruiting Officer*[8], and *Richard III*[9]. *The Merchant of Venice*[10] was their first performance, shown initially on September 15, 1752. Encountering opposition from religious organizations, Lewis and his company left for Jamaica in 1754 or 1755. Soon after, Lewis Hallam, Jr., founded *the American Company*[11], opened a theater in New York, and presented *the first professionally mounted American play*[12]—*The Prince of Parthia*[13], by *Thomas Godfrey*[14]—in 1767.

In the 18th century, laws forbidding the performance of plays were passed in *Massachusetts*[15] in 1750, in *Pennsylvania*[16] in 1759, and in *Rhode Island*[17] in 1761, and plays were banned in most states during *the American Revolutionary War*[18] at the urging of *the Continental Congress*[19]. In 1794, president of Yale College, *Timothy Dwight IV*[20], in his "Essay on the Stage", declared that "*to indulge a taste for play-going means nothing more or less than the loss of that most valuable treasure: the immortal soul*[21]."

In spite of such laws, however, a few writers tried their hand at play-writing. Most likely, the first plays written in America were by European-born authors—we know of original plays being written by Spaniards, Frenchmen and Englishmen dating back as early as 1567—although no plays were printed in America until *Robert Hunter*[22]'s *Androboros*[23] in 1714. Still, in the early years, most of the plays produced came from Europe;

7. repertoire: *n.* 剧目
8.《征兵官》
9.《理查三世》
10.《威尼斯商人》

11. 美国公司
12. 第一部专业制作的美国戏剧
13.《安息王子》
14. 托马斯·戈弗雷

15. 马萨诸塞州
16. 宾夕法尼亚州
17. 罗得岛州

18. 美国独立战争
19. 大陆会议
20. 蒂莫西·德怀特四世(耶鲁大学第四任校长)

21. 沉迷于看戏意味着失去最宝贵的财富:不朽的灵魂。

22. 罗伯特·亨特
23.《安德罗波罗斯》

only with Godfrey's *The Prince of Parthia* in 1767 do we get a professionally produced play written by an American, although it was a last-minute substitute for Thomas Forrest[24]'s comic opera *The Disappointment*[25]; or, *The Force of Credulity*[26], and although the first play to treat American themes seriously.

24. 托马斯·福斯特
25. 《失望》
26. 《轻信的力量》

Revolutionary Period

The Revolutionary period was a boost[27] for dramatists, for whom the political debates were fertile ground for both satires, as seen in the works of *Mercy Otis Warren*[28] and *Colonel Robert Munford*[29], and for plays about heroism[30], as in the works of *Hugh Henry Brackenridge*[31]. The post-war period saw the birth of American social comedy in *Royall Tyler*[32]'s *The Contrast*[33], which established a much-imitated[34] version of the "*Yankee*[35]" character. But there were no professional dramatists until *William Dunlap*[36], whose work as playwright, translator, manager and theater historian has earned him the title of "Father of American Drama"; in addition to translating the plays of French melodramas[37], Dunlap wrote plays in a variety of styles, of which *André*[38] and *The Father*[39] are his best.

27. boost: n. 推动,促进
28. 摩希·奥蒂斯·沃伦
29. 罗伯特·芒福德
30. heroism: n. 英雄事迹
31. 休·亨利·布莱肯里兹
32. 罗亚尔·泰勒
33. 《对比》
34. much-imitated: a. 大量模仿的
35. Yankee: n. 美国佬
36. 威廉·邓拉普
37. 传奇剧
38. 《安德烈》
39. 《父亲》

Pre-war Theater

"*The Walnut*[40]" was founded in 1809 by *the Circus of Pepin and Breschard*[41], which is the oldest theater in America. The Walnut's first theatrical production,

40. 核桃剧团
41. 佩平布沙尔马戏团

The Rivals[42], was staged in 1812. In attendance was *President Thomas Jefferson*[43]. Provincial theaters frequently lacked heat and minimal theatrical property and scenery. *Apace with*[44] the country's westward expansion, some entrepreneurs operated floating theaters on barges or riverboats that would travel from town to town. A large town could afford a long "run"—or period of time during which a touring company would stage consecutive multiple performances—of a production, and in 1841, a single play was shown in New York City for an *unprecedented*[45] three weeks.

John Drew[46], a famous American actor, playing the part of Petruchio from *The Taming of the Shrew*. William Shakespeare's works were commonly performed. American plays of the period were mostly melodramas, a famous example of which was *Uncle Tom's Cabin*[47], adapted from the novel of the same name by *Harriet Beecher Stowe*[48].

In 1821, *William Henry Brown*[49] established *the African Grove Theatre*[50] in New York City. It was the third attempt to have an African-American theater, but this was the most successful of them all. The company put on not only Shakespeare, but also staged the first play written by an African-American, *The Drama of King Shotaway*[51]. The theater was shut down in 1823. African-American theater was relatively *dormant*[52], except for the 1858 play *The Escape*[53]; or, *A Leap for Freedom*[54] by *William Wells Brown*[55], who was an ex-slave. African-American works would not be regarded again until the 1920s *Harlem Renaissance*[56].

42.《情敌》
43. 托马斯·杰斐逊(美国第三任总统)
44. apace with: 随着
45. unprecedented: a. 前所未有的
46. 约翰·德鲁
47.《汤姆叔叔的小屋》
48. 哈里耶特·比彻·斯托(美国作家,又称斯托夫人)
49. 威廉·亨利·布朗(剧院经理人)
50. 非洲丛林剧院
51.《沙努瓦王的奇遇》
52. dormant: a. 不活跃的
53.《逃亡》
54.《自由的飞跃》
55. 威廉·威尔斯·布朗(美国黑人剧作家、小说家)
56. 哈莱姆文艺复兴

A popular form of theater during this time was the *minstrel show*[57], which featured white (and sometimes, especially after the Civil War, black) actors dressed in "blackface (painting one's face, etc. with dark makeup to imitate the coloring of an African or African-American)." The players entertained the audience using *comic skits*[58], *parodies*[59] of popular plays and musicals, and general *buffoonery*[60] and *slapstick comedy*[61], all with heavy utilization of *racial stereotyping*[62] and racist themes.

Throughout the 19th century, theater culture was associated with *hedonism*[63] and even violence, and actors (especially women), were looked upon as little better than prostitutes. *Jessie Bond*[64] wrote that by the middle of the 19th century, The stage was *at a low ebb*[65], Elizabethan glories and Georgian artificiality had alike faded into the past, *stilted tragedy and vulgar farce*[66] were all the *would-be*[67] playgoers had to choose from, and the theatre had become *a place of evil repute*[68]. On April 15, 1865, less than a week after the end of *the United States Civil War*[69], *Abraham Lincoln*[70], while watching a play at *Ford's Theater*[71] in Washington, D. C., was assassinated by a nationally popular stage-actor of the period, *John Wilkes Booth*[72].

Victorian burlesque[73], a form of *bawdy comic theater*[74] mocking high art and culture, was imported from England about 1860 and in America became a form of farce in which females in male roles mocked the politics and culture of the day. Criticized for its sexuality and outspokenness, this form of entertainment was hounded

57. minstrel show: 吟游表演
58. comic skit: 喜剧小品
59. parody: n. 拙劣的模仿
60. buffoonery: n. 滑稽戏
61. 打闹喜剧
62. 种族固定形象

63. hedonism: n. 享乐主义

64. 杰西·邦德(英国女演员)

65. at a low ebb: 处于低谷

66. 矫揉造作的悲剧和庸俗的闹剧
67. would-be: a. 将要成为的
68. 声名狼藉的地方
69. 美国内战
70. 亚伯拉罕·林肯(美国第十六任总统)
71. 福特剧院
72. 约翰·威尔克斯·布斯(美国演员)
73. 维多利亚时期的滑稽剧
74. 下流的喜剧剧场

off the "*legitimate stage*[75]" and found itself relegated to saloons and barrooms. The producers toned down the politics and played up the sexuality, until *the burlesque shows*[76] eventually became little more than pretty girls *in skimpy clothing*[77] singing songs, while male comedians told *raunchy jokes*[78].

The drama of the pre-war period tended to be a derivative in form, imitating European melodramas and romantic tragedies, but native in content, appealing to popular *nationalism*[79] by dramatizing current events and portraying American heroism. But playwrights were limited by a set of factors, including the need for plays to be profitable, the *middle-brow*[80] tastes of American theater-goers, and the lack of copyright protection and compensation for playwrights. During this time, the best strategy for a dramatist was to become an actor and/or a manager, after the model of *John Howard Payne*[81], *Dion Boucicault*[82] and *John Brougham*[83]. This period saw the popularity of certain native character types, especially the "Yankee", the "Negro" and the "Indian". Meanwhile, increased immigration brought a number of plays about the Irish and Germans, which often *dovetailed*[84] with concerns over *temperance*[85] and Roman Catholic. This period also saw plays about American expansion to the West (including plays about *Mormonism*[86]) and about rights of women. At the same time, America had created new dramatic forms in *the Tom Shows*[87], *the showboat theater*[88] and the minstrel show.

75. 正统戏剧

76. 滑稽戏演出
77. 穿着轻薄的衣服
78. raunchy joke: 色情笑话

79. nationalism: 国家主义

80. middle-brow: *a.* 中产阶级趣味的

81. 约翰·霍华德·佩恩(美国剧作家、演员)
82. 戴昂·博西凯尔特(美籍爱尔兰作家、神秘剧作家)
83. 约翰·布鲁厄姆(美国剧作家、剧院经理、演员)

84. dovetailed: *a.* 吻合的
85. temperance: *n.* 节欲

86. Mormonism: *n.* 摩门教

87. the Tom Show: 汤姆秀
88. the showboat theater: 船戏剧院

Assignment

Review what you've learned from this chapter and complete the following note-taking with related information.

Ⅰ. Playwrights and masterpieces （知名剧作家及其代表作——自编序号总结）.

Playwrights	Masterpieces

Ⅱ. List all first things happened in this period（自编序号）.

Further Reading

Walnut Street Theatre

The Walnut Street Theatre, at 825 Walnut Street on the corner of 9th and Walnut Street in the Washington Square West neighborhood of Philadelphia, Pennsylvania, is said to be the oldest continuously operating theatre in the English-speaking world and the oldest in the United States.

The venue is operated by *the Walnut Street Theatre Company*, a non-profit organization, and has three stages: the Mainstage, for the company's primary and larger productions, the Independence Studio 3, a studio located on the building's third floor for smaller productions, and the Studio 5 on the fifth floor, which is rented out for independent productions. The company wants to build a theatre-in-the-round next door, where the parking lot currently is.

The Walnut Street Theatre was built by the Circus of Pepin and Breschard,

which toured the United States from 1807 until 1815. Pepin and Breschard constructed numerous venues in cities along the East Coast of the United States, which often featured, along with performances of their circus, classical plays as well as horse dramas（马戏剧）. The theatre was founded in 1809, going by the name of The New Circus. In 1811, the two partners commissioned（委托）architect William Strickland to design and construct a stage and orchestra pit for theatrical performances and the theatre's name was changed to The Olympic. The official website says that the name The Walnut Street Theatre was first used there in 1820, though the name was changed back to The Olympic in 1822 and to The Walnut again in 1828. A travel guidebook from 1849 indicates that in the mid-19th century, this building was called The American Theatre.

The Walnut was the first theatre to install gas footlights（燃气脚灯）in 1837. In 1855 it was also the first theatre to feature air conditioning. The theatre switched to electric chandeliers（枝形吊灯）and footlights in 1892. The theatre has undergone many renovations since its opening.

The first theatrical production at the theatre was *The Rivals* in 1812 (President Thomas Jefferson was in attendance). Edwin Booth and John Sleeper Clarke purchased the theatre in 1865, and then the theatre became part of The Shubert Organization in 1941. While part of the Shubert chain, the theatre housed many pre-Broadway tryouts（试演剧目）of soon-to-be classics, including:

A Streetcar Named Desire with Marlon Brando (1947)
Mister Roberts with Henry Fonda (1948)
Gigi with Audrey Hepburn (1951)
The Diary of Anne Frank with Susan Strasberg (1955)
A Raisin in the Sun with Sidney Poitier (1959)
A Man for All Seasons starring Paul Scofield (1961)

On October 15, 1966, The Walnut Street Theatre was designated（指定）a National Historic Landmark and in 1969, the theatre was purchased by a non-profit organization and turned over to the new Walnut Street Theatre Corporation. On

September 23, 1976, it was the site of the first presidential debate between Gerald R. Ford and Jimmy Carter.

The Walnut Street Theatre Company, a non-profit regional producing company, was formed in 1983 by Bernard Havard. In 1984, the Walnut Street Theatre School was established and over 1,200 students enroll annually, and 1986 saw the introduction of the Independence Studio on 3 series. To this day, the company produces five productions a season on the theater's main stage and is the most subscribed theatre company in the world. In Fall 2008, the theater celebrated its 200th season of live entertainment.

Chapter Three
A Brief History of American Drama (2)

Post-war Theater

In the *postbellum*[89] North, theater flourished as a post-war boom allowed longer and more-frequent productions. The *advent*[90] of American rail transport allowed production companies, its actors, and large, elaborate sets to travel easily between towns, which made permanent theaters in small towns feasible. The invention and practical application of electric lighting also led to changes to and improvements of scenery styles and the designing of theater *interiors*[91] and seating areas.

For playwrights, the period after the war brought more financial reward and aesthetic respect (including professional criticism) than was available earlier. In terms of form, spectacles, melodramas and farces remained popular, but *poetic drama*[92] and *romanticism*[93] almost died out completely due to the new emphasis upon realism, which was adopted by serious drama, melodrama and comedy alike. This realism was not quite the European realism of Ibsen's *Ghosts*, but a combination of scenic realism with a less romantic view of life that accompanied the cultural *turmoil*[94] of the period. The most ambitious effort towards realism during this period came from *James Herne*[95], who was influenced by the ideas of Ibsen, *Hardy*[96] and Zola regarding realism, truth, and literary quality; his most important achievement, *Margaret Fleming*[97], enacts the principles he expounded in his essay

Notes:

89. postbellum: *a.* (美国)内战后的
90. advent: *n.* 到来
91. interior: *n.* 内部
92. poetic drama: 诗剧
93. romanticism: *n.* 浪漫主义
94. turmoil: *n.* 混乱;骚乱
95. 詹姆斯·何恩(美国剧作家)
96. 托马斯·哈代(英国作家)
97. 《玛格丽特·弗莱明》

Art for Truth's Sake in the Drama[98].

20th Century Theatre

By the beginning of the 20th century, legitimate theater had become decidedly more sophisticated in the United States, as it had in Europe. The stars of this era, such as *Ethel Barrymore and John Barrymore*[99], were often seen as even more important than the show itself. The advance of motion pictures also led to many changes in theater. The popularity of musicals may have been due in part to the fact the early films had no sound, and could thus not compete, until *The Jazz Singer*[100] of 1927, which combined both talking and music in a moving picture. More complex and sophisticated dramas bloomed in this time period, and acting styles became more *subdued*[101]. Even by 1915, actors were being lured away from theater and to the silver screen, and *vaudeville*[102] was beginning to face stiff competition.

While *revues*[103] consisting of mostly unconnected songs, *sketches*[104], *comedy routines*[105], and dancing girls dominated for the first 20 years of the 20th century, musical theater would eventually develop beyond this. One of the first major steps was *Show Boat*[106], with music by *Jerome Kern*[107] and lyrics by *Oscar Hammerstein*[108]. It featured songs and non-musical scenes which were integrated to develop the show's plot. The next great step forward was *Oklahoma!*[109]. Its "*dream ballets*[110]" used dance to carry forward the plot and develop the characters.

98.《戏剧艺术为了真理而存在》

99. 埃塞尔·巴里摩尔和约翰·巴里摩尔(美国演员)

100.《爵士歌手》

101. subdued: *a.* 克制的

102. vaudeville: *n.* 歌舞杂耍

103. revue: *n.* 滑稽剧
104. sketch: *n.* 喜剧小品
105. 喜剧套路

106.《演出船》
107. 杰罗姆·克恩(作曲家)
108. 奥斯卡·汉默斯坦(词作家、制作人)
109.《俄克拉荷马》
110. dream ballet: 梦中芭蕾

Amateur performing groups have always had a place alongside professional acting companies. *The Amateur Comedy Club, Inc.*[111] was founded in New York City on April 18, 1884. It was organized by seven gentlemen who broke away from *the Madison Square Dramatic Organization*[112], a socially prominent company. The ACC (The Amateur Comedy Club) staged its first performance on February 13, 1885. It has performed continuously ever since, making it the oldest, continuously performing theatrical society in the United States.

Early 20th century theater was dominated by *the Barrymores*[113]—Ethel Barrymore, John Barrymore, and Lionel Barrymore. Other greats included *Laurette Taylor*[114], *Jeanne Eagels*[115], and *Eva Le Gallienne*[116]. The massive social change that went on during *the Great Depression*[117] also had an effect on theater in the United States. Plays took on social roles, identifying with immigrants and the unemployed. *The Federal Theatre Project*[118], *a New Deal Program*[119] set up by Franklin D. Roosevelt, helped to promote theater and provide jobs for actors. The program staged many elaborate and controversial plays such as *It Can't Happen Here*[120] by *Sinclair Lewis*[121] and *The Cradle Will Rock*[122] by *Marc Blitzstein*[123]. By contrast, the legendary producer *Brock Pemberton*[124] (founder of *the Tony Awards*[125]) was among those who felt that it was more than ever a time for comic entertainment, in order to provide an escape from the prevailing harsh social conditions.

The years between the World Wars were years of

111. 业余喜剧俱乐部

112. 麦迪逊广场戏剧社

113. 巴里摩尔家族(美国的演艺家族)

114. 劳雷特·泰勒
115. 珍妮·尼格尔斯
116. 伊娃·勒·加安娜
117. 大萧条时期

118. 联邦剧院项目
119. 新政计划

120.《这里不会发生这样的事》
121. 辛克莱·刘易斯
122.《摇篮将覆》
123. 马克·布利茨斯坦(美国作家、作曲家)
124. 布罗克·彭伯顿(美国戏剧制作人)
125. 托尼奖(美国戏剧奖)

extremes. *Eugene O'Neill*[126]'s plays were the high point for serious dramatic plays leading up to the outbreak of war in Europe. *Beyond the Horizon*[127] (1920), for which he won his first *Pulitzer Prize*[128], he later won Pulitzers for *Anna Christie*[129] (1922) and *Strange Interlude*[130] (1928) as well as *the Nobel Prize in Literature*[131]. *Alfred Lunt and Lynn Fontanne*[132] remained a popular acting couple in the 1930s.

1940 proved to be a pivotal year for African-American theater. *Frederick O'Neal*[133] and *Abram Hill*[134] founded *ANT*[135], or the American Negro Theater, the most renowned African-American theater group of the 1940s. Their stage was small and located in the basement of a library in Harlem, and most of the shows were attended and written by African-Americans. Some shows include *Theodore Browne*[136]'s *Natural Man*[137] (1941), Abram Hill's *Walk Hard*[138] (1944), and *Owen Dodson*[139]'s *Garden of Time*[140] (1945). Many famous actors received their training at ANT (the American Negro Theater), including *Harry Belafonte*[141], *Sidney Poitier*[142], among many others.

Mid-20th century theater saw a wealth of *Great Leading Ladies*[143], including *Helen Hayes*[144], *Katherine Cornell*[145], and *Ruth Gordon*[146].

The 1960s began with the promise of *the Kennedys' Camelot*[147], soon destroyed by political tragedy, social turmoil and a disheartening inflation. Inevitably, the theatre was affected adversely by these developments, although the number of plays mounted in first-class theatre rose very slightly for much of the decade. The

126. 尤金·奥尼尔(美国知名剧作家)
127.《天边外》
128. 普利策奖
129.《安娜·克里斯蒂》
130.《奇异的插曲》
131. 诺贝尔文学奖
132. 阿尔弗雷德·伦特和林恩·芳丹

133. 弗雷德里克·奥尼尔
134. 亚伯兰·希尔
135. ANT (American Negro Theater): 美国黑人剧院

136. 西奥多·布朗
137.《自然人》
138.《永不止步》
139. 欧文·道森(作家、教育家)
140.《时间花园》
141. 亨瑞·贝拉方特
142. 西德尼·波蒂埃

143. 杰出的女主角们
144. 海伦·海斯
145. 凯瑟琳·康奈尔
146. 鲁思·戈登
147. 肯尼迪核心体系

older generation of playwrights continued to die off, while the younger dramatists went into slides from which they never recovered. As if the nation wished to laugh away its growing *malaise*[148], the lone new writer of major stature proved to be *Neil Simon*[149], whose very *Jewish slant*[150] on New York life provided comic relief through the decade and onwards into the 1990s with such plays as *Barefoot in the Park*[151], *Plaza Suite*[152] and *the semi-autobiographical trilogy*[153].

The growth and maturity of Off-Broadway were recognized in the 1970s when works performed here were awarded Pulitzer Prizes for the first time. No fewer than three Off-Broadway plays won the award during the decade. Similarly, one Broadway success which earned the prize and one of the Off-Broadway winners had initially been presented in regional theatre. Indeed, the most important playwrights to emerge in the decade were all at first identified with Off-Broadway, *albeit*[154] several subsequently enjoyed some success on Broadway. *Sam Shepard*[155]'s writing revealed his interest in low types and in the mythology of the American Southwest. *David Rabe*[156] became the spokesman for those unhappily *engulfed*[160] in the Vietnam War. The most forceful and *variegated*[161] of the new dramatists was probably *David Mamet*[162], who went on to achieve major success on Broadway. *In a lighter vein*[163], *Terrence McNally*[164] demonstrated a *deft*[165] comic touch in dealing with lower middle-class Easterners. For the musical theatre, one of the most significant events was the coming of age of *Stephen Sondheim*[166], who earlier had shown remarkable

148. malaise: n. 萎靡不振
149. 尼尔·西蒙
150. 犹太人的视角

151. 《斗气夫妻》
152. 《酒店套房》
153. 半自传体三部曲

154. albeit: conj. 尽管

155. 山姆·夏普德

156. 大卫·拉贝
160. engulf: v. 陷入；卷入
161. variegated: a. 多样化的
162. 大卫·马梅
163. 以轻松的方式
164. 特伦斯·麦克纳利
165. deft: a. 高超的

166. 斯蒂芬·桑德海姆

skills as a *lyricist*[167] and then as a songwriter.

The history and reception of the two most interesting American playwrights to win wide recognition in the 1980s suggests in some small measure why Broadway suffers from some of its current *ailments*[168]. Certainly the most *trumpeted*[169] and *garlanded*[170] of the new writers has been *August Wilson*[171], who has offered Broadway a number of new plays, each dealing with the lives of American blacks in a different decade. His first success was *Ma Rainey's Black Bottom*[172] in 1984. It depicted the hard, sometimes violent life of a singer in the 1920s. His plays contained magnificently theatrical scenes, but their writing often seemed *slapdash*[173], incorporating mysticism, music, violence and whatever else might have momentary effect; overall, his writing seemed *sloppy*.[174] Nevertheless, in 15 years his plays won two Pulitzer Prizes and five *Drama Critics Circle Awards*[175]. By contrast, the writings of *A. R. Gurney*[176] display superior craftsmanship and are superbly witty. But he deals with American high society and that seems a subject clearly *out of vogue*[177]. As a result, his works have been largely confined to Off-Broadway and regional theater. Musically, the stage has been dominated by the spectacular productions of Englishmen and Frenchmen, notably the works of *Andrew Lloyd Webber*[178].

167. lyricist: *n.* 词作家

168. ailment: *n.* 小毛病

169. trumpeted: *a.* 受吹捧的
170. garlanded: *a.* 受欢迎的
171. 奥古斯特·威尔逊
172.《蕾妮大婶的黑臀舞曲》

173. slapdash: *a.* 草率的

174. sloppy: *a.* 马虎的

175. 戏剧评论奖
176. A. R. 格尼

177. out of vogue: 过时

178. 安德鲁·劳埃德·韦伯（英国知名作曲家）

Assignment

Review what you've learned from this chapter and complete the following note-taking with related information.

Ⅰ. **A summary of distinguished people of this period**（20世纪知名人物及

其代表作或事迹).

People	Achievements
1	
2	
...	

II. Search the web for Webber's masterpiece *The Phantom of the Opera* (《歌剧魅影》) and write a summary of it.

Further Reading

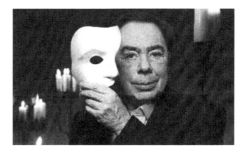

Andrew Lloyd Webber

Andrew Lloyd Webber (1948—), Baron (男爵) Lloyd-Webber, is an English composer and impresario (剧院经理人) of musical theatre. Several of his musicals have run for more than a decade both in the West End and on Broadway. He has composed 13 musicals, a song cycle, a set of variations, two film scores, and a Latin Requiem Mass (追思弥撒曲). Several of his songs have been widely recorded and were hits outside of their parent musicals, notably "*The Music of the Night*" from *The Phantom of the Opera*, "*I Don't Know How to Love Him*" from *Jesus Christ Superstar*, "*Don't Cry for Me, Argentina*" and "*You Must Love Me*" from

Evita, "*Any Dream Will Do*" from *Joseph and the Amazing Technicolor Dream-coat* and "*Memory*" from *Cats*.

He has received a number of awards, including a knighthood (爵位) in 1992, followed by a peerage (贵族地位) from Queen Elizabeth Ⅱ for services to Music, seven Tonys, three Grammys (as well as the Grammy Legend Award), an Academy Award, fourteen Ivor Novello Awards (全英原创音乐奖), seven Olivier Awards, a Golden Globe, a Brit Award, the 2006 Kennedy Center Honors, and the 2008 Classic Brit Award (全英古典音乐奖) for Outstanding Contribution to Music. He has a star on the Hollywood Walk of Fame, is an inductee (应选者) into the Songwriter's Hall of Fame, and is a fellow of the British Academy of Songwriters, Composers and Authors.

His company, the Really Useful Group, is one of the largest theatre operators in London. Producers in several parts of the UK have staged productions, including national tours, of the Lloyd Webber musicals under licence from the Really Useful Group. Lloyd Webber is also the president of *the Art Educational School*, a performing arts school located in Chiswick, West London. He is involved in a number of charitable activities, including *the Elton John AIDS Foundation*, *Nordoff Robbins*, *Prostate Cancer UK and War Child*. In 1992 he set up *the Andrew Lloyd Webber Foundation* (韦伯基金会) which supports the arts, culture and heritage in the UK.

Chapter Four
Eugene O'Neill and
A Long Day's Journey into Night

Eugene Gladstone O'Neill (October 16, 1888—November 27, 1953) was an American playwright and *Nobel laureate*[1] in Literature. His poetically titled plays were among the first to introduce into U.S. drama techniques of realism earlier associated with Russian playwright Anton Chekhov, Norwegian playwright Henrik Ibsen, and Swedish playwright August Strindberg. The drama *Long Day's Journey into Night* is often numbered on the short list of the finest U.S. plays in the 20th century, alongside Tennessee Williams's *A Streetcar Named Desire* and Arthur Miller's *Death of a Salesman*. He is called "father of American drama" for he almost *single-handedly*[2] transformed the American theater and brought it into the 20th century.

O'Neill's plays were among the first to include speeches in American English *vernacular*[3] and involve characters on the *fringes*[4] of society. They struggle to maintain their hopes and aspirations, but ultimately slide into *disillusionment*[5] and despair. Of his very few comedies, only one is well-known (*Ah, Wilderness!*). Nearly all of his other plays involve some degree of tragedy and personal pessimism.

Notes:

1. Nobel laureate: 诺贝尔奖得主

2. single-handedly: *ad.* 单枪匹马地

3. vernacular: *n.* 方言
4. fringe: *n.* 边缘

5. disillusionment: *n.* 幻灭

Early Life

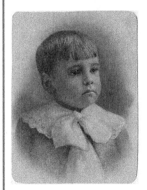

Portrait of O'Neill as a Child, 1893

O'Neill was born in a hotel, the Barrett House, at Broadway and 43rd Street. He was the son of Irish immigrant actor James O'Neill and Mary Ellen Quinlan, who was also of *Irish descent*[6]. Because his father was often on tour with a theatrical company, accompanied by Eugene's mother, O'Neill was sent to St. Aloysius Academy for Boys, a Catholic boarding school in the Riverdale section of the Bronx, where he found his only *solace*[7] in books. His father suffered from alcoholism; his mother from an addiction to *morphine*[8], prescribed to relieve the pains of the difficult birth of her third son, Eugene.

The O'Neill family reunited for summers in New London, Connecticut. O'Neill also briefly attended Betts Academy in Stamford. He attended Princeton University for one year. Accounts vary as to why he left. He may have been dropped for attending too few classes, been suspended for "*conduct code violations*[9]", or "for breaking a window", or according to a more concrete but possibly *apocryphal*[10] account, because he threw "a beer bottle into the window of Professor Woodrow Wilson", the future president of the United States.

6. Irish descent: 爱尔兰后裔

7. solace: *n.* 慰藉

8. morphine: *n.* 吗啡

9. 破坏校规

10. apocryphal: *a.* 可疑的

O'Neill spent several years at sea, during which he suffered from depression and *alcoholism*[11]. Despite this, he had a deep love for the sea and it became a prominent theme in many of his plays, several of which are set on board ships like those on which he worked. O'Neill joined the Marine Transport Workers Union of the Industrial Workers of the World (*IWW*[12]), which was fighting for improved living conditions for the working class. O'Neill's parents and elder brother Jamie (who drank himself to death at the age of 45) died within three years of one another, not long after he had begun to make his mark in the theater.

11. alcoholism: *n.* 酗酒

12. IWW: 世界产业工人组织

Career

After his experience in 1912—1913 at a *sanatorium*[13] where he was recovering from *tuberculosis*[14], he decided to devote himself full-time to writing plays (the events immediately prior to going to the sanatorium are dramatized in his masterpiece, *Long Day's Journey into Night*). O'Neill had previously been employed by the *New London Telegraph*, writing poetry as well as reporting.

In the fall of 1914, he entered Harvard University to attend a course in dramatic technique given by Professor George Baker. He left after one year and did not complete the course.

O'Neill's first play, *Bound East for Cardiff*, premiered at this theatre on a wharf in Provincetown, Massachusetts.

13. sanatorium: *n.* 疗养院
14. tuberculosis: *n.* 肺结核

During the 1910s O'Neill was a *regular*[15] on the Greenwich Village literary scene, where he also *befriended*[16] many *radicals*[17], most notably Communist Labor Party of America founder John Reed. O'Neill also had a brief romantic relationship with Reed's wife, writer Louise Bryant. O'Neill was portrayed by Jack Nicholson in the 1981 film *Reds*, about the life of John Reed.

His involvement with the Provincetown Players began in mid-1916. O'Neill is said to have arrived for the summer in Provincetown with "a trunk full of plays". Susan Glaspell describes a reading of *Bound East for Cardiff* that took place in the living room of Glaspell and her husband George Cram Cook's home on Commercial Street, *adjacent*[18] to the *wharf*[19] (pictured)

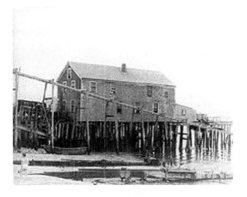

that was used by the players for their theater: "So Gene took *Bound East for Cardiff* out of his trunk, and Freddie Burt read it to us, Gene staying out in the dining-room while reading went on. He was not left alone in the dining-room when the reading had finished." The Provincetown Players performed many of O'Neill's early

15. regular: *n.* 常客

16. befriend: *v.* 和……交朋友
17. radical: *n.* 激进分子

18. adjacent: *a.* 邻近的
19. wharf: *n.* 码头

works in their theaters both in Provincetown and on Mac Dougal Street in Greenwich Village. Some of these early plays began downtown and then moved to Broadway.

One of these early one acts written by O'Neill was *The Web*. Written in 1913, this was the first time O'Neill explored the famous themes he thrived in his later career. *The Web* was one of O'Neill's first dramas, which was a huge stepping stone as O'Neill was exploring fields in which he had never before been explored with such success.

O'Neill's first published play, *Beyond the Horizon*, opened on Broadway in 1920 to great acclaim, and was awarded the Pulitzer Prize for Drama. His first major hit[20] was *The Emperor Jones*, which ran on Broadway in 1920 and obliquely[21] commented on the U. S. occupation of Haiti that was a topic of debate in that year's presidential election. His best-known plays include *Anna Christie* (Pulitzer Prize 1922), *Desire Under the Elms* (1924), *Strange Interlude* (Pulitzer Prize 1928), *Mourning Becomes Electra* (1931), and his only well-known comedy, *Ah, Wilderness*, a wistful re-imagining of his youth[22] as he wished it had been. In 1936 he received the Nobel Prize for Literature after he had been nominated that year by Henrik Schück, member of the Swedish Academy. After a ten-year pause, O'Neill's now-renowned[23] play *The Iceman Cometh* was produced in 1946. The following year's *A Moon for the Misbegotten* failed, and it was decades before coming to be considered as among his best works.

20. hit: *n.* 成功演出
21. obliquely: *ad.* 隐晦地
22. a wistful re-imagining of his youth: 对青年时代的怀念
23. now-renowned: *a.* 当代有名的

He was also part of the modern movement to partially revive the classical heroic mask from ancient Greek theatre and *Japanese Noh theatre*[24] in some of his plays, such as *The Great God Brown* and *Lazarus Laughed*.

24. Japanese Noh theatre：日本能剧（日本主要传统戏剧，主要以日本传统文学作品为脚本，在表演形式上辅以面具、服装、道具和舞蹈组成）

Family Life

O'Neill was married to Kathleen Jenkins from October 2, 1909 to 1912, during which time they had one son, Eugene O'Neill, Jr. (1910—1950). In 1917, O'Neill met Agnes Boulton, a successful writer of commercial fiction, and they married on April 12, 1918. They lived in a home owned by her parents in Point Pleasant, New Jersey after their marriage. The years of their marriage—during which the couple lived in Connecticut and Bermuda and had two children, Shane and Oona—are described vividly in her 1958 memoir *Part of a Long Story*. They divorced in 1929, after O'Neill abandoned Boulton and the children for the actress Carlotta Monterey. O'Neill and Carlotta married less than a month after he officially divorced his previous wife.

In 1929, O'Neill and Monterey moved to the Loire Valley in central France. During the early 1930s they returned to the United States and lived in Sea Island, Georgia, at a house called *Casa Genotta*. He moved to Danville, California in 1937 and lived there until 1944. His house there, *Tao House*, is today the Eugene O'Neill National Historic Site.

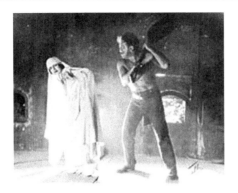

Actress Carlotta Monterey in Plymouth Theatre Production of O'Neill's *The Hairy Ape*, 1922 (Monterey later became the playwright's third wife.)

In their first years together, Monterey organized O'Neill's life, enabling him to devote himself to writing. She later became addicted to *potassium bromide*[25], and the marriage *deteriorated*[26], resulting in a number of separations, although they never divorced.

In 1943, O'Neill *disowned*[27] his daughter Oona for marrying the English actor, director, and producer Charlie Chaplin when she was 18 and Chaplin was 54. He never saw Oona again. He also had distant relationships with his sons. Eugene O'Neill Jr., a Yale *classicist*[28], suffered from alcoholism and committed suicide in 1950 at the age of 40. Shane O'Neill became *a heroin addict*[29] and moved into the family home in Bermuda, Spithead, with his new wife, where he supported himself by selling off the furnishings. He was disowned by his father before also committing suicide (by jumping out of a window) a number of years later. Oona ultimately inherited Spithead and the connected estate (subsequently known as the Chaplin Estate).

25. potassium bromide: 溴化钾
26. deteriorate: v. 恶化
27. disown: v. 脱离关系
28. classicist: n. 古典主义学者
29. a heroin addict: (吸食海洛因的)瘾君子

Illness and Death

After suffering from multiple health problems (including depression and alcoholism) over many years, O'Neill ultimately faced a severe *Parkinsons-like tremor*[30] in his hands which made it impossible for him to write during the last 10 years of his life; he had tried using dictation but found himself unable to compose in that way. While at Tao House, O'Neill had intended to write a cycle of 11 plays *chronicling*[31] an American family since the 1800s. Only two of these, *A Touch of the Poet* and *More Stately Mansions*, were ever completed. As his health worsened, O'Neill lost inspiration for the project and wrote three largely autobiographical plays, *The Iceman Cometh*, *Long Day's Journey into Night*, and *A Moon for the Misbegotten*. He managed to complete *Moon for the Misbegotten* in 1943, just before leaving Tao House and losing his ability to write. Drafts of many other uncompleted plays were destroyed by Carlotta at Eugene's request.

30. Parkinsons-like tremor: 与帕金森氏症相类似的颤抖症

31. chronicle: v. 按年代记录

Grave of Eugene O'Neill

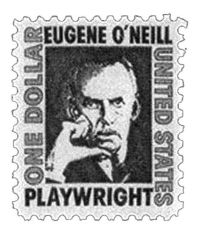

O'Neill Stamp Issued in 1967

O'Neill died in Room 401 of the Sheraton Hotel (now Boston University's Kilachand Hall) on Bay State Road in Boston, on November 27, 1953, at the age of 65. As he was dying, he whispered his last words: "I knew it. I knew it. Born in a hotel room and died in a hotel room." O'Neill was *interred*[32] in the Forest Hill Cemetery in Boston's Jamaica Plain neighborhood. In 1956 Carlotta arranged for his autobiographical play *Long Day's Journey into Night* to be published, although his written instructions had stipulated that it not be made public until 25 years after his death. It was produced on stage to tremendous critical acclaim and won the Pulitzer Prize in 1957. This last play is widely considered to be his finest. Other *posthumously-published*[33] works include *A Touch of the Poet* (1958) and *More Stately Mansions* (1967).

In 1967, the United States Postal Service honored O'Neill with a Prominent Americans series (1965—1978) $1 postage stamp.

32. inter: v. 埋葬

33. posthumously-published: a. （作家）去世后出版的

A Long Day's Journey into Night

A Long Day's Journey into Night, a drama in four acts, written by O'Neill in 1939—1941 and produced and published posthumously in 1956. The play, which is considered an American masterpiece, was awarded a Pulitzer Prize in 1957.

This autobiographical play is a shattering depiction of a day in the dreary life of a couple and their two sons. James Tyrone, a semiretired actor, is vain, self-obsessed, and miserly; his wife, Mary, feels worthless and retreats into a morphine-induced haze. Jamie, their older son, is a bitter alcoholic. James refuses to acknowledge the illness of his consumptive younger son, Edmund. As Mary sinks into hallucination and madness, father and sons confront each other in painful scenes that reveal their hidden motives and interdependence.

O'Neill wrote *A Moon for the Misbegotten* (1952) as a sequel, charting the subsequent life of Jamie Tyrone.

Characters

JAMES TYRONE

MARY CAVAN TYRONE, his wife

JAMES TYRONE, JR., their elder son

EDMUND TYRONE, their younger son

CATHLEEN, *second girl*[34]

Scenes

ACT 1 *Living room of the Tyrones' summer home* 8:30 *A.M. of a day in August*, 1912

ACT 2, SCENE 1 *The same, around* 12:45

34. second girl: 女仆

ACT 2, SCENE 2 *The same, about a half hour later*

ACT 3 *The same, around 6:30 that evening*

ACT 4 *The same, around midnight*

ACT 1

SCENE—*Living room of* JAMES TYRONE's *summer home on a morning in August, 1912. At rear are two double doorways with portieres.*[35] *The one at right leads into a front parlor*[36] *with the formally arranged, set appearance of a room rarely occupied. The other opens on a dark, windowless back parlor, never used except as a passage from living room to dining room. Against the wall between the doorways is a small bookcase, with a picture of Shakespeare above it, containing novels by Balzac, Zola, Stendhal, philosophical and sociological works by Schopenhauer, Nietzsche, Marx, Engels, Kropotkin, Max Sterner, plays by Ibsen, Shaw, Strindberg, poetry by Swinburne, Rossetti, Wilde, Ernest Dowson, Kipling, etc.*[37]

In the right wall, rear, is a screen door[38] *leading out on the porch which extends halfway around the house. Farther forward, a series of three windows looks over the front lawn to the harbor and the avenue that runs along the water front. A small wicker*[39] *table and an ordinary oak desk are against the wall, flanking*[40] *the windows. In the left wall, a similar series of windows looks out on the grounds in back of the house. Beneath them is a wicker couch with cushions, its head toward rear. Farther back is a large, glassed-in*[41] *bookcase with sets*[42] *of Dumas, Victor Hugo, Charles Lever, three sets of Shakespeare, The World's Best Literature in fifty large volumes, Hume's History of England, Thiers' History of the*

35. At rear are two double doorways with portieres: 舞台后侧是两扇门,挂着门帘。
36. parlor: n. 客厅
37. 这段描述中,奥尼尔列举了许多 19 世纪(尤其是 19 世纪晚期)的作家。这是奥尼尔采用小说手法描写戏剧细节的一个例子。奥尼尔也采用了同样的手法来描述剧中人物的外貌和行为。
38. screen door: 纱门
39. wicker: n. 柳条
40. flank: v. 在……侧面
41. glassed-in: a. 用玻璃结构封起来的
42. set: n. 一套

Consulate and Empire, Smollett's *History of England*, Gibbon's *Roman Empire* and miscellaneous[43] volumes of old plays, poetry, and several histories of Ireland. The astonishing thing about these sets is that all the volumes have the look of having been read and reread. The hardwood floor is nearly covered by a rug, inoffensive[44] in design and color. At center is a round table with a green shaded reading lamp[45], the cord[46] plugged in one of the four sockets[47] in the chandelier[48] above. Around the table within reading light range are four chairs, three of them wicker armchairs, the fourth (at right front of table) a varnished oak rocker with leather bottom.

It is around 8:30. Sunshine comes through the windows at right.

As the curtain rises, the family have just finished breakfast. MARY TYRONE and her husband enter together from the back parlor, coming from the dining room.

Mary is fifty-four, about medium height. She still has a young, graceful figure, a trifle plump[49], but showing little evidence of middle-aged waist and hips, although she is not tightly corseted[50]. Her face is distinctly Irish in type. It must once have been extremely pretty, and is still striking[51]. It does not match her healthy figure but is thin and pale with the bone structure prominent. Her nose is long and straight, her mouth wide with full, sensitive lips. She uses no rouge[52] or any sort of make-up. Her high forehead is framed by thick, pure white hair. Accentuated[53] by her pallor[54] and white hair, her dark brown eyes appear black. They are unusually large and beautiful, with black brows and long curling lashes.

What strikes one immediately is her extreme nervousness. Her hands are never still. They were once beautiful hands, with

43. miscellaneous: *a.* 各种各样的

44. inoffensive: *a.* 不令人讨厌的
45. a green shaded reading lamp: 一盏带绿色灯罩的台灯
46. cord: *n.* 电线
47. socket: *n.* 插座
48. chandelier: *n.* 垂吊灯

49. a trifle plump: 略微丰腴

50. corset: *v.* 穿束腹衣
51. striking: *a.* 出众的

52. rouge: *n.* 口红

53. accentuate: *v.* 使突出
54. pallor: *n.* 苍白

long, tapering⁵⁵ fingers, but rheumatism⁵⁶ has knotted the joints and warped the fingers, so that now they have an ugly crippled look. One avoids looking at them, the more so because one is conscious she is sensitive about their appearance and humiliated by her inability to control the nervousness which draws attention to them.

She is dressed simply but with a sure sense of what becomes her. Her hair is arranged with fastidious⁵⁷ care. Her voice is soft and attractive. When she is merry, there is a touch of Irish lilt⁵⁸ in it. Her most appealing quality is the simple, unaffected charm of a shy Convent-girl youthfulness she has never lost—an innate unworldly innocence.

JAMES TYRONE is sixty-five but looks ten years younger. About five feet eight, broad-shouldered and deep-chested, he seems taller and slenderer because of his bearing⁵⁹, which has a soldierly quality of head up, chest out, stomach in, shoulders squared. His face has begun to break down but he is still remarkably good looking—a big, finely shaped head, a handsome profile, deep-set light-brown eyes⁶⁰. His grey hair is thin with a bald spot like a monk's tonsure⁶¹.

The stamp of his profession is unmistakably on him. Not that he indulges in any of the deliberate temperamental posturings of the stage star. He is by nature and preference a simple, unpretentious⁶² man, whose inclinations⁶³ are still close to his humble beginnings and his Irish farmer forebears⁶⁴. But the actor shows in all his unconscious habits of speech, movement and gesture. These have the quality of belonging to a studied technique. His voice is remarkably fine, resonant⁶⁵ and flexible, and he takes great pride in it.

His clothes, assuredly⁶⁶, do not costume any romantic

55. tapering: *a.* 尖细的
56. rheumatism: *n.* 风湿病

57. fastidious: *a.* 挑剔的

58. lilt: *n.* 轻快活泼的调子

59. bearing: *n.* 举止

60. deep-set light-brown eyes: 深陷的浅棕色眼睛
61. tonsure: *n.* 秃顶

62. unpretentious: *a.* 不张扬的
63. inclination: *n.* （性格上的）倾向
64. forebear: *n.* 祖先

65. resonant: *a.* 洪亮的

66. assuredly: *ad.* 确实地

part. He wears a threadbare[67], ready-made[68], grey sack suit[69] and shineless black shoes, a collar-less shirt with a thick white handkerchief knotted loosely around his throat. There is nothing picturesquely[70] careless about this get-up[71]. It is commonplace shabby[72]. He believes in wearing his clothes to the limit of usefulness, is dressed now for gardening, and doesn't give a damn[73] how he looks. He has never been really sick a day in his life. He has no nerves. There is a lot of stolid, earthy peasant in him, mixed with streaks of sentimental melancholy and rare flashes of intuitive sensibility.[74]

Tyrone's arm is around his wife's waist as they appear from the back parlor. Entering the living room he gives her a playful hug[75].

TYRONE: You're a fine armful now, Mary, with those twenty pounds you've gained.

MARY: [*smiles affectionately*[76]] I've gotten too fat, you mean, dear. I really ought to reduce.

TYRONE: None of that, my lady! You're just right. We'll have no talk of reducing. Is that why you ate so little breakfast?

MARY: So little? I thought I ate a lot.

TYRONE: You didn't. Not as much as I'd like to see, anyway.

MARY: [*teasingly*] Oh you! You expect everyone to eat the enormous breakfast you do. *No one else in the world could without dying of indigestion.*[77] [*She comes forward to stand by the right of table.*]

TYRONE: [*following her*] I hope I'm not as big a

67. threadbare: *a.* 破旧的
68. ready-made: *a.* 陈旧的
69. sack suit: 普通西装
70. picturesquely: *ad.* 别致地
71. get-up: 一身装扮
72. shabby: *a.* 寒酸的

73. doesn't give a damn: 不在乎

74. 他有乡下种田人鲁钝的底子,可是粗中带细,间或也容易伤感,偶尔出其不意还会本能地体贴人。
75. a playful hug: 开玩笑地搂住

76. smiles affectionately: 亲热地一笑

77. No one else in the world could without dying of indigestion: 别人要是像你那么吃,早就撑死了。

	glutton[78] as that sounds. With hearty satisfaction. But thank God, I've kept my appetite and I've the digestion of a young man of twenty, if I am sixty-five.	78. glutton: *n.* 贪吃的人
MARY:	You surely have, James. No one could deny that. [*She laughs and sits in the wicker armchair at right rear of table. He comes around in back of her and selects a cigar from a box on the table and cuts off the end with a little clipper*[79]. *From the dining room JAMIE'S and EDMUND'S voices are heard. Mary turns her head that way.*] Why did the boys stay in the dining room, I wonder? Cathleen must be waiting to clear the table.	79. clipper: *n.* 剪刀
TYRONE:	[*jokingly but with an undercurrent of resentment*[80]] It's a secret *confab*[81] they don't want me to hear, I suppose. I'll bet they're *cooking up*[82] some new scheme to touch the Old Man. [*She is silent on this, keeping her head turned toward their voices. Her hands appear on the table top, moving restlessly. He lights his cigar and sits down in the rocker at right of table, which is his chair, and puffs*[83] *contentedly.*] There's nothing like the first after-breakfast cigar, if it's a good one, and this new lot have the right mellow flavor. They're a great bargain, too. I got them dead cheap. It was McGuire put me on to them.	80. an undercurrent of resentment: 心里稍有怒意 81. confab: *n.* 交谈 82. cook up: 编造，策划 83. puff: *n.* 吸几口烟
MARY:	[*a trifle acidly*[84]] I hope he didn't put you	84. a trifle acidly: 有点不悦地

	on to any new piece of property at the same time. His real estate bargains don't work out so well.	
TYRONE:	[*defensively*] I wouldn't say that, Mary. After all, he was the one who advised me to buy that place on Chestnut Street and I made a quick *turnover*[85] on it for a fine profit.	85. turnover: *n.* 快速周转资金
MARY:	[*smiles now with teasing affection*[86]] I know. The famous one stroke of good luck. I'm sure McGuire never dreamed— [*Then she pats his hand.*] Never mind, James. I know it's a waste of breath trying to convince you, *you're not a cunning real estate speculator.*[87]	86. smiles now with teasing affection: 略带嘲弄的微笑 87. you're not a cunning real estate speculator: 你可不是个狡猾的房地产商。
TYRONE:	[*huffily*[88]] I've no such idea. But land is land, and it's safer than the stocks and bonds of Wall Street swindlers. [*then placatingly*[89]] But let's not argue about business this early in the morning. [*A pause. The boys' voices are again heard and one of them has a fit of coughing. Mary listens worriedly. Her fingers play nervously on the table top.*]	88. huffily: *ad.* 暴躁地 89. placatingly: *ad.* 安抚地
MARY:	James, it's Edmund you ought to scold for not eating enough. He hardly touched anything except coffee. He needs to eat to keep up his strength. I keep telling him that but he says he simply has no appetite. Of course, there's nothing takes away your	

appetite like a bad summer cold.

TYRONE: Yes, it's only natural. So don't let yourself get worried—

MARY: [*quickly*] Oh, I'm not. I know he'll be all right in a few days if he takes care of himself. [*As if she wanted to dismiss the subject but can't.*] But it does seem a shame he should have to be sick right now.

TYRONE: Yes, it is bad luck. [*He gives her a quick, worried look.*] But you mustn't let it upset you, Mary. Remember, you've got to take care of yourself, too.

MARY: [*quickly*] I'm not upset. There's nothing to be upset about. What makes you think I'm upset?

TYRONE: Why, nothing, except you've seemed a bit high-strung[90] the past few days.

MARY: [*forcing a smile*] I have? Nonsense, dear. It's your imagination. [*with sudden tenseness*] You really must not watch me all the time, James. I mean, it makes me self-conscious.

TYRONE: [*putting a hand over one of her nervously playing ones*] Now, now, Mary. That's your imagination. If I've watched you it was to admire how fat and beautiful you looked. [*His voice is suddenly moved by deep feeling.*] I can't tell you the deep happiness it gives me, darling, to see you as you've been since you came back to us, your dear

90. high-stung: *a.* 很紧张的

	old self again. [*He leans over and kisses her cheek impulsively—then turning back adds with a constrained air*⁹¹.] So keep up the good work, Mary.	91. He leans over and kisses her cheek impulsively—then turning back adds with a constrained air: 他弯下腰来亲亲她的脸颊，然后又情不自禁地加了一句。
MARY:	[*has turned her head away*] I will, dear. [*She gets up restlessly and goes to the windows at right.*] Thank heavens, the fog is gone. [*She turns back.*] I do feel out of sorts this morning. I wasn't able to get much sleep with that awful foghorn going all night long.	
TYRONE:	Yes, it's like having a sick whale in the back yard. It kept me awake, too.	
MARY:	[*affectionately amused.*] Did it? You had a strange way of showing your restlessness. You were snoring so hard I couldn't tell which was the foghorn! [*She comes to him, laughing, and pats his cheek playfully.*] Ten foghorns couldn't disturb you. You haven't a nerve in you. You've never had.	
TYRONE:	[*his vanity piqued—testily*⁹²] Nonsense. You always exaggerate about my snoring.	92. his vanity piqued—testily: 感到有点丢脸——不高兴地
MARY:	I couldn't. If you could only hear yourself once—[*A burst of laughter comes from the dining room. She turns her head, smiling.*] What's the joke, I wonder?	
TYRONE:	[*grumpily*⁹³] It's on me. I'll bet that much. It's always on the Old Man.	93. grumpily: *ad.* 脾气冲地
MARY:	[*teasingly*] Yes, it's terrible the way we all pick on you, isn't it? You're so abused!	

	[*She laughs—then with a pleased, relieved air.*] Well, no matter what the joke is about, it's a relief to hear Edmund laugh. He's been so *down in the mouth*[94] lately.	94. down in the mouth: *a.* 情绪低落的
TYRONE:	[*ignoring this—resentfully*] Some joke of Jamie's, I'll *wager*[95]. He's forever making sneering fun of somebody, that one.	95. wager: *v.* 打赌
MARY:	Now don't start in on poor Jamie, dear. [*without conviction*] He'll turn out all right in the end, you wait and see.	
TYRONE:	He'd better start soon, then. He's nearly thirty-four.	
MARY:	[*ignoring this*] Good heavens, are they going to stay in the dining room all day? [*She goes to the back parlor doorway and calls.*] Jamie! Edmund! Come in the living room and give Cathleen a chance to clear the table. [*Edmund calls back, "We're coming, Mama." She goes back to the table.*]	
TYRONE:	[*grumbling*[96]] You'd find excuses for him no matter what he did.	96. grumbling: *a.* 抱怨的
MARY:	[*sitting down beside him, pats his hand.*] Shush.	

　　Their sons JAMES, JR. and EDMUND enter together from the back parlor. They are both grinning, still chuckling over what had caused their laughter, and as they come forward they glance at their father and their grins grow broader.

JAMIRE, the elder, is thirty-three. He has his father's broad-shouldered, deep-chested physique[97], is an inch taller and weighs less, but appears shorter and stouter[98] because he lacks TYRONE's bearing and graceful carriage[99]. He also lacks his father's vitality. The signs of premature disintegration are on him[100]. His face is still good looking, despite marks of dissipation[101], but it has never been handsome like TYRONE's, although JAMIE resembles him rather than his mother. He has fine brown eyes, their color midway between his father's lighter and his mother's darker ones. His hair is thinning and already there is indication of a bald spot like TYRONE's. His nose is unlike that of any other member of the family, pronouncedly aquiline. Combined with his habitual expression of cynicism it gives his countenance a Mephistophelian cast.[102] But on the rare occasions when he smiles without sneering, his personality possesses the remnant[103] of a humorous, romantic, irresponsible Irish charm—that of the beguiling ne'er-do-well[104], with a strain of the sentimentally poetic, attractive to women and popular with men.

He is dressed in an old sack suit, not as shabby as Tyrone's, and wears a collar and tie. His fair skin is sunburned a reddish, freckled tan.[105]

EDMUND is ten years younger than his brother, a couple of inches taller, thin and wiry[106]. Where JAMIE takes after his father, with little resemblance to his mother, EDMUND looks like both his parents, but is more like his mother. Her big, dark eyes are the dominant feature in his long, narrow Irish face. His mouth has the same quality of hypersensitiveness[107] hers possesses. His high forehead is hers accentuated, with dark brown hair, sun bleached[108] to red at the

97. broad-shouldered, deep-chested physique：宽肩魁梧的体格
98. stouter：a. 结实的
99. carriage：n. 举止
100. The signs of premature disintegration are on him：人还没老就显得颓唐了。
101. dissipation：n.（多年沉溺于酒色使他）面容憔悴
102. 他的鼻子却与家中其他人不一样，完全是鹰钩鼻。这样的鼻子再加上一天到晚对人冷嘲热讽的态度，就好像在脸上戴了一副魔鬼式的面具。
103. remnant：n. 剩余
104. that of the beguiling ne'er-do-well：天生可爱的性子
105. 他白皙的皮肤晒成了棕褐色，脸上都是雀斑。
106. wiry：a. 瘦长结实的
107. hypersensitiveness：n. 高度敏感
108. bleach：v. 使脱色

ends, brushed straight back from it. But his nose is his father's and his face in profile recalls Tyrone's.[109] Edmund's hands are noticeably like his mother's, with the same exceptionally long fingers. They even have to a minor degree the same nervousness. It is in the quality of extreme nervous sensibility that the likeness of Edmund to his mother is most marked.[110]

He is plainly in bad health. Much thinner than he should be, his eyes appear feverish[111] and his cheeks are sunken[112]. His skin, in spite of being sunburned a deep brown, has a parched sallowness.[113] He wears a shirt, collar and tie, no coat, old flannel[114] trousers, brown sneakers[115].

MARY: [turns smilingly to them, in a merry tone that is a bit forced] I've been teasing your father about his snoring. [to TYRONE] I'll leave it to the boys, James. They must have heard you. No, not you, Jamie. I could hear you down the hall almost as bad as your father. You're like him. As soon as your head touches the pillow you're off and ten foghorns couldn't wake you. [She stops abruptly[116], catching Jamie's eyes regarding her with an uneasy, probing[117] look. Her smile vanishes and her manner becomes self-conscious.] Why are you staring, Jamie? [Her hands flutter up to her hair.[118]] Is my hair coming down? It's hard for me to do it up properly now. My eyes are getting so bad and I never can find my glasses.

109. his face in profile recalls Tyrone's: 从侧面看他很像蒂龙

110. 艾德蒙和母亲最相似的地方就在于极度敏感。

111. feverish: a. 像在发烧似的

112. sunken: a. 凹陷的

113. 他的皮肤虽然被晒成了深棕色，但却显出一种干枯的黄褐色。

114. flannel: a. 法兰绒的

115. sneaker(s): n. 胶底运动鞋

116. abruptly: ad. 突然地

117. probing: a. 窥探的

118. 她轻轻抬起手，拨弄了一下头发。

JAMIE:	[*looks away guiltily*] Your hair's all right, Mama. I was only thinking how well you look.	
TYRONE:	[*heartily*] Just what I've been telling her, Jamie. She's so fat and *sassy*[119], there'll soon be no holding her.	119. sassy: *a.* 无礼的
EDMUND:	Yes, *you certainly look grand*[120], Mama. [*She is reassured and smiles at him lovingly. He winks with a kidding grin.*] I'll back you up about Papa's snoring. *Gosh, what a racket!*[121]	120. 您的确看上去身体不错。 121. 天哪，好厉害，像打雷一样！
JAMIE:	I heard him, too. [*He quotes, putting on a ham-actor manner.*[122]] "The Moor, I know his trumpet."[123] [*His mother and brother laugh.*]	122. 他引用莎士比亚的词语，同时做出表演的姿态。 123. 此处为《奥赛罗》中的台词："是摩尔人的号角声，我知道，他来了！"
TYRONE:	[*scathingly*[124]] If it takes my snoring to make you remember Shakespeare instead of *the dope sheet on the ponies*[125], I hope I'll keep on with it.	124. scathingly: *ad.* 尖刻地 125. the dope sheet on the ponies: 赌马的马经
MARY:	Now, James! You mustn't be so *touchy*[126]. [*Jamie shrugs his shoulders and sits down in the chair on her right.*]	126. touchy: *a.* 易怒的
EDMUND:	[*irritably*] Yes, for Pete's sake, Papa! The first thing after breakfast! Give it a rest, can't you? [*He slumps down*[127] *in the chair at left of table next to his brother. His father ignores him.*]	127. slump down: 跌坐
MARY:	[*reprovingly*[128]] Your father wasn't finding fault with you. You don't have to always take Jamie's part. You'd think you were the one ten years older.	128. reprovingly: *ad.* 埋怨地

JAMIE:	[*boredly*] What's all the fuss about? Let's forget it.	
TYRONE:	[*contemptuously*[129]] Yes, forget! Forget everything and face nothing! It's a convenient philosophy if you've no ambition in life except to—	129. contemptuously: *ad.* 轻蔑地
MARY:	James, do be quiet. [*She puts an arm around his shoulder—coaxingly*[130].] You must have gotten out of the wrong side of the bed this morning. [*to the boys, changing the subject*] What were you two grinning about like Cheshire cats when you came in? What was the joke?	130. coaxingly: *ad.* 抚慰地
TYRONE:	[*with a painful effort to be a good sport*[131]] Yes, let us in on it, lads.[132] I told your mother I knew damned well it would be one on me, but never mind that, I'm used to it.	131. with a painful effort to be a good sport: 努力做出有风度的样子 132. let us in on it, lads: 说一说吧，我的孩子们。
JAMIE:	[*dryly*[133]] Don't look at me. This is the Kid's story.	133. dryly: *ad.* 冷淡地
EDMUND:	[*grins*] I meant to tell you last night, Papa, and forgot it. Yesterday when I went for a walk I dropped in at the Inn—	
MARY:	[*worriedly*] You shouldn't drink now, Edmund.	
EDMUND:	[*ignoring this*] And who do you think I met there, *with a beautiful bun on*[134], but Shaughnessy, the tenant on that farm of yours.	134. with a beautiful bun on: 喝得酩酊大醉
MARY:	[*smiling*] That *dreadful*[135] man! But he is	135. dreadful: *a.* 令人讨厌的

funny.

TYRONE: [*scowling*[136]] He's not so funny when you're his landlord. *He's a wily Shanty Mick, that one. He could hide behind a corkscrew.*[137] What's he complaining about now, Edmund—for I'm damned sure he's complaining. I suppose he wants his rent lowered. I let him have the place for almost nothing, just to keep someone on it, and he never pays that till I threaten to *evict*[138] him.

EDMUND: No, he didn't *beef about*[139] anything. He was so pleased with life he even bought a drink, and that's practically unheard of. He was delighted because he'd had a fight with your friend, Harker, the *Standard Oil*[140] millionaire, and won a glorious victory.

MARY: [*with amused dismay*[141]] Oh, Lord! James, you'll really have to do something—

TYRONE: Bad luck to Shaughnessy, anyway!

JAMIE: [*maliciously*[142]] I'll bet the next time you see Harker at the club and give him the old respectful bow, he won't see you.

EDMUND: Yes. Harker will think you're no gentleman for *harboring*[143] a *tenant*[144] who isn't humble in the presence of a king of America.

TYRONE: Never mind the Socialist *gabble*[145]. I don't care to listen—

MARY: [*tactfully*[146]] Go on with your story,

136. scowling: *a.* 带怒气的

137. 他是个爱尔兰滑头，一肚子鬼主意。

138. evict: *v.* 驱逐

139. beef about: 抱怨

140. Standard Oil: 美孚石油

141. with amused dismay: 又好气又好笑

142. maliciously: *ad.* 恶狠狠地

143. harbor: *v.* 窝藏
144. tenant: *n.* 佃户

145. gabble: *n.* 胡说八道

146. tactfully: *ad.* 机智地

Edmund.

EDMUND: [*grins at his father provocatively*[147]] Well, you remember, Papa, the ice pond on Harker's estate is right next to the farm, and you remember Shaughnessy keeps pigs. Well, it seems there's a break in the fence and the pigs have been bathing in the millionaire's ice pond, and Harker's *foreman*[148] told him he was sure Shaughnessy had broken the fence *on purpose*[149] to give his pigs a free *wallow*[150].

MARY: [*shocked and amused*] Good heavens!

TYRONE: [*sourly, but with a trace of admiration*[151]] I'm sure he did, too, the dirty *scallywag*[152]. It's like him.

EDMUND: So Harker came in person to *rebuke*[153] Shaughnessy. [*He chuckles.*] A very bonehead play![154] If I needed any further proof that our *ruling plutocrats*[155], especially the ones who inherited their *boodle*[156], are not mental giants, that would *clinch*[157] it.

TYRONE: [*with appreciation, before he thinks*] Yes, he'd be no match for Shaughnessy. [*then he growls*[158]] Keep your damned *anarchist*[159] remarks to yourself. I won't have them in my house. [*But he is full of eager anticipation.*] What happened?

EDMUND: Harker had as much chance as I would with *Jack Johnson*[160]. Shaughnessy got a few drinks under his belt and was waiting at the

147. provocatively: *ad.* 挑衅地
148. foreman: *n.* 管家
149. on purpose: 有意地
150. wallow: *n.* 泡泥水澡
151. 说话酸溜溜的，但带着一丝钦佩
152. scallywag: *n.* 流氓
153. rebuke: *v.* 斥责
154. 真是很蠢的举动啊！
155. ruling plutocrats: 财阀统治阶级
156. 尤其是托祖宗恩德庇护的笨蛋们
157. clinch: *v.* 确定
158. growl: *v.* 怒吼
159. anarchist: *a.* 无政府主义者的
160. Jack Johnson: 杰克·约翰逊（美国第一位世界重量级黑人拳王）

gate to welcome him. He told me he never gave Harker a chance to open his mouth. He began by shouting that he was no slave Standard Oil could *trample on*[161]. He was a King of Ireland, if he had his rights, and *scum*[162] was scum to him, no matter how much money it had stolen from the poor.

MARY: Oh, Lord! [*But she can't help laughing.*]

EDMUND: Then he accused Harker of making his foreman break down the fence to *entice*[163] the pigs into the ice pond in order to destroy them. The poor pigs, Shaughnessy yelled, had caught their death of cold. Many of them were dying of *pneumonia*[164], and several others had been taken down with *cholera*[165] from drinking the poisoned water. He told Harker he was hiring a lawyer to sue him for damages. And he *wound up*[166] by saying that he had to put up with *poison ivy, ticks, potato bugs*[167], snakes and *skunks*[168] on his farm, but he was an honest man who drew the line somewhere, and he'd be damned if he'd stand for a Standard Oil thief *trespassing*[169]. So would Harker kindly remove his dirty feet from the *premises*[170] before he sicked the dog on him. And Harker did! [*He and Jamie laugh.*]

MARY: [*shocked but giggling*] Heavens, what a terrible tongue that man has!

161. trample on: 践踏

162. scum: *n.* 人渣

163. entice: *v.* 诱使

164. pneumonia: *n.* 肺炎

165. cholera: *n.* 霍乱

166. wound up: 生气

167. poison ivy, ticks, potato bugs: 毒葛、扁虱和马铃薯瓢虫

168. skunk: *n.* 臭鼬

169. trespass: *v.* 非法侵入

170. premise: *n.* 房屋

TYRONE: [*admiringly before he thinks*] The damned old *scoundrel*¹⁷¹! By God, you can't beat him! [*He laughs—then stops abruptly*¹⁷² *and scowls*¹⁷³.] The dirty blackguard! He'll get me in serious trouble yet. I hope you told him I'd be mad as hell—

EDMUND: *I told him you'd be tickled to death over the great Irish victory,*¹⁷⁴ *and so you are. Stop faking, Papa.*

TYRONE: Well, I'm not tickled to death.

MARY: [*teasingly*] You are, too, James. You're simply delighted!

TYRONE: No, Mary, a joke is a joke, but—

EDMUND: I told Shaughnessy he should have reminded Harker that a Standard Oil millionaire ought to welcome the flavor of *hog*¹⁷⁵ in his ice water as an appropriate touch.

TYRONE: The devil you did! [*frowning*] Keep your damned Socialist anarchist sentiments out of my affairs!¹⁷⁶

EDMUND: Shaughnessy almost wept because he hadn't thought of that one, but he said he'd include it in a letter he's writing to Harker, along with a few other insults he'd overlooked. [*He and Jamie laugh.*]

TYRONE: What are you laughing at? There's nothing funny—A fine son you are to help that *blackguard*¹⁷⁷ get me into a lawsuit!

MARY: Now, James, don't lose your temper.

171. scoundrel: *n.* 恶棍
172. abruptly: *ad.* 突然地
173. scowl: *v.* 怒视

174. 我告诉他爱尔兰人大获全胜。

175. hog: *n.* 猪

176. 别用你那该死的无政府主义想法来干扰我的事。

177. blackguard: *n.* 恶棍

TYRONE:	[*turns on JAMIE*] And you're worse than he is, encouraging him. I suppose you're regretting you weren't there to prompt Shaughnessy with a few nastier insults. *You've a fine talent for that, if for nothing else.*[178]	178. 这是你的拿手好戏，别的你都不行。
MARY:	James! There's no reason to scold Jamie. [*JAMIE is about to make some sneering remark to his father, but he shrugs his shoulders.*]	
EDMUND:	[*with sudden nervous exasperation*[179]] Oh, for God's sake, Papa! If you're starting that stuff again, I'll beat it[180]. [*He jumps up.*] I left my book upstairs, anyway. [*He goes to the front parlor, saying disgustedly*[181].] God, Papa, I should think you'd get sick of hearing yourself— [*He disappears. TYRONE looks after him angrily.*]	179. exasperation: n. 恼怒 180. I'll beat it: 我就走了。 181. disgustedly: ad. 厌烦地
MARY:	You mustn't mind Edmund, James. Remember he isn't well. [*Edmund can be heard coughing as he goes upstairs. She adds nervously.*] A summer cold makes anyone irritable.	
JAMIE:	[*genuinely concerned*] It's not just a cold he's got. The kid is damned sick. [*His father gives him a sharp warning look but he doesn't see it.*]	
MARY:	[*turns on him resentfully*] Why do you say that? It is just a cold! Anyone can tell that! You always imagine things!	
TYRONE:	[*with another warning glance at JAMIE— easily*] All Jamie meant was Edmund might	

	have a touch of something else, too, which makes his cold worse.	
JAMIE:	Sure, Mama. That's all I meant.	
TYRONE:	Doctor Hardy thinks it might be a bit of *malarial fever*[182] he caught when he was in the *tropics*[183]. If it is, *quinine*[184] will soon cure it.	182. malarial fever: *n.* 疟疾 183. tropics: *n.* 热带地区 184. quinine: *n.* 奎宁
MARY:	[*a look of contemptuous hostility flashes across her face*[185]] Doctor Hardy! I wouldn't believe a thing he said, if he swore on *a stack of*[186] Bibles! I know what doctors are. They're all alike. Anything, they don't care what, to keep you coming to them. [*She stops short*[187], *overcome by a fit of acute self-consciousness as she catches their eyes fixed on her. Her hands jerk*[188] *nervously to her hair. She forces a smile.*] What is it? What are you looking at? Is my hair?	185. 她脸上突然闪过一丝轻蔑而仇视的表情 186. a stack of: 一堆 187. short: *ad.* 突然地 188. jerk: *v.* 猛揪
TYRONE:	[*puts his arm around her—with guilty heartiness, giving her a playful hug*] There's nothing wrong with your hair. The healthier and fatter you get, the *vainer*[189] you become. You'll soon spend half the day *primping*[190] before the mirror.	189. vain: *a.* 自负的 190. primp: *v.* 精心打扮
MARY:	[*half reassured*] I really should have new glasses. My eyes are so bad now.	
TYRONE:	[*with Irish blarney*[191]] Your eyes are beautiful, and well you know it. [*He gives her a kiss. Her face lights up with a charming, shy embarrassment. Suddenly and startlingly*[192]	191. blarney: *n.* 奉承话 192. startlingly: *ad.* 令人吃惊地

one sees in her face the girl she had once been, not a ghost of the dead, but still a living part of her.]

MARY: You mustn't be so silly, James. Right in front of Jamie!

TYRONE: Oh, he's on to you, too. He knows this fuss about eyes and hair is only *fishing for*[193] compliments. Eh, Jamie?

193. fish for: 捞取

JAMIE: [*His face has cleared, too, and there is an old boyish charm in his loving smile at his mother.*] Yes. You can't kid us, Mama.

MARY: [*laughs and an Irish lilt comes into her voice*] Go along with both of you! [*Then she speaks with a girlish gravity.*] But I did truly have beautiful hair once, didn't I, James?

TYRONE: The most beautiful in the world!

MARY: It was a rare shade of reddish brown and so long it came down below my knees. You ought to remember it, too, Jamie. It wasn't until after Edmund was born that I had a single grey hair. Then it began to turn white. [*The girlishness fades from her face.*]

TYRONE: [*quickly*] And that made it prettier than ever.

MARY: [*again embarrassed and pleased*] Will you listen to your father, Jamie—after thirty-five years of marriage! He isn't a great actor for nothing, is he? What's come over you, James? Are you pouring coals of fire on my

head for teasing you about snoring? Well then, I take it all back. It must have been only the foghorn I heard. [*She laughs, and they laugh with her. Then she changes to a brisk businesslike air.*[194]] But I can't stay with you any longer, even to hear compliments. I must see the cook about dinner and the day's marketing. [*She gets up and sighs with humorous exaggeration.*] Bridget is so lazy. And so sly. She begins telling me about her relatives so *I can't get a word in edgeways*[195] and scold her. Well, I might as well get it over. [*She goes to the back-parlor doorway, then turns, her face worried again.*] You mustn't make Edmund work on the grounds with you, James, remember. [*Again with the strange obstinate*[196] *set to her face.*] Not that he isn't strong enough, but he'd *perspire*[197] and he might catch more cold.

[*She disappears through the back parlor. TYRONE turns on JAMIE condemningly.*]

TYRONE: You're a fine *lunkhead*[198]! Haven't you any sense? The one thing to avoid is saying anything that would get her more upset over Edmund.

JAMIE: [*shrugging his shoulders*] All right. Have it your way. I think it's the wrong idea to let Mama go on kidding herself. It will only make the shock worse when she has to face

194. 然后，她摆出一副公事公办的神情。

195. 我一句话也插不上嘴。

196. obstinate: *a.* 顽固的

197. perspire: *v.* 流汗

198. lunkhead: *n.* 呆子

it. Anyway, you can see she's deliberately fooling herself with that summer cold talk. She knows better.

TYRONE: Knows? Nobody knows yet.

JAMIE: Well, I do. I was with Edmund when he went to Doc Hardy on Monday. I heard him pull that touch of malaria stuff. He was *stalling*[199]. That isn't what he thinks any more. You know it as well as I do. You talked to him when you went uptown yesterday, didn't you?

TYRONE: He couldn't say anything for sure yet. He's to phone me today before Edmund goes to him.

JAMIE: [*slowly*] He thinks it's *consumption*[200], doesn't he, Papa?

TYRONE: [*reluctantly*] He said it might be.

JAMIE: [*moved, his love for his brother coming out*] Poor kid! God damn it! [*He turns on his father accusingly.*] It might never have happened if you'd sent him to a real doctor when he first got sick.

TYRONE: What's the matter with Hardy? He's always been our doctor up here.

JAMIE: Everything's the matter with him! Even in this *hick burg*[201] he's rated third class! He's a cheap old quack!

TYRONE: That's right! Run him down! Run down everybody! Everyone is a fake to you!

JAMIE: [*contemptuously*] Hardy only charges a dollar.

199. stall: *v.* 拖延;瞎扯

200. consumption: *n.* 肺痨

201. hick burg: 乡下地方

	That's what makes you think he's a fine doctor!	
TYRONE:	[*stung*] That's enough! You're not drunk now! There's no excuse—[*He controls himself—a bit defensively.*] If you mean I can't afford one of the fine society doctors who *prey on*[202] the rich summer people—	202. prey on: 掠夺(敲竹杠)
JAMIE:	Can't afford? You're one of the biggest property owners around here.	
TYRONE:	That doesn't mean I'm rich. It's all *mortgaged*[203]—	203. mortgage: v. 抵押
JAMIE:	Because you always buy more instead of paying off mortgages. If Edmund was a lousy acre of land you wanted, the sky would be the limit!	
TYRONE:	That's a lie! And your sneers against Doctor Hardy are lies! He doesn't *put on frills*[204], or have an office in a fashionable location, or drive around in an expensive automobile. That's what you pay for with those other five-dollars-to-look-at-your-tongue fellows, not their skill.	204. put on frills: 装腔作势
JAMIE:	[*with a scornful*[205] *shrug of his shoulders*] Oh, all right. I'm a fool to argue. You can't change the leopard's spots.	205. scornful: a. 轻蔑的
TYRONE:	[*with rising anger*] No, you can't. You've taught me that lesson only too well. I've lost all hope you will ever change yours. You dare tell me what I can afford? You've never known the value of a dollar and never	

will! You've never saved a dollar in your life! At the end of each season you're penniless! You've thrown your salary away every week on *whores*[206] and whiskey!

JAMIE: My salary! Christ!

TYRONE: It's more than you're worth, and you couldn't get that if it wasn't for me. If you weren't my son, there isn't a manager in the business who would give you a part, your reputation *stinks*[207] so. As it is, I have to humble my pride and beg for you, saying you've *turned over a new leaf*[208], although I know it's a lie!

JAMIE: I never wanted to be an actor. You forced me on the stage.

TYRONE: That's a lie! You made no effort to find anything else to do. You left it to me to get you a job and I have no influence except in the theater. Forced you! You never wanted to do anything except *loaf*[209] in barrooms! You'd have been content to sit back like a lazy lunk and *sponge on*[210] me for the rest of your life! After all the money I'd wasted on your education, and all you did was get fired in disgrace from every college you went to!

JAMIE: Oh, for God's sake, don't *drag up*[211] that ancient history!

TYRONE: It's not ancient history that you have to come home every summer to live on me.

206. whore: *n.* 妓女

207. stink: *v.* 发恶臭（此处指名声不好）

208. turn over a new leaf: 改过自新

209. loaf: *v.* 游荡

210. sponge on: 依赖

211. drag up: 翻出

JAMIE:	I earn my board and lodging working on the grounds. It saves you hiring a man.	
TYRONE:	Bah! You have to be driven to do even that much! [*His anger ebbs into a weary complaint.*²¹²] I wouldn't give a damn if you ever displayed the slightest sign of gratitude. The only thanks is to have you sneer at me for a dirty *miser*²¹³, sneer at my profession, sneer at every damned thing in the world—except yourself.	212. 他怒气渐深，化为埋怨的老调。 213. miser: *n.* 守财奴
JAMIE:	[*wryly*²¹⁴] That's not true, Papa. You can't hear me talking to myself, that's all.	214. wryly: *ad.* 苦笑地
TYRONE:	[*stares at him puzzledly, then quotes mechanically*] "Ingratitude, the vilest weed that grows"!²¹⁵	215.（出自莎剧《李尔王》）忤逆不孝，毒草之尤。
JAMIE:	I could see that line coming! God, how many thousand times! [*He stops, bored with their quarrel, and shrugs his shoulders.*] All right, Papa. I'm a *bum*²¹⁶. Anything you like, so long as it stops the argument.	216. bum: *n.* 无业游民
TYRONE:	[*with indignant appeal now*²¹⁷] If you'd get ambition in your head instead of *folly*²¹⁸! You're young yet. You could still make your mark. You had the talent to become a fine actor! You have it still. You're my son!	217. 一副理直气壮的口吻 218. folly: *n.* 胡闹；荒唐事
JAMIE:	[*boredly*] Let's forget me. I'm not interested in the subject. Neither are you. [*Tyrone gives up. Jamie goes on casually.*] What started us on this? Oh, Doc Hardy.	

When is he going to call you up about Edmund?

TYRONE: Around lunch time. [*He pauses—then defensively.*] I couldn't have sent Edmund to a better doctor. Hardy's treated him whenever he was sick up here, since he was knee high. He knows his constitution as no other doctor could. It's not a question of my being miserly, as you'd like to make out. [*bitterly*] And what could the finest specialist in America do for Edmund, after he's deliberately ruined his health by the mad life he's led ever since he was fired from college? Even before that when he was in prep school, he began *dissipating*[219] and playing the Broadway sport to imitate you, when he's never had your *constitution*[220] to stand it. You're a healthy *hulk*[221] like me—or you were at his age—but he's always been a bundle of nerves like his mother. I've warned him for years his body couldn't stand it, but he wouldn't *heed*[222] me, and now it's too late.

JAMIE: [*sharply*] What do you mean, too late? You talk as if you thought—

TYRONE: [*guiltily explosive*] Don't be a damned fool! I meant nothing but what's plain to anyone! His health has broken down and he may be an *invalid*[223] for a long time.

JAMIE: [*stares at his father, ignoring his explanation*] I

219. dissipate: *v.* 浪费时间精力做某事

220. constitution: *n.* 体格
221. hulk: *n.* 强壮的人

222. heed: *v.* 留心

223. invalid: *n.* 病人

*know it's an Irish peasant idea consumption is fatal.*²²⁴ It probably is when you live in a *hovel*²²⁵ on a *bog* ²²⁶, but over here, with modern treatment—

TYRONE: Don't I know that! What are you *gabbing about*²²⁷, anyway? And keep your dirty tongue off Ireland, with your sneers about peasants and bogs and hovels! [*accusingly*] The less you say about Edmund's sickness, the better for your conscience! You're more responsible than anyone!

JAMIE: [*stung*] That's a lie! I won't stand for that, Papa!

TYRONE: It's the truth! You've been the worst influence for him. He grew up admiring you as a hero! A fine example you set him! If you ever gave him advice except in the ways of rottenness, I've never heard of it! You made him old before his time, pumping him full of what you consider worldly wisdom, when he was too young to see that your mind was so poisoned by your own failure in life, you wanted to believe every man was a *knave*²²⁸ with his soul for sale, and every woman who wasn't a whore was a fool!

JAMIE: [*with a defensive air of weary indifference again*] All right. I did put Edmund wise to things, but not until I saw he'd started to *raise hell*²²⁹, and knew he'd laugh at me if I

224. 我知道按照爱尔兰乡巴佬的看法，肺痨是治不好的。
225. hovel: *n.* 小茅屋
226. bog: *n.* 泥潭

227. gab about: 唠叨

228. knave: *n.* 无赖

229. raise hell: 闹翻天

	tried the good advice, older brother stuff. All I did was *make a pal of*²³⁰ him and be absolutely frank so he'd learn from my mistakes that—[*He shrugs his shoulders—cynically*²³¹.] Well, that if you can't be good you can at least be careful. [*His father snorts*²³² *contemptuously. Suddenly Jamie becomes really moved.*] That's a rotten accusation, Papa. You know how much the kid means to me, and how close we've always been—not like the usual brothers! I'd do anything for him.	230. make a pal of him: 和他做朋友 231. cynically: *ad.* 讥讽地 232. snort: *v.* 发出轻蔑声
TYRONE:	[*impressed—mollifyingly*²³³] I know you may have thought it was for the best, Jamie. I didn't say you did it deliberately to harm him.	233. mollifyingly: *ad.* 好言相劝地
JAMIE:	Besides it's damned *rot*²³⁴! I'd like to see anyone influence Edmund more than he wants to be. His quietness fools people into thinking they can do what they like with him. But he's stubborn as hell inside and what he does is what he wants to do, and to hell with anyone else! What had I to do with all the crazy stunts he's pulled in the last few years—working his way all over the map as a sailor and all that stuff. I thought that was a damned fool idea, and I told him so. You can't imagine me getting fun out of being on the beach in South America, or living in filthy dives, drinking	234. rot: *n.* 废话

rotgut[235], can you? No, thanks! I'll stick to Broadway, and a room with a bath, and bars that serve *bonded Bourbon*[236].

TYRONE: You and Broadway! It's made you what you are! [*with a touch of pride*] Whatever Edmund's done, he's had the guts to go off on his own, where he couldn't come *whining*[237] to me the minute he was broke.

JAMIE: [*stung into sneering jealousy*[238]] He's always come home broke finally, hasn't he? And what did his going away get him? Look at him now! [*He is suddenly shamefaced*[239].] Christ! That's a lousy thing to say. I don't mean that.

TYRONE: [*decides to ignore this*] He's been doing well on the paper. I was hoping he'd found the work he wants to do at last.

JAMIE: [*sneering jealously again*] A hick town rag![240] Whatever bull they hand you, they tell me he's a pretty bum reporter. If he weren't your son—Ashamed again. No, that's not true! They're glad to have him, but it's the special stuff that gets him by. Some of the poems and *parodies*[241] he's written are damned good. [*grudgingly*[242] *again*] Not that they'd ever get him anywhere on the big time. Hastily. But he's certainly made a damned good start.

TYRONE: Yes. He's made a start. You used to talk about wanting to become a newspaper man

235. rotgut: n. 劣酒

236. bonded Bourbon: 上等的波旁威士忌

237. whine: v. 抱怨

238. stung into sneering jealousy: 受到打击，妒忌起来，反唇相讥

239. shamefaced: a. 惭愧的

240. 小城的破报纸。

241. parody: n. 讽刺小品文
242. grudgingly: ad. 勉强地

but you were never willing to start at the bottom. You expected—

JAMIE: Oh, for Christ's sake, Papa! Can't you *lay off*[243] me!

TYRONE: [*stares at him—then looks away—after a pause*] It's damnable luck Edmund should be sick right now. It couldn't have come at a worse time for him. [*He adds, unable to conceal an almost furtive uneasiness.*[244]] Or for your mother. It's damnable she should have this to upset her, just when she needs peace and freedom from worry. She's been so well in the two months since she came home. [*His voice grows husky*[245] *and trembles a little.*] It's been heaven to me. This home has been a home again. But I needn't tell you, Jamie.

[*His son looks at him, for the first time with an understanding sympathy. It is as if suddenly a deep bond of common feeling existed between them in which their antagonisms*[246] *could be forgotten.*]

JAMIE: [*almost gently*] I've felt the same way, Papa.

TYRONE: Yes, this time you can see how strong and sure of herself she is. She's a different woman entirely from the other times. She has control of her nerves—or she had until Edmund got sick. Now you can feel her growing tense and frightened underneath. I wish to God we could keep the truth from

243. lay off: 休息（此处意为：别再唠叨我了！）

244. 他又加了一句，但不敢乱说。

245. husky: *a.* 沙哑的

246. antagonism: *n.* 敌意

	her, but we can't if he has to be sent to a *sanatorium*²⁴⁷. What makes it worse is her father died of consumption. She worshiped him and she's never forgotten. Yes, it will be hard for her. But she can do it! She has the will power now! We must help her, Jamie, in every way we can!	247. sanatorium: *n.* 疗养院
JAMIE:	[*moved*] Of course, Papa. [*hesitantly*] Outside of nerves, she seems perfectly all right this morning.	
TYRONE:	[*with hearty confidence now*] Never better. She's full of fun and *mischief*²⁴⁸. [*Suddenly he frowns at Jamie suspiciously.*] Why do you say, seems? Why shouldn't she be all right? What the hell do you mean?	248. mischief: *n.* 顽皮
JAMIE:	Don't start *jumping down my throat*²⁴⁹! God, Papa, this ought to be one thing we can talk over frankly without a battle.	249. jump down one's throat: 责骂某人
TYRONE:	I'm sorry, Jamie. [*tensely*] But go on and tell me—	
JAMIE:	There's nothing to tell. I was all wrong. It's just that last night—Well, you know how it is, I can't forget the past. I can't help being suspicious. Any more than you can. [*bitterly*] That's the hell of it.²⁵⁰ And it makes it hell for Mama! She watches us watching her—	250. That's the hell of it: 这种日子真难过。
TYRONE:	[*sadly*] I know. [*tensely*] Well, what was it? Can't you speak out?	
JAMIE:	Nothing, I tell you. Just my damned	

foolishness. Around three o'clock this morning, I woke up and heard her moving around in the spare room. Then she went to the bathroom. I pretended to be asleep. She stopped in the hall to listen, as if she wanted to make sure I was.

TYRONE: [with forced scorn] For God's sake, is that all? She told me herself the foghorn kept her awake all night, and every night since Edmund's been sick she's been up and down, going to his room to see how he was.

JAMIE: [eagerly] Yes, that's right, she did stop to listen outside his room. [hesitantly again] It was her being in the spare room that scared me. I couldn't help remembering that when she starts sleeping alone in there, it has always been a sign—

TYRONE: It isn't this time! It's easily explained. Where else could she go last night to get away from my snoring? [He gives way to[251] a burst of resentful anger.] By God, how you can live with a mind that sees nothing but the worst motives behind everything is beyond me!

JAMIE: [stung] Don't pull that![252] I've just said I was all wrong. Don't you suppose I'm as glad of that as you are!

TYRONE: [mollifyingly] I'm sure you are, Jamie. [A pause. His expression becomes somber. He

251. give way to: 听凭

252. Don't pull that: 不必装腔作势了!

speaks slowly with a superstitious dread.[253]] It would be like a curse she can't escape if worry over Edmund—It was in her long sickness after bringing him into the world that she first—

JAMIE: She didn't have anything to do with it!

TYRONE: I'm not blaming her.

JAMIE: [*bitingly*] Then who are you blaming? Edmund, for being born?

TYRONE: You damned fool! No one was to blame.

JAMIE: The bastard of a doctor was! From what Mama's said, he was another cheap quack like Hardy! You wouldn't pay for a first-rate—

TYRONE: That's a lie! [*furiously*] So I'm to blame! That's what you're driving at, is it? You evil-minded loafer!

JAMIE: [*warningly as he hears his mother in the dining room*] Ssh! [*Tyrone gets hastily to his feet and goes to look out the windows at right. Jamie speaks with a complete change of tone.*] Well, if we're going to cut the front hedge today, we'd better go to work.

[*Mary comes in from the back parlor. She gives a quick, suspicious glance from one to the other, her manner nervously self-conscious.*]

TYRONE: [*turns from the window—with an actor's heartiness*] Yes, it's too fine a morning to waste indoors arguing. Take a look out the window, Mary. There's no fog in the

253. He speaks slowly with a superstitious dread: 他慢腾腾地说，带着莫名的恐惧。

	harbor. I'm sure the spell of it we've had is over now.
MARY:	[*going to him*] I hope so, dear. [*to Jamie, forcing a smile*] Did I actually hear you suggesting work on the front hedge, Jamie? Wonders will never cease! You must want pocket money badly.
JAMIE:	[*kiddingly*] When don't I? [*He winks at her, with a derisive²⁵⁴ glance at his father.*] I expect a salary of at least one large iron man²⁵⁵ at the end of the week—to carouse on²⁵⁶!
MARY:	[*does not respond to his humor—her hands fluttering over the front of her dress*] What were you two arguing about?
JAMIE:	[*shrugs his shoulders*] The same old stuff.
MARY:	I heard you say something about a doctor, and your father accusing you of being evil-minded.
JAMIE:	[*quickly*] Oh, that. I was saying again Doc Hardy isn't my idea of the world's greatest physician.
MARY:	[*knows he is lying—vaguely*] Oh. No, I wouldn't say he was, either. [*changing the subject—forcing a smile*] That Bridget! I thought I'd never get away. She told me all about her second cousin on the police force in St. Louis. Then with nervous irritation. Well, if you're going to work on the hedge why don't you go? [*hastily*]

254. derisive: *a.* 嘲弄的

255. one large iron man: (俚语)1美元

256. carouse on: 大吃大喝

I mean, take advantage of the sunshine before the fog comes back. [*strangely, as if talking aloud to herself*] Because I know it will. [*Suddenly she is self-consciously aware that they are both staring fixedly at her—flurriedly*²⁵⁷, *raising her hands.*] Or I should say, the *rheumatism*²⁵⁸ in my hands knows. It's a better weather prophet than you are, James. [*She stares at her hands with fascinated repulsion*²⁵⁹.] Ugh! How ugly they are! Who'd ever believe they were once beautiful? [*They stare at her with a growing dread.*²⁶⁰]

TYRONE: [*takes her hands and gently pushes them down*] Now, now, Mary. None of that foolishness. They're the sweetest hands in the world. [*She smiles, her face lighting up, and kisses him gratefully. He turns to his son.*] Come on Jamie. Your mother's right to scold us. The way to start work is to start work. The hot sun will sweat some of that *booze fat*²⁶¹ off your *middle*²⁶². [*He opens the screen door and goes out on the porch and disappears down a flight of steps leading to the ground. JAMIE rises from his chair and, taking off his coat, goes to the door. At the door he turns back but avoids looking at her, and she does not look at him.*]

JAMIE: [*with an awkward, uneasy tenderness*] We're all so proud of you, Mama, so *darned*²⁶³

257. flurriedly: *ad.* 慌张地
258. rheumatism: *n.* 风湿

259. repulsion: *n.* 厌恶

260. They stare at her with a growing dread: 他们盯着她,恐惧起来。

261. booze fat: 酒鬼的肥膘
262. middle: *n.* 腰腹部

263. darned: *ad.* 非常

	happy. [*She stiffens²⁶⁴ and stares at him with a frightened defiance²⁶⁵. He flounders²⁶⁶ on.*] But you've still got to be careful. You mustn't worry so much about Edmund. He'll be all right.	264. stiffen: *v.* 挺直身体 265. defiance: *n.* 挑战 266. flounder: *v.* 支吾
MARY:	[*with a stubborn, bitterly resentful look*] Of course, he'll be all right. And I don't know what you mean, warning me to be careful.	
JAMIE:	[*rebuffed²⁶⁷ and hurt, shrugs his shoulders*] All right, Mama. I'm sorry I spoke. [*He goes out on the porch. She waits rigidly until he disappears down the steps. Then she sinks down in the chair he had occupied, her face betraying a frightened, furtive desperation, her hands roving²⁶⁸ over the table top, aimlessly moving objects around. She hears Edmund descending the stairs in the front hall. As he nears the bottom he has a fit of coughing. She springs to her feet, as if she wanted to run away from the sound, and goes quickly to the windows at right. She is looking out, apparently calm, as he enters from the front parlor, a book in one hand. She turns to him, her lips set in a welcoming, motherly smile.*]	267. rebuff: *v.* 断然拒绝 268. rove: *v.* 移动
MARY:	Here you are. I was just going upstairs to look for you.	
EDMUND:	I waited until they went out. I don't want to mix up in any arguments. I feel too rotten.	

MARY: [*almost resentfully*] Oh, I'm sure you don't feel half as badly as you make out. You're such a baby. You like to get us worried so we'll make a fuss over you. [*hastily*] I'm only teasing, dear. I know how miserably uncomfortable you must be. But you feel better today, don't you? [*worriedly, taking his arm*] All the same, you've grown much too thin. You need to rest all you can. Sit down and I'll make you comfortable. [*He sits down in the rocking chair and she puts a pillow behind his back.*] There. How's that?

EDMUND: Grand[269]. Thanks, Mama.

MARY: [*kisses him—tenderly*] All you need is your mother to nurse you. Big as you are, you're still the baby of the family to me, you know.

EDMUND: [*takes her hand—with deep seriousness*] Never mind me. You take care of yourself. That's all that counts.

MARY: [*evading[270] his eyes*] But I am, dear. [*forcing a laugh*] Heavens, don't you see how fat I've grown! I'll have to have all my dresses let out. [*She turns away and goes to the windows at right. She attempts a light, amused tone.*] They've started clipping the hedge. Poor Jamie! How he hates working in front where everyone passing can see him. There go the Chatfields

269. Grand.: 好极了

270. evade: v. 逃避;避开

in their new *Mercedes*[271]. It's a beautiful car, isn't it? Not like our secondhand *Packard*[272]. Poor Jamie! He bent almost under the hedge so they wouldn't notice him. They bowed to your father and he bowed back as if he were *taking a curtain call*[273]. In that *filthy*[274] old suit I've tried to make him throw away. [*Her voice has grown bitter.*] Really, he ought to have more pride than to make such a show of himself.

EDMUND: He's right not to give a damn what anyone thinks. Jamie's a fool to care about the Chatfields. *For Pete's sake*[275], who ever heard of them outside this hick burg?

MARY: [*with satisfaction*] No one. You're quite right, Edmund. *Big frogs in a small puddle.*[276] It is stupid of Jamie. [*She pauses, looking out the window—then with an undercurrent*[277] *of lonely yearning.*] Still, the Chatfields and people like them stand for something. I mean they have decent, *presentable*[278] homes they don't have to be ashamed of. They have friends who entertain them and whom they entertain. They're not cut off from everyone. [*She turns back from the window.*] Not that I want anything to do with them. I've always hated this town and everyone in it. You know that. I never wanted to live

271. Mercedes: 奔驰牌轿车

272. Packard: 派卡德牌轿车

273. take a curtain call: (演出结束后的) 鞠躬还礼
274. filthy: *a.* 脏兮兮的

275. For Pete's sake: 拜托! (表示惊讶或失望的语气)

276. Big frogs in a small puddle: 小泥塘里的大蛤蟆。
277. undercurrent: *n.* 潜流

278. Presentable: *a.* 富丽堂皇的

here in the first place, but your father liked it and insisted on building this house, and I've had to come here every summer.

EDMUND: Well, it's better than spending the summer in a New York hotel, isn't it? And this town's not so bad. I like it well enough. I suppose because it's the only home we've had.

MARY: I've never felt it was my home. It was wrong from the start. Everything was done in the cheapest way. Your father would never spend the money to make it right. It's just as well we haven't any friends here. I'd be ashamed to have them step in the door. But he's never wanted family friends. He hates calling on people, or receiving them. All he likes is to *hobnob*[279] with men at the club or in a barroom. Jamie and you are the same way, but you're not to blame. You've never had a chance to meet decent people here. I know you both would have been so different if you'd been able to associate with nice girls instead of—You'd never have *disgraced*[280] yourselves as you have, so that now no respectable parents will let their daughters be seen with you.

EDMUND: [*irritably*] Oh, Mama, forget it! Who cares? Jamie and I would be *bored stiff*[281]. And about the Old Man, what's the use of

279. hobnob: *v.* 交往甚密

280. disgrace: *v.* 羞辱

281. bored stiff: 百无聊赖

	talking? You can't change him.	
MARY:	[*mechanically rebuking*²⁸²] Don't call your father the Old Man. You should have more respect. [*then dully*] I know it's useless to talk. But sometimes I feel so lonely. [*Her lips quiver*²⁸³ *and she keeps her head turned away.*]	282. rebuke: v. 责怪 283. quiver: v. 颤抖
EDMUND:	Anyway, you've got to be fair, Mama. It may have been all his fault in the beginning, but you know that later on, even if he'd wanted to, we couldn't have had people here—[*He flounders guiltily.*] I mean, you wouldn't have wanted them.	
MARY:	[*wincing*²⁸⁴—*her lips quivering pitifully*] Don't. I can't bear having you remind me.	284. wince: v. 畏缩
EDMUND:	Don't take it that way! Please, Mama! I'm trying to help. Because it's bad for you to forget. The right way is to remember. So you'll always be *on your guard*²⁸⁵. You know what's happened before. [*miserably*] God, Mama, you know I hate to remind you. I'm doing it because it's been so wonderful having you home the way you've been, and it would be terrible—	285. on your guard: 警觉
MARY:	[*strickenly*²⁸⁶] Please, dear. I know you mean it for the best, but—[*A defensive uneasiness comes into her voice again.*] I don't understand why you should suddenly say such things. What put it in your mind this	286. strickenly: ad. 痛苦至极

	morning?	
EDMUND:	[*evasively*²⁸⁷] Nothing. Just because I feel rotten and blue, I suppose.	287. evasively: *ad.* 逃避地
MARY:	Tell me the truth. Why are you so suspicious all of a sudden?	
EDMUND:	I'm not!	
MARY:	Oh, yes you are. I can feel it. Your father and JAMIE, too—particularly JAMIE.	
EDMUND:	Now don't start imagining things, Mama.	
MARY:	[*her hands fluttering*²⁸⁸] It makes it so much harder, living in this atmosphere of constant suspicion, knowing everyone is spying on me, and none of you believe in me, or trust me.	288. flutter: *v.* 颤动
EDMUND:	That's crazy, Mama. We do trust you.	
MARY:	If there was only some place I could go to get away for a day, or even an afternoon, some woman friend I could talk to—not about anything serious, simply laugh and gossip and forget for a while—someone besides the servants—that stupid Cathleen!	
EDMUND:	[*gets up worriedly and puts his arm around her*] Stop it, Mama. *You're getting yourself worked up over nothing.*²⁸⁹	289. You're getting yourself worked up over nothing: 你真是无缘无故地自寻烦恼。
MARY:	Your father goes out. He meets his friends in barrooms or at the club. You and JAMIE have the boys you know. You go out. But I am alone. I've always been alone.	
EDMUND:	[*soothingly*] Come now! You know that's	

	a *fib*²⁹⁰. One of us always stays around to keep you company, or goes with you in the automobile when you take a drive.	290. fib: *n.* 小谎话
MARY:	[*bitterly*] Because you're afraid to trust me alone! [*She turns on*²⁹¹ *him—sharply.*] I insist you tell me why you act so differently this morning—why you felt you had to remind me—	291. turn on: 反击；攻击
EDMUND:	[*hesitates—then blurts out*²⁹² *guiltily*] It's stupid. It's just that I wasn't asleep when you came in my room last night. You didn't go back to your and Papa's room. You went in the spare room for the rest of the night.	292. blurt out: 脱口而出
MARY:	Because your father's snoring was driving me crazy! For heaven's sake, haven't I often used the spare room as my bedroom? [*bitterly*] But I see what you thought. That was when—	
EDMUND:	[*too vehemently*²⁹³] I didn't think anything!	293. vehemently: *ad.* 激烈地
MARY:	So you pretended to be asleep in order to spy on me!	
EDMUND:	No! I did it because I knew if you found out I was *feverish*²⁹⁴ and couldn't sleep, it would upset you.	294. feverish: *a.* 发烧的
MARY:	Jamie was pretending to be asleep, too, I'm sure, and I suppose your father—	
EDMUND:	Stop it, Mama!	
MARY:	Oh, I can't bear it, Edmund, when even you—! [*Her hands flutter up*²⁹⁵ *to pat her hair*	295. flutter up: 轻飘飘地抬起来

in their aimless, distracted way. Suddenly a strange undercurrent of revengefulness comes into her voice.[296]] It would serve all of you right if it was true!

EDMUND: Mama! Don't say that! That's the way you talk when—

MARY: Stop suspecting me! Please, dear! You hurt me! I couldn't sleep because I was thinking about you. That's the real reason! I've been so worried ever since you've been sick. [*She puts her arms around him and hugs him with a frightened, protective tenderness.*]

EDMUND: [*soothingly*] That's foolishness. You know it's only a bad cold.

MARY: Yes, of course, I know that!

EDMUND: But listen, Mama. I want you to promise me that even if it should turn out to be something worse, you'll know I'll soon be all right again, anyway, and you won't worry yourself sick, and you'll keep on taking care of yourself—

MARY: [*frightenedly*] I won't listen when you're so silly! There's absolutely no reason to talk as if you expected something dreadful! Of course, I promise you. I give you my sacred word of honor! [*then with a sad bitterness*] But I suppose you're remembering I've promised before on my word of honor.

296. Suddenly a strange undercurrent of revengefulness comes into her voice: 突然间,说话声音里含着一股报复的意味。

EDMUND: No!

MARY: [*her bitterness receding into*297 *a resigned helplessness*] I'm not blaming you, dear. How can you help it? How can any one of us forget? [*strangely*] That's what makes it so hard—for all of us. We can't forget.

EDMUND: [*grabs her shoulder*] Mama! Stop it!

MARY: [*forcing a smile*] All right, dear. I didn't mean to be so gloomy. Don't mind me. Here. Let me feel your head. Why, it's nice and cool. You certainly haven't any fever now.

EDMUND: Forget! It's you—

MARY: But I'm quite all right, dear. [*with a quick, strange, calculating*298, *almost sly glance at him*] Except I naturally feel tired and nervous this morning, after such a bad night. I really ought to go upstairs and lie down until lunch time and take a nap. [*He gives her an instinctive look of suspicion—then, ashamed of himself, looks quickly away. She hurries on nervously.*] What are you going to do? Read here? It would be much better for you to go out in the fresh air and sunshine. But don't get overheated, remember. Be sure and wear a hat. [*She stops, looking straight at him now. He avoids her eyes. There is a tense pause. Then she speaks jeeringly*299.] Or are you afraid to trust me alone?

297. recede into: 减弱

298. calculating: *a.* 审慎的

299. jeeringly: *ad.* 嘲弄地

EDMUND: [*tormentedly*³⁰⁰] No! Can't you stop talking like that! I think you ought to take a nap. [*He goes to the screen door—forcing a joking tone.*] I'll go down and help Jamie bear up. I love to lie in the shade and watch him work. [*He forces a laugh in which she makes herself join. Then he goes out on the porch and disappears down the steps. Her first reaction is one of relief. She appears to relax. She sinks down in one of the wicker armchairs at rear of table and leans her head back, closing her eyes. But suddenly she grows terribly tense again. Her eyes open and she strains forward*³⁰¹, *seized by a fit of nervous panic. She begins a desperate battle with herself. Her long fingers, warped*³⁰² *and knotted*³⁰³ *by rheumatism, drum on the arms of the chair, driven by an insistent life of their own, without her consent.*]

CURTAIN

300. tormentedly: *ad.* 痛苦地

301. strain forward: *v.* 前倾

302. warped: *a.* 弯曲地
303. knotted: *a.* 指关节突出的

Assignment

Ⅰ. Review what you've learned from this chapter and complete the following note-taking with related information.

Facts of O'Neill's Childhood	
Facts of O'Neill's Family	
Reason of O'Neill being Called "the Father of American Drama"	
Masterpieces of O'Neill	

Ⅱ. Share your opinion of the Tyrones. Which one of the family impressed you most? Why?

Further Reading

Plot Summary of *A Long Day's Journey into Night*
ACT 1

James Tyrone is a 65-year-old actor who had long ago bought a "vehicle" play for himself and had established his reputation based on this one role with which he had toured for years. Although that "vehicle" had served him well financially, he is now resentful that his having become so identified with this character has limited his scope and opportunities as a classical actor. He is a wealthy though somewhat miserly man. His money is all tied up in property which he hangs on to in spite of impending financial hardship. His dress and appearance are showing signs of his strained financial circumstances, but he retains many of the mixed affectations of a classical actor in spite of his shabby attire.

His wife Mary has recently returned from treatment for morphine addiction and has put on weight as a result. She is looking much healthier than the family has been accustomed to, and they remark frequently on her improved appearance. However, she still retains the haggard facial features of a long-time addict. As recovering addict, she is restless and anxious. She also suffers from insomnia, which is not made any easier by her husband and children's loud snoring. When Edmund, her younger son, hears her moving around at night and entering the spare bedroom, he becomes alarmed, because this is the room where, in the past, she would satisfy her morphine addiction. He questions her about it indirectly. She reassures him that she just went there to get away from her husband's snoring.

In addition to Mary's problems, the family is worried about Edmund's coughing; they fear that he might have tuberculosis, and are anxiously awaiting a doctor's diagnosis. Edmund is more concerned about the effect a positive diagnosis might have on his mother than on himself. The constant possibility that she might relapse worries him still further. Once again, he indirectly speaks to his mother

about her addiction. He asks her to "promise not to worry yourself sick and to take care of yourself". "Of course I promise you," she protests, but then adds ("with a sad bitterness"), "But I suppose you're remembering I've promised before on my word of honor."

ACT 2

Jamie Tyrone and Edmund taunt each other about stealing their father's alcohol and watering it down so he won't notice. They speak about Mary's conduct. Jamie berates Edmund for leaving their mother unsupervised. Edmund berates Jamie for being suspicious. Both, however, are deeply worried that their mother's morphine abuse may have resurfaced. Jamie points out to Edmund that they had concealed their mother's addiction from him for ten years. Jamie explains to Edmund that his innocence about the nature of the disease was understandable but deluded. They discuss the upcoming results of Edmund's tests for tuberculosis, and Jamie tells Edmund to prepare for the worst.

Their mother appears. She is distraught about Edmund's coughing, which he tries to suppress so as not to alarm her, fearing anything that might trigger her addiction again. When Edmund accepts his mother's excuse that she had been upstairs so long because she had been "lying down", Jamie looks at them both contemptuously. Mary notices and starts becoming defensive and belligerent, berating Jamie for his cynicism and disrespect for his parents. Jamie is quick to point out that the only reason he has survived as an actor is through his father's influence in the business.

Mary speaks of her frustration with their summer home, its impermanence and shabbiness, and her husband's indifference to his surroundings. With irony, she alludes to her belief that this air of detachment might be the very reason he has tolerated her addiction for so long. This frightens Edmund, who is trying desperately to hang on to his belief in normality while faced with two emotionally horrific problems at once. Finally, unable to tolerate the way Jamie is looking at her, she asks him angrily why he is doing it. "You know!", he shoots back, and tells her to take a look at her glazed eyes in the mirror.

ACT 3

The third act opens with Mary and Cathleen returning home from their drive to the drugstore, where Mary has sent Cathleen in to purchase her morphine prescription. Not wanting to be alone, Mary does not allow Cathleen to go to the kitchen to finish dinner and offers her a drink instead. Mary does most of the talking and discusses her love for fog but her hatred of the foghorn and her husband's obvious obsession with money. It is obvious that Mary has already taken some of her "prescription". She talks about her past in a Catholic convent and the promise she once had as a pianist and the fact that it was once thought that she might become a nun. She also makes it clear that while she fell in love with her husband from the time she met him, she had never taken to the theatre crowd. She shows her arthritic hands to Cathleen and explains that the pain in her hands is why she needs her prescription—an explanation which is untrue and transparent to Cathleen.

When Mary dozes off under the influence of the morphine, Cathleen exits to prepare dinner. Mary awakes and begins to have bitter memories about how much she loved her life before she met her husband. She also decides that her prayers as a dope fiend are not being heard by the Virgin, but still decides to go upstairs to get more drugs, but before she can do so, her son, Edmund, and her husband, James, return home.

Although both men are drunk, they both realize that she is back on morphine, although Mary attempts to act as if she is not. Jamie, the other son, has not returned home, but has elected instead to continue drinking and to visit the local whorehouse. After calling Jamie a "hopeless failure" Mary warns that his bad influence will drag his brother down as well. After seeing the condition that Mary is in, her husband expresses the regret that he bothered to come home, and he attempts to ignore her as she continues her remarks, which include blaming him for Jamie's drinking, and noting that the Irish are stupid drunks. Then, as often happens in the play, Mary and James try to get over their animosity and attempt to express their love for one another by remembering happier days. When James goes to the basement to get another bottle of whiskey, Mary continues to talk with her son, Edmund.

When Edmund reveals that he has tuberculosis, Mary refuses to believe it, and attempts to discredit Dr. Hardy, due to her inability to face the reality and most importantly the severity of the situation. She accuses Edmund of attempting to get more attention by blowing everything out of proportion. In retaliation, Edmund reminds his mother that her own father died of tuberculosis, and then, before exiting, he adds how difficult it is to have a "dope fiend for a mother". By herself, Mary admits that she needs more drugs and hopes that someday she will "accidentally" overdose, because she knows that if she did so on purpose, the Virgin would never forgive her. When James comes back with more alcohol he notes that there was evidence that Jamie had attempted to pick the locks to the whiskey cabinet in the cellar, as he has done before. Mary ignores this and bursts out that she is afraid that Edmund is going to die. She also confides to James that Edmund does not love her because of her drug problem. When James attempts to console her, Mary again rues having giving birth to Edmund, who appears to have been conceived to replace a baby Mary and James lost before Edmund's birth. When Cathleen announces dinner, Mary indicates that she is not hungry and is going to lie down. James goes in to dinner all alone, knowing that Mary is really going upstairs to get more drugs.

ACT 4

At midnight, Edmund comes home to find his father playing solitaire. While the two argue and drink, they also have an intimate, tender conversation. James explains his stinginess, and also reveals that he ruined his career by staying in an acting job for money. After so many years playing the same part, he lost his talent for versatility. Edmund talks to his father about sailing and of his aspiration to become a great writer one day. They hear Jamie coming home drunk, and James leaves to avoid fighting. Jamie and Edmund converse, and Jamie confesses that although he loves Edmund more than anyone else, he again ambiguously lashes out at his father calling on him to fail. Jamie passes out. When James returns, Jamie wakes up, and they quarrel anew. Mary, lost in her morphine dreams of the past, comes downstairs. Holding her wedding gown, she kneels and prays, with her husband and sons silently watching her.

Chapter Five

Tennessee Williams and *The Glass Menagerie*

Thomas Lanier Williams III (March 26, 1911—February 25, 1983), known by his pen name Tennessee Williams, was a poetic American playwright.

After years of *obscurity*[1], at age 33 he became suddenly famous with the success of *The Glass Menagerie*[2] (1944) in New York City. This play closely reflected his own unhappy family background. It was the first of a string of successes, including *A Streetcar Named Desire*[3] (1947), *Cat on a Hot Tin Roof*[4] (1955), and *Sweet Bird of Youth*[5] (1959). With his later work, he attempted a new style that did not appeal to audiences. Increasing alcohol and drug dependence *inhibited*[6] his creative expression. His drama *A Streetcar Named Desire* is often numbered on short lists of the finest American plays of the 20th century alongside Eugene O'Neill's *Long Day's Journey into Night* and Arthur Miller's *Death of a Salesman*.

Much of Williams' most acclaimed work has been adapted for the cinema. He also wrote short stories, poetry, essays and a volume of memoirs. In 1979, four years before his death, Williams was *inducted*[7] into the American Theater Hall of Fame[8].

Early Life

Thomas Lanier Williams III was born in Columbus, Mississippi. His father was a traveling shoe salesman who became alcoholic and was frequently away from home.

Notes:

1. obscurity: n. 默默无闻
2. 《玻璃动物园》
3. 《欲望号街车》
4. 《铁皮屋顶上的猫》
5. 《青春甜蜜小鸟》
6. inhibit: v. 抑制
7. induct: v. 授予(称号)
8. the American Theater Hall of Fame: 美国戏剧名人堂

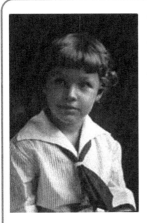

Tennessee Williams (age 5) in Clarksdale, MS.

Williams lived the first ten years of his life in his *maternal grandparents' home*[9]. His early life was spent in an atmosphere of *genteel culture*[10], so when the family moved to St. Louis, he confronted a big shock. Their *cramped*[11] apartment and the ugliness of the city life made a lasting impression on him.

He had two *siblings*[12], older sister Rose Isabel Williams (1909—1996) and younger brother Walter Dakin Williams (1919—2008).

As a young child Williams nearly died from a case of *diphtheria*[13] that left him weak and virtually confined to his house during a period of *recuperation*[14] that lasted a year. At least in part as a result of his illness, he was less *robust*[15] as a child than his father wished. Cornelius Williams, a *descendant*[16] of hearty East Tennessee pioneer stock, had a violent temper and was a man prone to use his fists. He regarded what he thought was his son's *effeminacy*[17] with *disdain*[18]. Edwina, locked in an unhappy marriage, focused her *overbearing attention*[19] almost entirely on her frail young son. Many critics and historians note that Williams drew from his own *dysfunctional*[20] family in much of his writing.

When Williams was eight years old, his father was promoted to a job at the home office of the International Shoe Company in St. Louis, Missouri. His mother's

9. maternal grandparents: 外祖父母
10. genteel culture: 上流文化
11. cramped: *adj.* 狭窄的
12. sibling: *n.* 兄弟姐妹
13. diphtheria: *n.* 白喉
14. recuperation: *n.* 复原
15. robust: *a.* 强健的
16. descendant: *n.* 后裔
17. effeminacy: *n.* 柔弱
18. disdain: *n.* 蔑视
19. overbearing attention: 专横的母爱
20. dysfunctional: *a.* 不正常的

continual search for what she considered to be an appropriate address, as well as his father's heavy drinking and *loudly turbulent behavior*[21], caused them to move numerous times around St. Louis. Williams attended Soldan High School, a setting he referred to in his play *The Glass Menagerie*. Later he studied at University City High School. At age 16, Williams won third prize for an essay published in *Smart Set*, titled "Can a Good Wife Be a Good Sport?" A year later, his short story "The Vengeance of Nitocris[22]" was published in the August 1928 issue of the magazine *Weird Tales*. That same year he first visited Europe with his maternal grandfather Dakin.

From 1929 to 1931, Williams attended the University of Missouri in Columbia where he enrolled in journalism classes. He was bored by his classes and distracted by *unrequited love*[23] for a girl. Soon he began entering his poetry, essays, stories, and plays in writing contests, hoping to earn extra income. His first submitted play was *Beauty Is the Word* (1930), followed by *Hot Milk at Three in the Morning* (1932). As recognition for *Beauty*, a play about rebellion against religious upbringing, he became the first freshman to *receive honorable mention*[24] in a writing competition.

At University of Missouri, Williams joined the Alpha Tau Omega *fraternity*[25], but he did not fit in well with his fraternity brothers. After he failed a military training course in his junior year, his father pulled him out of school and put him to work at the International Shoe Company factory. Although Williams hated the *monotony*[26], the job forced him out of the *gentility*[27] of his

21. loudly turbulent behavior: 聒噪又暴戾的行为

22. 《尼托克里斯的复仇》

23. unrequited love: 暗恋

24. receive honorable mention: 获得荣誉奖

25. fraternity: *n.* 兄弟会

26. monotony: *n.* 单调日子
27. gentility: *n.* 文雅

upbringing. His dislike of his new 9-to-5 routine drove Williams to write *prodigiously*[28]. He set a goal of writing one story a week. Williams often worked on weekends and late into the night. His mother recalled his intensity:

Tom would go to his room with black coffee and cigarettes and I would hear the typewriter clicking away at night in the silent house. Some mornings when I walked in to wake him for work, I would find him sprawled fully dressed across the bed, too tired to remove his clothes.

Overworked, unhappy, and lacking further success with his writing, by his 24th birthday Williams had suffered a nervous breakdown and left his job. He drew from memories of this period, and a particular factory co-worker, to create the character Stanley Kowalski in *A Streetcar Named Desire*. By the mid-1930s his mother separated from his father due to his worsening alcoholism and abusive temper. They never divorced.

In 1936, Williams enrolled at Washington University in St. Louis; while there, he wrote the play *Me, Vashya*[29] (1937). In the autumn of 1937, he transferred to the University of Iowa, where he graduated with a B. A. in English in August 1938. He later studied at the Dramatic Workshop of The New School in New York City. Speaking of his early days as a playwright and an early collaborative play called *Cairo, Shanghai, Bombay!*[30], Williams wrote, "The laughter... *enchanted*[31] me. Then and there the theatre and I found each other for better and for worse. I know it's the only thing that saved my life." Around 1939, he adopted "Tennessee Williams" as his professional name.

28. prodigiously: *ad.* 惊人地

29.《多此一举》

30.《开罗、上海、孟买!》
31. enchant: *v.* 使着魔

Williams' writings reference some of the poets and writers he most admired in his early years: *Hart Crane*, *Arthur Rimbaud*, *Anton Chekhov* (*from the age of ten*), *William Shakespeare*, *Clarence Darrow*, *D. H. Lawrence*, *Katherine Mansfield*, *August Strindberg*, *William Faulkner*, *Thomas Wolfe*, *Emily Dickinson*, *William Inge*, *James Joyce*, *and Ernest Hemingway*.[32]

Career

As Williams struggled to gain production and an audience for his work in the late 1930s, he worked at a string of menial jobs that included a *stint*[33] as caretaker on a chicken ranch in Laguna Beach, California. In 1939, with the help of his agent Audrey Wood, Williams was awarded a $1,000 grant from *the Rockefeller Foundation*[34] in recognition of his play *Battle of Angels*[35]. It was produced in Boston in 1940 and was poorly received.

Using some of the Rockefeller funds, Williams moved to New Orleans in 1939 to write for the Works Progress Administration (WPA), *a federally funded program*[36] begun by President Franklin D. Roosevelt created to put people to work. Williams lived for a time in New Orleans' French Quarter, including 722 Toulouse Street, the setting of his 1977 play *Vieux Carré*[37]. The building is now part of The Historic New Orleans Collection. The Rockefeller grant brought him to the attention of the Hollywood film industry and Williams received a six-month contract as a writer from the *Metro-Goldwyn-Mayer film studio*[38], earning $250 weekly.

32. 此处列举了田纳西·威廉斯推崇的诗人和作家们：哈特·克兰、亚瑟·兰波、安东尼·契科夫、莎士比亚、克莱伦斯·丹诺、D. H. 劳伦斯、凯瑟琳·曼斯菲尔德、奥古斯塔·斯特林堡、威廉·福克纳、托马斯·伍尔夫、艾米莉·迪金森、威廉·英奇、詹姆斯·乔伊斯、欧内斯特·海明威

33. stint: *n.* 一小段时间

34. the Rockefeller Foundation: 洛克菲勒基金会（洛克菲勒家族创办的慈善事业基金会）

35.《天使之战》

36. a federally funded program: 联邦政府资助项目

37.《老广场》

38. Metro-Goldwyn-Mayer film studio: 米高梅电影公司

During the winter of 1944—1945, his memory play *The Glass Menagerie* developed from his 1943 short story *Portrait of a Girl in Glass*, was produced in Chicago and garnered[39] good reviews. It moved to New York where it became an instant hit and enjoyed a long Broadway run. Elia Kazan (who directed many of Williams' greatest successes) said of Williams: "Everything in his life is in his plays, and everything in his plays is in his life." *The Glass Menagerie* won the award for the best play of the season, *the New York Drama Critics' Circle Award*[40].

The huge success of his next play, *A Streetcar Named Desire*, secured his reputation as a great playwright in 1947. During the late 1940s and 1950s, Williams began to travel widely with his partner Frank Merlo (1922—September 21, 1963), often spending summers in Europe. He moved often to stimulate his writing, living in New York, New Orleans, Key West, Rome, Barcelona, and London. Williams wrote, "Only some radical change can divert[41] the downward course of my spirit, some startling[42] new place or people to arrest[43] the drift[44], the drag[45]."

Williams arriving at funeral services for Dylan Thomas, 1953. Between 1948 and 1959 Williams had seven of his plays produced on Broadway: *Summer and Smoke*[46] (1948), *The Rose Tattoo*[47] (1951), *Camino Real*[48] (1953), *Cat on a Hot Tin Roof* (1955), *Orpheus Descending*[49] (1957), *Garden District*[50] (1958), and *Sweet Bird of Youth* (1959). By 1959, he had earned two Pulitzer Prizes, three New York Drama Critics' Circle

39. garner: *v.* 获得

40. the New York Drama Critics' Circle Award: 纽约戏剧评论协会奖

41. divert: *v.* 转移
42. startling: *a.* 令人吃惊的
43. arrest: *v.* 阻止
44. drift: *n.* 流浪
45. drag: *n.* 无聊

46.《夏与烟》
47.《玫瑰黥纹》
48.《卡密诺·利尔》
49.《琴神下凡》
50.《公园区》

Awards, three *Donaldson Awards*[51], and a *Tony Award*[52].

Williams' work reached wide audiences in the early 1950s when *The Glass Menagerie* and *A Streetcar Named Desire* were adapted as motion pictures. Later plays also adapted for the screen included *Cat on a Hot Tin Roof*, *The Rose Tattoo*, *Orpheus Descending*, *The Night of the Iguana*[53], *Sweet Bird of Youth*, and *Summer and Smoke*.

After the extraordinary successes of the 1940s and 1950s, he had more personal turmoil and theatrical failures in the 1960s and 1970s. Although he continued to write every day, the quality of his work suffered from his increasing *alcohol and drug consumption*[54], as well as occasional poor choices of collaborators. In 1963, his partner Frank Merlo died.

Consumed by depression over the loss, and in and out of treatment facilities while under the control of his mother and brother Dakin, Williams *spiralled downward*[55]. His plays *Kingdom of Earth*[56] (1967), *In the Bar of a Tokyo Hotel*[57] (1969), *Small Craft Warnings*[58] (1973), *The Two Character Play*[59] (also called *Out Cry*, 1973), *The Red Devil Battery Sign*[60] (1976), *Vieux Caérr* (1978), *Clothes for a Summer Hotel*[61] (1980), and others were all box office failures. Negative press notices wore down his spirit. His last play, *A House Not Meant to Stand*[62], was produced in Chicago in 1982. Despite largely positive reviews, it ran for only 40 performances.

Critics and audiences alike failed to appreciate Williams' new style and the approach to theater he developed during the 1970s.

In 1974, Williams received the St. Louis Literary

51. Donaldson Awards：唐纳森戏剧奖
52. 托尼奖（美国话剧和音乐剧最高奖）
53. 《巫山风雨夜》
54. alcohol and drug consumption：饮酒量和服药量
55. spiralled downward：螺旋式下降
56. 《地球王国》
57. 《在一家东京酒店的酒吧》
58. 《小船警报》
59. 《双人戏》（又名《呐喊》）
60. 《红魔鬼电池》
61. 《夏季旅馆着装记》
62. 《不该建起的房子》

Award from the Saint Louis University Library Associates. In 1979, four years before his death, he was inducted into the American Theater Hall of Fame.

Personal Life

Throughout his life Williams remained close to his sister, Rose, who was diagnosed with *schizophrenia*[63] as a young woman. In 1943, as her behavior became increasingly disturbing, she was subjected to a *lobotomy*[64], requiring her to be institutionalized for the rest of her life. As soon as he was financially able, Williams moved Rose to a private institution just north of New York City, where he often visited her. He gave her a percentage interest in several of his most successful plays, the *royalties*[65] from which were applied toward her care. The devastating effects of Rose's illness may have contributed to Williams' alcoholism and his dependence on various combinations of *amphetamines*[66] and *barbiturates*[67].

After some early attempts at relationships with women, by the late 1930s Williams began exploring his *homosexuality*[68]. In New York City, he joined a gay social circle that included fellow writer and close friend Donald Windham (1920—2010) and his partner Fred Melton. In the summer of 1940, Williams initiated a relationship with Kip Kiernan (1918—1944), a young Canadian dancer he met in Provincetown, Massachusetts. When Kiernan left him to marry a woman, Williams was *distraught*[69]. Kiernan's death four years later at age 26 was another heavy blow.

63. schizophrenia: *n.* 精神分裂症

64. lobotomy: *n.* 脑叶白质切除术

65. royalty: *n.* 版税

66. amphetamines: 安非他命(抑郁症治剂)

67. barbiturates: 巴比妥类药物(助眠镇静剂)

68. homosexuality: *n.* 同性恋

69. distraught: *a.* 悲伤的

On a 1945 visit to Taos, New Mexico, Williams met Pancho Rodríguezy González, a hotel clerk of Mexican heritage. Rodríguez was, *by all accounts*[70], a loving and loyal companion. But he was also prone to jealous rages and excessive drinking, and their relationship was *tempestuous*[71]. In February 1946 Rodríguez left New Mexico to join Williams in his New Orleans apartment. They lived and traveled together until late 1947, when Williams ended the relationship. Rodríguez and Williams remained friends, however, and were in contact as late as the 1970s.

Williams spent the spring and summer of 1948 in Rome in the company of an Italian teenager, called "Rafaello" in Williams' Memoirs. He provided financial assistance to the younger man for several years afterward. Williams drew from this for his first novel, *The Roman Spring of Mrs. Stone*[72].

235 E 58th Street, New York, New York

70. by all accounts: 据说

71. tempestuous: *a.* 紧张起伏的

72.《罗马之春》

Tennessee Williams' House, Key West, Florida

When he returned to New York that spring, Williams met and fell in love with Frank Merlo (1922—1963). An occasional actor of *Sicilian*[73] heritage, he had served in the U. S. Navy in World War Ⅱ. This was the enduring romantic relationship of Williams' life, and it lasted 14 years until *infidelities*[74] and drug abuse on both sides ended it. Merlo, who had become Williams' personal secretary, took on most of the details of their domestic life. He provided a period of happiness and stability, acting as a balance to the playwright's frequent *bouts with depression*[75]. Williams feared that, like his sister Rose, he would fall into insanity. His years with Merlo, in an apartment in Manhattan and a modest house in Key West, Florida were Williams' happiest and most productive period. Shortly after their breakup, Merlo was diagnosed with inoperable lung cancer. Williams returned to him and cared for him until his death on September 20, 1963.

In the years following Merlo's death, Williams *descended into*[76] a period of nearly *catatonic depression*[77] and increasing drug use; this resulted in several hospitalizations and commitments to mental health

73. Sicilian: *a.* 西西里的

74. infidelity: *n.* 不忠

75. bouts with depression: 多次抑郁症的发作

76. descend into: 陷入
77. catatonic depression: 紧张性忧郁症

facilities. He submitted to injections by Dr. Max Jacobson—known popularly as Dr. Feelgood—who used increasing amounts of amphetamines to overcome his depression. During this time, influenced by his mother, a Roman Catholic *convert*[78], Williams joined the Catholic Church (though he later claimed that he never took his conversion seriously). *He was never truly able to recoup his earlier success, or to entirely overcome his dependence on prescription drugs.*[79]

Edwina Dakin, Williams' mother, died in 1980 at the age of 95. Her health had begun failing during the early 1970s and she lived in a care facility from 1975 onward. Williams rarely saw his mother in her later years and *retained a strong animosity toward her*[80]; friends described his reaction to her death as "mixed".

Death

On February 25, 1983, Williams was found dead at age 71 in his suite at the Hotel Elysée in New York. Chief Medical Examiner of New York City Elliot M. Gross reported that Williams had choked to death from *inhaling*[81] the plastic cap of a bottle of the type that might contain a *nasal spray*[82] or *eye solution*[83].

He wrote in his will in 1972: "I, Thomas Lanier (Tennessee) Williams, being in sound mind upon this subject, and having declared this wish repeatedly to my close friends—do hereby state my desire to be buried at sea. More specifically, I wish to be buried at sea at as close a possible point as the American poet Hart Crane

78. convert: *n.* 皈依者

79. 他始终未能重现往日辉煌，也无法彻底摆脱对处方药的依赖。

80. 对她怀有强烈的敌意

81. inhale: *v.* 吸入
82. nasal spray: 鼻用喷雾
83. eye solution: 洗眼剂

died by choice in the sea... I wish to be sewn up⁸⁴ in a canvas sack⁸⁵ and dropped overboard⁸⁶, as stated above, as close as possible to where Hart Crane was given by himself to the great mother of life which is the sea: The Caribbean, specifically, if that fits the geography of his death. Otherwise—wherever fits it." But his brother Dakin Williams arranged for him to be buried at Calvary Cemetery in St. Louis, Missouri, where his mother is buried.

Williams left his literary rights to The University of the South in Sewanee, Tennessee, an Episcopal school, in honor of his maternal grandfather, Walter Dakin, an *alumnus*⁸⁷ of the university. The funds support a creative writing program. When Rose died in 1996 after many years in a mental institution, she *bequeathed*⁸⁸ $7 million from her part of the Williams estate to The University of the South.

84. sew up: 缝入
85. a canvas sack: 帆布袋
86. overboard: *ad.* 自船上落下

87. alumnus: *n.* (男)校友

88. bequeath: *v.* 把……捐赠给

The Glass Menagerie

The Glass Menagerie is a four-character memory play by Tennessee Williams that *premiered*⁸⁹ in 1944 and *catapulted*⁹⁰ Williams from obscurity to fame. The play has strong autobiographical elements, featuring characters based on Williams himself, his *histrionic*⁹¹ mother, and his mentally fragile sister Laura. In writing the play, Williams drew on an earlier short story, as well as a screenplay he had written under the title of *The Gentleman Caller*⁹².

The Glass Menagerie was Williams' first successful play. After a shaky start it was *championed*⁹³ by Chicago

89. premiere: *v.* 首次公演
90. catapult: *v.* 促使

91. histrionic: *a.* 做作的

92.《来访的绅士》

93. champion: *v.* 支持

critics Ashton Stevens and Claudia Cassidy, whose enthusiasm helped build audiences so the producers could move the play to Broadway where it won the New York Drama Critics Circle Award in 1945. After then, Williams went on to become one of America's most highly regarded playwrights.

Being a "memory play", *The Glass Menagerie* can be presented with unusual freedom from convention. Expressionism and all other unconventional techniques in drama have only one valid aim, and that is a closer approach to truth.

Characters

AMANDA WINGFIELD [*the mother*]: *A little woman of great but confused vitality clinging frantically to another time and place.* [94] Her characterization must be carefully created, not copied from type. She is not *paranoiac*[95], but her life is *paranoia*[96]. There is much to admire in Amanda, and as much to love and pity as there is to laugh at. Certainly she has endurance and a kind of heroism, and though her foolishness makes her unwittingly cruel at times, *there is tenderness in her slight person*[97].

LAURA WINGFIELD [*her daughter*]: Amanda, having failed to establish contact with reality, continues to live vitally in her illusions, but Laura's situation is even *graver*[98]. A childhood illness has left her crippled, one leg slightly shorter than the other, and held in a brace. This defect need not be more than suggested on the stage. Stemming from this, Laura's separation increases till she is like a piece of her own glass collection, too exquisitely

94. 身材娇小的女人，极富活力，但思绪不宁，痴狂地沉溺于往事。
95. paranoiac: *n.* 偏执狂者
96. paranoia: *n.* 偏执（状态）

97. 在她瘦弱的身体中蕴藏着柔情。

98. grave: *a.* 阴郁的

fragile to move from the shelf.

TOM WINGFIELD [*her son, and the narrator of the play*]: A poet with a job in a warehouse. His nature is not *remorseless*[99], but to escape from a trap he has to act without pity.

JIM O'CONNOR [*the gentleman caller*]: A nice, ordinary, young man.

SCENE: An alley in St Louis

PART 1: Preparation for a Gentleman Caller (scenes 1–5)

PART 2: The Gentleman Calls (scenes 6–7)

Time: Now and the Past

SCENE 1

The Wingfield apartment is in the rear of the building, one of those vast hive-like conglomerations[100] *of cellular living-units that flower as warty growths in overcrowded urban centers of lower middle-class population and are symptomatic of the impulse of this largest and fundamentally enslaved section of American society to avoid fluidity*[101] *and differentiation*[102] *and to exist and function as one interfused*[103] *mass of automatism.*

The apartment faces an alley[104] *and is entered by a fire-escape*[105], *a structure whose name is a touch of accidental poetic truth, for all of these huge buildings are always burning with the slow and implacable fires of human desperation. The fire-escape is included in the set—that is, the landing of it and steps descending from it.*

99. remorseless: *a.* 冷酷的

100. conglomeration: *n.* 混合物

101. fluidity: *n.* 流动性
102. differentiation: *n.* 分化
103. interfused: *a.* 混合的

104. alley: *n.* 小巷
105. fire-escape: *n.* 太平梯

The scene is memory and is therefore non-realistic. Memory takes a lot of poetic licence. It omits some details; others are exaggerated, according to the emotional value of the articles it touches, for memory is seated predominantly[106] in the heart. The interior is therefore rather dim and poetic.

[At the rise of the curtain, the audience is faced with the dark, grim[107] rear wall of the Wingfield tenement. This building, which runs parallel to the footlights, is flanked[108] on both sides by dark, narrow alleys which run into murky[109] canyons of tangled clothes-lines[110], garbage cans, and the sinister lattice-work of neighbouring fire-escapes[111]. It is up and down these side alleys that exterior entrances and exits are made, during the play. At the end of TOM's opening commentary, the dark tenement wall slowly reveals (by means of a transparency[112]) the interior of the ground floor Wingfield apartment.

Downstage is the living-room, which also serves as a sleeping-room for LAURA, the sofa unfolding to make her bed. Upstage, centre, and divided by a wide arch or second proscenium with transparent faded portieres[113] (or second curtain), is the dining-room. In an old-fashioned what-not[114] in the living-room are seen scores of transparent glass animals. A blown-up photograph[115] of the father hangs on the wall of the living-room, facing the audience, to the left of the archway[116]. It is the face of a very handsome young man in a doughboy's[117] First World War cap. He is gallantly[118] smiling, ineluctably[119] smiling, as if to say "I will be smiling forever".

The audience hears and sees the opening scene in the dining-room through both the transparent fourth wall of the

106. predominantly: *ad.* 主要地

107. grim: *a.* 阴森的
108. flank: *v.* 位于……侧面
109. murky: *a.* 黑暗的
110. tangled clothes-lines: 缠绕在一起的衣架
111. 附近一带引起人不祥联想的那些避火梯的格子栏杆

112. transparency: *n.* 透明

113. 挂着褪色的透明门帘的第二舞台
114. what-not: *n.* 古董架

115. 一幅放大的照片
116. archway: *n.* 拱门
117. doughboy: *n.* 步兵
118. gallantly: *ad.* 漂亮地
119. ineluctably: *ad.* 不可避免地

building and the transparent gauze portieres[120] of the dining-room arch. It is during this revealing scene that the fourth wall slowly ascends out of sight. This transparent exterior wall is not brought down again until the very end of the play, during TOM's final speech.

The narrator is an undisguised convention of the play.[121] He takes whatever licence[122] with dramatic convention as is convenient to his purposes.

TOM enters dressed as a merchant sailor from alley, stage left, and strolls across the front of the stage to the fire-escape. There he stops and lights a cigarette. He addresses the audience.]

TOM: Yes, I have tricks in my pocket, I have things up my sleeve. But I am the opposite of a stage magician. He gives you illusion that has the appearance of truth. I give you truth in the pleasant disguise of illusion.

To begin with, I turn back time. I reverse it to that *quaint*[123] period, the thirties, when the huge middle class of America was *matriculating*[124] in a school for the blind. Their eyes had failed them, or they had failed their eyes, and *so they were having their fingers pressed forcibly down on the fiery Braille alphabet of a dissolving economy.*[125]

In Spain there was revolution. Here there was only shouting and confusion.

In Spain there was *Guernica*[126]. Here there were *disturbances of labour*[127], sometimes pretty violent, in otherwise peaceful cities such as Chicago, Cleveland,

120. gauze portiere: n. 纱帘

121. 叙述者在戏剧中是个名正言顺的常规人物。
122. licence: n. 自由

123. quaint: a. 古怪的
124. matriculate: v. 批准入学

125. 所以他们用手指头使劲地按着分崩离析的经济，就像按着叫人恼火的布莱叶盲字。
126. Guernica: n. 格尔尼卡（西班牙小镇，在二战中遭到了德军的武装摧毁，此处暗指人们反纳粹的革命行为）
127. disturbances of labour: 工人闹事

Saint Louis...

This is the social background of the play.

[MUSIC]

The play is memory.

Being a memory play, it is dimly lighted, it is sentimental, it is not realistic.

In memory everything seems to happen to music. That explains the *fiddle*[128] in the wings.

I am the narrator of the play, and also a character in it. The other characters are my mother Amanda, my sister Laura, and a gentleman caller who appears in the final scenes.

He is the most realistic character in the play, being an *emissary*[129] from a world of reality that we were somehow set apart from.

But since I have a poet's weakness for symbols, I am using this character also as a symbol; he is the *long-delayed*[130] but always expected something that we live for. There is a fifth character in the play who doesn't appear except in this larger-than-life-size photograph over the *mantel*[131].

This is our father who left us a long time ago.

He was a telephone man who fell in love with long distances; he gave up his job with the telephone company and *skipped the light fantastic out of town...*[132]

The last we heard of him was a picture postcard from *Mazatlan*[133], on the Pacific coast of Mexico, containing a message of two words—

"Hello—Good-bye!" and no address.

128. fiddle: *n.* 小提琴

129. emissary: *n.* 使者

130. long-delayed: *a.* 迟迟不来的

131. mantel: *n.* 壁炉架

132. 悄悄地溜出了城

133. Mazatlan: *n.* 马萨特兰（墨西哥城市）

I think the rest of the play will explain itself...

[*AMANDA's voice becomes audible through the portieres. LEGEND ON SCREEN: "OU SONT LES NEIGES"*[134] *He divides the portieres and enters the upstage area. AMANDA and LAURA are seated at a drop-leaf table*[135]. *Eating is indicated by gestures without food or utensils. AMANDA faces the audience. TOM and LAURA are seated in profile.*

The interior has lit up softly and through the scrim[136] *we see AMANDA and LAURA seated at the table in the upstage area.*]

AMANDA: [*calling*] Tom?

TOM: Yes, Mother.

AMANDA: *We can't say grace until you come to the table!*[137]

TOM: Coming, Mother. [*He bows slightly and withdraws, reappearing a few moments later in his place at the table.*]

AMANDA: [*to her son*] Honey, don't push with your fingers. If you have to push with something, the thing to push with is *a crust of bread*[138]. And *chew*[139]—chew! Animals have *secretions*[140] in their stomachs which enable them to digest food without *mastication*[141], but human beings are supposed to chew their food before they swallow it down. Eat food leisurely, son, and really enjoy it. A well-cooked meal has lots of delicate flavors that have to be held in the mouth for appreciation. *So chew your

134. 屏幕上出现说明词:"雪在哪里"

135. 折叠桌

136. scrim: *n.* 纱幕

137. 你不来吃饭,我们不能祷告哩!

138. 一块面包
139. chew: *v.* 咀嚼
140. secretion: *n.* 分泌液

141. mastication: *n.* 咀嚼

food and give your salivary glands a chance to function!^142

[*Tom deliberately lays his imaginary fork down and pushes his chair back from the table.*]

TOM： I haven't enjoyed one bite of this dinner because of your constant directions on how to eat it. It's you that makes me rush through meals with your *hawk-like*^143 attention to every bite I take. Sickening—spoils my appetite—all this discussion of—animals' secretion—salivary glands—mastication!

AMANDA： [*lightly*] Temperament like a Metropolitan star!^144 [*He rises and crosses downstage.*] You're not excused from the table.^145

TOM： I'm getting a cigarette.

AMANDA： You smoke too much. [*Laura rises.*]

LAURA： I'll bring in the *blancmangé*^146.

[*He remains standing with his cigarette by the portieres during the following.*]

AMANDA： [*rising*] No, sister, no, sister—you be the lady this time and I'll be the *darkey*^147.

LAURA： I'm already up.

AMANDA： *Resume your seat*^148, little sister—I want you to stay fresh and pretty—for gentleman callers!

LAURA： I'm not expecting any gentleman callers.

AMANDA： [*crossing out to kitchenette*^149, *airily*^150] Sometimes they come when they are least expected! Why, I remember one Sunday afternoon in Blue Mountain—[*Enters kitchenette.*]

142. 所以嚼嚼你吃的东西，让你的唾液腺有机会发挥作用。

143. hawk-like： *a.* 老鹰似的

144. 脾气大得像大都会剧院的明星！
145. 你离开餐桌连对不起都不说一声。

146. blancmangé： *n.* 牛奶冻

147. darkey： *n.* 黑人（此处指黑人女仆）

148. 重新坐下

149. kitchenette： *n.* 小厨房
150. airily： *adv.* 轻盈地

TOM: I know what's coming!

LAURA: Yes. But let her tell it.

TOM: Again?

LAURA: She loves to tell it.

[*Amanda returns with bowl of dessert.*]

AMANDA: One Sunday afternoon in Blue Mountain—your mother received—*seventeen*!—gentlemen callers! Why, sometimes there weren't chairs enough to accommodate them all. We had to send the *nigger*[151] over to bring in folding chairs from *the parish house*[152].

TOM: [*remaining at portieres*] How did you entertain those gentleman callers?

AMANDA: I understood the art of conversation!

TOM: I bet you could talk.

AMANDA: Girls in those days knew how to talk, I can tell you.

TOM: Yes?

AMANDA: They knew how to entertain their gentlemen callers. It wasn't enough for a girl to be possessed of a pretty face and a graceful figure *although I wasn't alighted in either respect*[153]. *She also needed to have a nimble wit and a tongue to meet all occasions.*[154]

TOM: What did you talk about?

AMANDA: Things of importance going on in the world! *Never anything coarse or common or vulgar.*[155]

[*She addresses Tom as though he were seated in the vacant chair at the table though he remains by portieres. He plays this scene*

151. nigger: *n.* 黑鬼（黑
仆）
152. 教堂

153. 尽管我在这两点上一点也不差
154. 她还需要有机灵的头脑和高明的口才来应付各种场面才行。

155. Never anything coarse or common or vulgar: 从来不谈粗鲁、庸俗或是下流的事情。

as though he held the book.]

My callers were gentleman—all! Among my callers were some of the most prominent young planters of the Mississippi Delta—planters and sons of planters!

[*Tom motions for music and a spot of light on Amanda. Her eyes lift, her face glows, her voice becomes rich and elegiac[156].*]

There was young Champ Laughlin who later became vice-president of the Delta Planters Bank. Hadley Stevenson who was drowned in Moon Lake and left his widow one hundred and fifty thousand in Government bonds. There were the Cutrere brothers, Wesley and Bates. *Bates was one of my bright particular beaux!*[157] He got in a quarrel with that wild Wainwright boy. They shot it out on the floor of Moon Lake Casino. Bates was shot through the stomach. Died in the ambulance on his way to Memphis. His widow was also well provided for, came into eight or ten thousand acres, that's all. *She married him on the rebound*[158]—never loved her—carried my picture on him the night he died! And there was that boy that every girl in the Delta had set her cap for! That brilliant, brilliant young Fitzhugh boy from Greene County!

TOM: What did he leave his widow?

AMANDA: He never married! Gracious, you talk as though all of my old admirers had *turned up their toes to the daisies*[159]!

TOM: Isn't this the first you've mentioned that still survives?

AMANDA: That Fitzhugh boy went North and made a fortune—came to be known as the Wolf of Wall Street! He had the Midas touch,

156. elegiac: a. 哀伤的

157. 那些缠着我一个劲献殷勤的机灵小伙子当中，就有贝茨！

158. 她利用他情绪一时波动嫁给了他……

159. turn up toes to the daisies: 死亡

	whatever he touched turned to gold! And I could have been Mrs Duncan J. Fitzhugh, mind you! But—I picked your father!
LAURA:	[*rising*] Mother, let me clear the table.
AMANDA:	No, dear, you go in front and study your typewriter chart. Or practice your shorthand a little. Stay fresh and pretty! —It's almost time for our gentlemen callers to start arriving. [*She flounces*[160] *girlishly toward the kitchenette.*] How many do you suppose we're going to entertain this afternoon?

[*Tom throws down the paper and jumps up with a groan.*]

| LAURA: | [*alone in the dining-room*] I don't believe we're going to receive any, Mother. |
| AMANDA: | [*reappearing, airily*] What? No one—not one? You must be joking! |

[*Laura nervously echoes her laugh. She slips in a fugitive manner through the half-open portieres and draws them in gently behind her. A shaft of very clear light is thrown on her face against the faded tapestry of the curtains.*[161]] [MUSIC: "THE GLASS MENAGERIE" UNDER FAINTLY. *Lightly.*]

| AMANDA: | Not one gentleman caller? It can't be true! There must be a flood, there must have been a tornado! |
| LAURA: | It isn't a flood, it's not a tornado, Mother. I'm just not popular like you were in Blue Mountain... [*Tom utters another groan. Laura glances at him with a faint, apologetic smile. Her voice catching a little.*] Mother's afraid I'm going to be an old maid. |

160. flounces: v. 蹦蹦跳跳地

161. A shaft of very clear light is thrown on her face against the faded tapestry of the curtains: 一道非常明亮的灯光照在她的脸上,后面是一片褪色的帷幕。

[*THE SCENE DIMS OUT WITH "GLASS MENAGERIE"*]

SCENE 2

[*"Laura, Haven't You Ever Liked Some Boy?"*
On the dark stage the screen is lighted with the image of blue roses. Gradually Laura's figure becomes apparent and the screen goes out. The music subsides. Laura is seated in the delicate ivory chair at the small claw-foot table[162]. She wears a dress of soft violet material for a kimono[163]—her hair tied back from her forehead with a ribbon. She is washing and polishing her collection of glass. Amanda appears on the fire-escape steps. At the sound of her ascent, Laura catches her breath, thrusts the bowl of ornaments away and seats herself stiffly before the diagram of the typewriter keyboard as though it held her spellbound[164]. Something has happened to Amanda. It is written in her face as she climbs to the landing: a look that is grim and hopeless and a little absurd. She has on one of those cheap or imitation velvety-looking cloth coats with imitation fur collar[165]. Her hat is five or six years old, one of those dreadful cloche hats that were worn in the late twenties and she is clasping[166] an enormous black patent-leather pocketbook with nickel clasps and initials. This is her full-dress outfit, the one she usually wears to the D. A. R. Before entering she looks through the door. She purses her lips, opens her eyes very wide, rolls them upward, and shakes her head. Then she slowly lets herself in the door. Seeing her mother's expression Laura touches her lips with a nervous gesture.]

LAURA: Hello, Mother, I was—[*She makes a nervous gesture toward the chart on the wall.*

162. 爪型桌腿的小桌子

163. kimono: n. 和服

164. ……好像那张图表使她着了迷似的。

165. imitation fur collar: 假皮领

166. clasp: v. 紧抱

[*Amanda leans against the shut door and stares at Laura with a martyred[167] look.*]

AMANDA: Deception? Deception? [*She slowly removes her hat and gloves, continuing the sweet suffering stare. She lets the hat and gloves fall on the floor—a bit of acting.*]

LAURA: [*shakily*] How was the D. A. R.[168] meeting? [*Amanda slowly opens her purse and removes a dainty white handkerchief which she shakes out delicately and delicately touches to her lips and nostrils.*] Didn't you go to the D. A. R. meeting, Mother?

AMANDA: [*faintly, almost inaudibly[169]*]—No.—No. [*then more forcibly*] I did not have the strength—to go to the D. A. R. In fact, I did not have the courage! I wanted to find a hole in the ground and hide myself in it for ever! [*She crosses slowly to the wall and removes the diagram of the typewriter keyboard. She holds it in front of her for a second, staring at it sweetly and sorrowfully—then bites her lips and tears it into two pieces.*]

LAURA: [*faintly*] Why did you do that, Mother? [*Amanda repeats the same procedure with the chart of the Gregg alphabet[170].*] Why are you—

AMANDA: Why? Why? How old are you, Laura?

LAURA: Mother, you know my age.

AMANDA: I thought that you were an adult; it seems that I was mistaken.

[*She crosses slowly to the sofa and sinks down and stares at

167. martyred: *a.* 殉难的

168. D. A. R.: 美国革命妇女会

169. inaudibly: *ad.* (声音小的) 几乎听不见地

170. 格雷字母表

Laura.]

LAURA: Please don't stare at me, Mother.

[*Amanda closes her eyes and lowers her head. Count ten.*]

AMANDA: What are we going to do, what is going to become of us, what is the future?

[*Count ten.*]

LAURA: Has something happened, Mother? [*Amanda draws a long breath and takes out the handkerchief again. Dabbing process.*] Mother, has—something happened?

AMANDA: I'll be all right in a minute, I'm just bewildered—[*count five*]—by life…

LAURA: Mother, I wish that you would tell me what's happened!

AMANDA: As you know, I was supposed to be inducted into my office at the D. A. R. this afternoon. But I stopped off at Rubicam's business college to speak to your teachers about your having a cold and ask them what progress they thought you were making down there.

LAURA: Oh…

AMANDA: I went to the typing instructor and introduced myself as your mother. She didn't know who you were. Wingfield, she said. We don't have any such student enrolled at the school! I assured her she did, that you had been going to classes since early in January. "I wonder," she said, " if you could be talking about that

terribly shy little girl who dropped out of school after only a few days' attendance?" "No," I said, "Laura, my daughter, has been going to school every day for the past six weeks!" "Excuse me," she said. She took the attendance book out and there was your name, unmistakably printed, and all the dates you were absent until they decided that you had dropped out of school. I still said, "No, there must have been some mistake! There must have been some mix-up in the records!" And she said, "No—I remember her perfectly now. Her hands shook so that she couldn't hit the right keys! The first time we gave a speed-test, she broke down completely—was sick at the stomach and almost had to be carried into the wash-room! After that morning she never showed up any more. We phoned the house but never got any answer"—while I was working at Famous and Barr, I suppose, demonstrating those—Oh! I felt so weak I could barely keep on my feet! I had to sit down while they got me a glass of water! Fifty dollars' tuition, all of our plans—my hopes and ambition for you—just gone *up the spout*[171], just gone up the spout like that. [Laura draws a long breath and gets awkwardly to her feet. She crosses to the *victrola*[172] and winds it up.] What are

171. up the spout: 无可挽回

172. victrola: *n.* 手摇留声机

you doing?

LAURA: Oh! [*She releases the handle and returns to her seat.*]

AMANDA: Laura, where have you been going when you've gone on pretending that you were going to business college?

LAURA: I've just been going out walking.

AMANDA: That's not true.

LAURA: It is. I just went walking.

AMANDA: Walking? Walking? In winter? Deliberately courting *pneumonia*[173] in that light coat? Where did you walk to, Laura?

LAURA: All sorts of places—mostly in the park.

AMANDA: Even after you'd started catching that cold?

LAURA: *It was the lesser of two evils*[174], Mother. I couldn't go back up. I—threw up—on the floor!

AMANDA: From half past seven till after five every day you mean to tell me you walked around in the park, because you wanted to make me think that you were still going to Rubicam's Business College?

LAURA: It wasn't as bad as it sounds. I went inside places to get warmed up.

AMANDA: Inside where?

LAURA: I went in the art museum and the bird-houses at the zoo. I visited the penguins every day! Sometimes I did without lunch and went to the movies. Lately I've been spending most of my afternoons in the

173. pneumonia: *n.* 肺炎

174. 总比上学要好一些。

jewel-box, that big glass-house where they raise the tropical flowers.

AMANDA: You did all this to deceive me, just for deception?

[*Laura looks down.*] Why?

LAURA: Mother, when you're disappointed, you get that awful suffering look on your face, like the picture of Jesus' mother in the museum!

AMANDA: Hush!

LAURA: I couldn't face it.

[*Pause. A whisper of strings.*]

[*Legend:* "*The Crust of Humility.*"]

AMANDA: [*hopelessly fingering the huge pocketbook*] So what are we going to do the rest of our lives? Stay home and watch the parades go by? Amuse ourselves with the glass menagerie, darling? Eternally play those worn-out phonograph records your father left as a painful reminder of him? We won't have a business career—we've given that up because it gave us nervous indigestion! [*laughs wearily*] What is there left but dependency all our lives? I know so well what becomes of unmarried women who aren't prepared to occupy a position. I've seen such pitiful cases in the South—barely tolerated spinsters living upon *the grudging patronage*[175] of sister's husband or brother's wife!—stuck away in some little mousetrap

175. 吝啬的恩惠

of a room—encouraged by one in-law to visit another—little birdlike women without any nest—eating the crust of humility all their life! Is that the future that we've mapped out for ourselves? I swear it's the only alternative I can think of! It isn't a very pleasant alternative, is it? Of course—some girls do marry. [*Laura twists her hands nervously.*] Haven't you ever liked some boy?

LAURA: Yes. I liked one once. [*rises*] I came across his picture a while ago.

AMANDA: [*with some interest*] He gave you his picture?

LAURA: No, it's in the year-book.

AMANDA: [*disappointed*] Oh—a high-school boy.

LAURA: Yes. His name was Jim. [*Laura lifts the heavy year-book from the claw-foot table.*] Here he is in The Pirates of Penzance.

AMANDA: [*absently*] The what?

LAURA: The *operetta*[176] the senior class put on. He had a wonderful voice and we sat across the aisle from each other Mondays, Wednesdays, and Fridays in the Aud. Here he is with the silver cup for debating! See his grin?

AMANDA: [*absently*] He must have had a jolly disposition.

LAURA: He used to call me—Blue Roses.

AMANDA: Why did he call you such a name as that?

176. operetta: *n.* 轻歌剧

LAURA: When I had that attack of *pleurosis*[177]—he asked me what was the matter when I came back. I said pleurosis—he thought that I said Blue Roses! So that's what he always called me after that. Whenever he saw me, he'd *holler*[178], "Hello, Blue Roses!" I didn't care for the girl that he went out with. Emily Meisenbach. Emily was the best-dressed girl at Soldan. She never struck me, though, as being sincere… It says in the Personal Section—they're engaged. That's—six years ago! They must be married by now.

AMANDA: Girls that aren't cut out for business careers usually wind up married to some nice man. [*gets up with a spark of revival*] Sister, that's what you'll do!

[*LAURA utters a startled, doubtful laugh. She reaches quickly for a piece of glass.*]

LAURA: But, Mother—

AMANDA: Yes? [*crossing to photograph*]

LAURA: [*in a tone of frightened apology*] I'm—crippled!

AMANDA: Nonsense! Laura, I've told you never, never to use that word. Why, you're not crippled, you just have a little defect—hardly noticeable, even! When people have some slight disadvantage like that, they cultivate other things to make up for it—develop charm—and *vivacity*[179] and—

177. pleurosis: *n.* 肋膜炎

178. holler: *v.* 喊叫

179. vivacity: *n.* 活泼

charm! That's all you have to do! [*She turns again to the photograph.*] One thing your father had plenty of—was charm!

[*Tom motions to the fiddle in the wings.*] THE SCENE FADES OUT WITH MUSIC

Assignment

I. Review what you've learned from this chapter and complete the following note-taking with related information.

Facts of Tennessee's Childhood	
Facts of Tennessee's Family	
Reason of Tennessee's Plummeted Popularity in 1960s	
Masterpieces of Tennessee W.	

II. Share your opinion of the Wingfields. Which one of the family impressed you most? Why?

Further Reading

Plot Summary of *The Glass Menagerie*

The Glass Menagerie is a four-character memory play by Tennessee Williams that premiered in 1944 and catapulted (使突然处于) Williams from obscurity (默默无闻) to fame. The play has strong autobiographical elements, featuring characters based on Williams himself, his histrionic (行为夸张的) mother, and his mentally fragile sister Laura. In writing the play, Williams drew on an earlier short story, as well as a screenplay he had written under the title of *The Gentleman Caller.*

The play premiered in Chicago in 1944. After a shaky (不稳的) start it was championed by Chicago critics Ashton Stevens and Claudia Cassidy, whose

enthusiasm helped build audiences so the producers could move the play to Broadway where it won the New York Drama Critics Circle Award in 1945. *The Glass Menagerie* was Williams's first successful play; he went on to become one of America's most highly regarded playwrights.

The play is introduced to the audience by Tom, the narrator and protagonist (主角), as a memory play based on his recollection of his mother Amanda and his sister Laura. Because the play is based on memory, Tom cautions the audience that what they see may not be precisely what happened.

Amanda Wingfield, a faded Southern belle of middle age, shares a dingy (阴暗邋遢的) St. Louis apartment with her son Tom, in his early twenties, and his slightly older sister, Laura. Although she is a survivor and a pragmatist, Amanda yearns for the comforts and admiration she remembers from her days as a debutante (初入社交界的女子). She worries especially about the future of her daughter Laura, a young woman with a limp (an aftereffect of a bout of polio) and a tremulous insecurity about the outside world. Tom works in a shoe warehouse doing his best to support the family. He chafes (恼火) under the banality (单调乏味) and boredom of everyday life and struggles to write, while spending much of his spare time going to the movies—or so he says—at all hours of the night.

Amanda is obsessed with finding a suitor (or, as she puts it, a "gentleman caller") for Laura, whose crippling shyness has led her to drop out of both high school and a subsequent (随后的) secretarial course, and who spends much of her time polishing and arranging her collection of little glass animals. Pressured by his mother to help find a caller for Laura, Tom invites an acquaintance from work named Jim home for dinner.

The delighted Amanda spruces up (精心布置) the apartment, prepares a special dinner, and converses coquettishly (卖弄风情地) with Jim, almost reliving her youth when she had an abundance of suitors calling on her. Laura discovers that Jim is the boy she was attracted to in high school and has often thought of since—though the relationship between the shy Laura and the "most likely to succeed" Jim was never more than a distant, teasing acquaintanceship. Initially, Laura is so overcome by shyness that she is unable to join the others at

dinner, and she claims to be ill. After dinner, however, Jim and Laura are left alone by candlelight in the living room, waiting for the electricity to be restored. (Tom has not paid the power bill, which hints to the audience that he is banking the bill money and preparing to leave the household.) As the evening progresses, Jim recognizes Laura's feelings of inferiority and encourages her to think better of herself. He and Laura share a quiet dance, in which he accidentally brushes against her glass menagerie, knocking a glass unicorn to the floor and breaking off its horn. Jim then compliments Laura and kisses her. After Jim reveals that he is already engaged to be married, Laura asks him to take the broken unicorn as a gift and he then leaves. When Amanda learns that Jim is to be married, she turns her anger upon Tom and cruelly lashes out (痛斥) at him—although Tom did not know that Jim was engaged, and Amanda knows this.

As Tom speaks at the end of the play, he says that he left home soon afterward and never returned. In Tom's final speech, he bids farewell to his mother and sister, and asks Laura to blow out the candles as the play ends.

Chapter Six

Arthur Miller and *Death of a Salesman*

Arthur Miller, in full Arthur Asher Miller, born October 17, 1915, New York, U.S.—died February 10, 2005, Roxbury, Connecticut, American playwright, who combined social awareness with a searching concern for his characters' inner lives. He is best known for *Death of a Salesman* (1949).

Early Life

Arthur Miller, the son of a woman's clothing company owner, was born in 1915 in New York City. His father lost his business in the Depression and the family was forced to move to a smaller home in Brooklyn.

After graduating from high school, Miller worked jobs ranging from radio singer to truck driver to clerk in an automobile-parts warehouse. Miller began writing plays as a student at the University of Michigan, joining *the Federal Theater Project*[1] in New York City after he received his degree.

Notes:

1. the Federal Theater Project: 联邦剧场计划 (1935年美国启动的一项新政倡议,旨在让专业戏剧人员继续工作直到经济好转)

Career

Miller's first public success was with *Focus*[2] (1945; filmed 1962 [made-for-television]), a novel about *anti-Semitism*[3]. *All My Sons*[4] (1947; filmed 1948), a drama about a manufacturer of *faulty*[5] war materials that strongly reflects the influence of Henrik Ibsen, was his first important play. It won Miller a Tony Award, and it was his first major collaboration with the director Elia Kazan, who also won a Tony.

Miller's next play, *Death of a Salesman*, became one of the most famous American plays of its period. It is the tragedy of Willy Loman, a man destroyed by false values that are in large part the values of his society. For Miller, it was important to place "the common man" at the centre of a tragedy. As he wrote in 1949:

The quality in such plays [i.e., tragedies] that does shake us... derives from the underlying fear of being displaced, the disaster inherent[6] in being torn away from our chosen image of what and who we are in this world. Among us today this fear is as strong, and perhaps stronger, than it ever was. In fact, it is the common man who knows this fear best.

Miller had been exploring the ideas underlying *Death of a Salesman* since he was a teenager, when he wrote a story about a Jewish salesman; he also drew on memories of an uncle. He wrote the play in 1948, and it opened in New York City, directed by Kazan, in February 1949. The play won a Tony Award for best

2. 《焦点》

3. anti-Semitism: *n.* 反犹太主义
4. 《全是我的孩子》
5. faulty: *a.* 有缺陷的

6. inherent: *a.* 内在的

play and a Pulitzer Prize for drama, while Miller and Kazan again each won individual Tony, as author and director respectively. The play was later adapted for the screen (1951 and several made-for-television versions) and was revived several times on Broadway.

Fredric March (centre) as Willy Loman in *Death of a Salesman*, Directed by Laslo Benedek

Miller based *The Crucible*[7] (1953) on the witchcraft trials in Salem, Massachusetts, in 1692—1693, a series of persecutions that he considered an echo of the *McCarthyism*[8] of his day, when investigations of *alleged subversive activities*[9] were widespread. Though not as popular as *Death of a Salesman*, it won a Tony for best play. It was also adapted numerous times for film and television. In 1956, when Miller was himself called before *the House Un-American Activities Committee*[10], he refused to name people he had seen 10 years earlier at an alleged communist writers' meeting. He was convicted of contempt but appealed and won.

7.《萨勒姆的女巫》(又译《熔炉》)

8. McCarthyism：*n.* 麦卡锡主义

9. 所谓的颠覆活动

10. 众议院非美活动委员会

Arthur Miller, Photograph by Inge Morath

A Memory of Two Mondays[11] and another short play, *A View from the Bridge*[12], about an Italian-American *longshoreman*[13] whose passion for his niece destroys him, were staged on the same bill in 1955. (A year later *A View from the Bridge* was performed in a revised, longer form.) *After the Fall*[14] is concerned with failure in human relationships and its consequences, *large and small*[15], by way of McCarthyism and *the Holocaust*[16]; it opened in January 1964, and it was understood as largely autobiographical, despite Miller's denials. *Incident at Vichy*[17], which began a brief *run*[18] at the end of 1964, is set in Vichy, France and examines Jewish identity. *The Price*[19] (1968) continued Miller's exploration of the theme of guilt and responsibility to oneself and to others by examining the *strained*[20] relationship between two brothers. He directed the London production of the play in 1969.

The Archbishop's Ceiling[21], produced in Washington, D.C., in 1977, dealt with the Soviet treatment of *dissident*[22] writers. *The American Clock*[23], a series of dramatic *vignettes*[24] based on *Studs Terkel's Hard Times*[25] (about the Great Depression), was produced at the 1980 American Spoleto Festival in Charleston, South Carolina. Miller's later plays included *The Ride Down Mount Morgan*[26] (1991), *Mr. Peters' Connections*[27] (1998), and *Resurrection*

11.《两个星期一的回忆》
12.《桥头眺望》
13. longshoreman: *n.* 码头工人
14.《堕落之后》
15. large and small: 大大小小各个方面
16. the Holocaust: (20世纪30年代和40年代纳粹对数百万犹太人的)大屠杀
17.《维希事件》
18. run: *n.* 演出
19.《代价》
20. strained: *a.* 紧张的
21.《大主教的天花板》
22. dissident: *a.* 持不同政见的
23.《美国大钟》
24. 一系列戏剧化的小插曲
25. 斯塔兹·特克尔(美国伟大的作家、广播家、历史学家、演员)的作品《艰难时世》
26.《骑下摩根山》
27.《彼得斯先生的关系》

Blues[28] (2002).

Miller also wrote a screenplay, *The Misfits*[29], *for his second wife*, the actress Marilyn Monroe; they were married from 1956 to 1961. *The Misfits*, released in 1961, was directed by John Huston and also starred Clark Gable; its filming served as the basis for Miller's final play, *Finishing the Picture*[30] (2004). *I Don't Need You Any More*[31], a collection of his short stories, appeared in 1967 and a collection of theatre essays in 1977. His autobiography, *Time bends*[32], was published in 1987. Miller received *the Japan Art Association's Praemium Imperiale Prize for Theatre/Film*[33] in 2001.

28.《复活的蓝调》
29.《不合时宜的人》
30.《完成影片》
31.《不再需要你》
32.《阿瑟米勒自传》
33. 日本艺术协会颁发的皇家剧院/电影奖

Monroe and Clark Gable in *The Misfits* (1961), Directed by John Huston

Death of a Salesman

Death of a Salesman (1949) was a hit from its first performance and has remained at the center of modern American drama ever since.

The play was first performed in an environment that must be called experimental. Miller had originally conceived of a model of a man's head as the stage setting.

He has said: "The first image that occurred to me which was to result in *Death of a Salesman* was of an enormous face the height of the proscenium[34] arch which would appear and then open up, and we would see the inside of a man's head. In fact, *The Inside of His Head* was the first title." This technique was not used, but when Miller worked with the director and producer of the first production, he helped develop a setting that became a model for the "American style" in drama. The *multilevel set*[35] permitted the play to shift from Willy Loman and his wife, Linda, having a conversation in their kitchen to their son's bedroom on the second level of the house.

It permitted portions of the stage to be reserved for Willy's visions of his brother, Ben, and for scenes outside the house such as *Willy's interlude*[36] with the woman in Boston.

In a way, the setup of the stage respected Miller's original plan, but instead of portraying a cross section of Willy's head, it presented a metaphor for a cross section of his life. The audience felt that they were looking in on more than a living room, as in the nineteenth-century Ibsen-like approach; they were looking in on an entire house and an entire life.

Using a cross section of a house as a metaphor was an especially important device in this play because of the play's *allusions*[37] to Greek tragedy. The death in *Death of a Salesman* implies the destruction of a family that has held certain beliefs that have been wrong from the start.

The life of the salesman has given Willy a sense of

34. proscenium: *n.* 舞台前部

35. 多层布景

36. interlude: *n.* 穿插

37. allusion: *n.* 暗喻

dignity and worth, and he imagines that the modern world has corrupted that sense by robbing salesmen of the value of their personality. He thinks the modern world has failed him, but he is wrong. His original belief that what counts is not what you know but whom you know and how well you are liked lies at the heart of his failure. When the play opens, he has failed. He cannot do the traveling salesman's job because he can no longer drive to the territory. He cannot sell what he needs to sell.

Willy *has inculcated*[38] his beliefs in his sons, Happy and Biff, and both are as *ineffectual*[39] as their father. Willy *doted*[40] on Biff and encouraged him to become a high school football star at the expense of his studies. But when Biff cannot pass an important course, and when his plans to make up the work are *subverted*[41] by his *disillusionment*[42] in his father, his dreams of a college football career are gone. He cannot change, cannot recover from this defeat. Happy, like his father, builds castles in the air and assumes somehow that he will be successful when he has nothing to back himself up with. He wants the glory—and he spends time in fanciful imaginings, as Willy does—but he cannot do the basic work that makes it possible to achieve glory.

Linda supports Willy's illusions, allowing him to be a fraud by believing—or pretending to believe—in his dream with him. Willy has permitted himself to feel that integrity, honesty, and fidelity are not so important as being well liked.

The play ends with Willy still unable to face the deceptions he *has perpetuated*[43]. He commits suicide in

38. inculcate: *v.* 反复灌输
39. ineffectual: *a.* 无用的
40. dot: *v.* 溺爱
41. subvert: *v.* 颠覆，破坏
42. disillusionment: *n.* 幻灭
43. perpetuate: *v.* 长存

the firm belief that his sons will be able to follow in his footsteps and succeed where he did not. He thinks that his insurance money will be just what they need to save the house and the family. What he does not realize is that they are no more capable than he is. They have been corrupted by his thinking, his values, his beliefs. And they cannot solve the problems that overwhelmed him.

Characters

WILLY LOMAN	UNCLE BEN
LINDA	HOWARD WAGNER
BIFF	JENNY
HAPPY	STANLEY
BERNARD	MISS FORSYTHE
THE WOMAN	LETTA
CHARLEY	

ACT 1

[*A melody is heard, played upon a flute. It is small and fine, telling of grass and trees and the horizon. The curtain rises.*]

[*Before us is the Salesman's house. We are aware of towering, angular shapes behind it, surrounding it on all sides[44]. Only the blue light of the sky falls upon the house and forestage; the surrounding area shows an angry glow of orange. As more light appears, we see a solid vault of apartment houses around the small, fragile-seeming home.[45] An air of the dream dings to the place, a dream rising out of reality. The kitchen at center seems actual enough, for there is a kitchen table with three chairs, and a refrigerator. But no other fixtures[46] are seen. At the back of the kitchen there is a draped entrance[47], which leads*

44. on all sides: 方方面面

45. 随着灯光越来越强烈,我们看到一排公寓房子那结构坚实的拱顶围着这幢外表脆弱的小屋。

46. fixture: v. 固定财产(此处指厨房器具)

47. 挂着门帘的入口

to the living room. To the right of the kitchen, on a level raised two feet[48], is a bedroom furnished only with a brass bedstead and a straight chair[49]. On a shelf over the bed a silver athletic trophy stands. A window opens onto the apartment house at the side.]

[Behind the kitchen, on a level raised six and a half feet, is the boys' bedroom, at present barely visible. Two beds are dimly seen, and at the back of the room a dormer window[50]. (This bedroom is above the unseen living room.) At the left a stairway curves up to it from the kitchen.[51]]

[The entire setting is wholly or, in some places, partially transparent. The roof-line of the house is one-dimensional; under and over it we see the apartment buildings. Before the house lies an apron, curving beyond the fore-stage into the orchestra.[52] This forward area serves as the back yard as well as the locale[53] of all Willy's imaginings and of his city scenes. Whenever the action is in the present the actors observe the imaginary wall-lines[54], entering the house only through its door at the left. But in the scenes of the past these boundaries are broken, and characters enter or leave a room by stepping "through" a wall onto the fore-stage.]

[From the right, Willy Loman, the Salesman, enters, carrying two large sample cases. The flute plays on. He hears but is not aware of it. He is past sixty years of age, dressed quietly. Even as he crosses the stage to the doorway of the house, his exhaustion is apparent. He unlocks the door, comes into the kitchen, and thankfully lets his burden down, feeling the soreness of his palms. A word-sigh escapes his lips — it might be "Oh, boy, oh, boy". He closes the door, then carries his cases out into the living room, through the draped

48. 高出舞台两英尺(的地方)
49. 一张铜床和一把靠背椅

50. a dormer window: 天窗
51. 左边有座楼梯从厨房绕上这间卧室。

52. 屋前是台口,绕出前台,直通乐池。
53. locale: n. 场所

54. wall-line: n. 外墙线

kitchen doorway.]

[*Linda, his wife, has stirred in her bed at the right. She gets out and puts on a robe, listening. Most often jovial*[55], *she has developed an iron repression of her exceptions to Willy's behavior—she more than loves him, she admires him, as though his mercurial nature, his temper, his massive dreams and little cruelties, served her only as sharp reminders of the turbulent longings within him, longings which she shares but lacks the temperament to utter and follow to their end.*]

LINDA: [*hearing Willy outside the bedroom, calls with some trepidation*[56]] Willy!

WILLY: It's all right. I came back.

LINDA: Why? What happened? [*slight pause.*] Did something happen, Willy?

WILLY: No, nothing happened.

LINDA: You didn't smash the car, did you?

WILLY: [*with casual irritation*] I said nothing happened. Didn't you hear me?

LINDA: Don't you feel well?

WILLY: I'm tired to the death. [*The flute has faded away. He sits on the bed beside her, a little numb*[57].] I couldn't make it. I just couldn't make it, Linda.

LINDA: [*very carefully, delicately*] Where were you all day? You look terrible.

WILLY: I got as far as a little above Yonkers. I stopped for a cup of coffee. Maybe it was the coffee.

LINDA: What?

WILLY: [*after a pause*] I suddenly couldn't drive any more. The car kept going off onto the shoulder,

55. jovial: *n.* 天性快活的

56. trepidation: *n.* 忧虑

57. numb: *a.* 呆滞的

y'know?[58]

LINDA: [*helpfully*] Oh. Maybe it was the steering again. I don't think Angelo knows the *Studebaker*[59].

WILLY: No, it's me, it's me. Suddenly I realize I'm goin' sixty miles an hour and I don't remember the last five minutes. I'm—I can't seem to—keep my mind to it.

LINDA: Maybe it's your glasses. You never went for your new glasses.

WILLY: No, I see everything. I came back ten miles an hour. It took me nearly four hours from Yonkers.

LINDA: [*resigned*[60]] Well, you'll just have to take a rest, Willy, you can't continue this way.

WILLY: I just got back from Florida.

LINDA: But you didn't rest your mind. Your mind is overactive, and the mind is what counts, dear.

WILLY: I'll start out in the morning. Maybe I'll feel better in the morning. [*She is taking off his shoes.*] These goddam arch supports[61] are killing me.

LINDA: Take an aspirin. Should I get you an aspirin? It'll soothe you.

WILLY: [*with wonder*] I was driving along, you understand? And I was fine. I was even observing the scenery. You can imagine, me looking at scenery, on the road every week of my life. But it's so beautiful up there, Linda, the trees are so thick, and the sun is warm. I

58. y'know?: "you know" 的缩写

59. Studebaker: *n.* 史蒂倍克牌汽车

60. resigned: *a.* 顺从的

61. arch supports: 足弓垫

opened the windshield and just let the warm air bathe over me. And then all of a sudden I'm goin' off the road! I'm tellin' ya, I absolutely forgot I was driving. If I'd've gone the other way over the white line I might've killed somebody. So I went on again—and five minutes later I'm dreamin' again, and I nearly ... [*He presses two fingers against his eyes.*] I have such thoughts, I have such strange thoughts.

LINDA: Willy, dear. Talk to them again. There's no reason why you can't work in New York.

WILLY: They don't need me in New York. I'm the New England man. I'm vital in New England.

LINDA: But you're sixty years old. They can't expect you to keep travelling every week.

WILLY: I'll have to *send a wire*[62] to Portland. I'm supposed to see Brown and Morrison tomorrow morning at ten o'clock to show the line. Goddammit, I could sell them! [*He starts putting on his jacket.*]

LINDA: [*taking the jacket from him*] Why don't you go down to the place tomorrow and tell Howard you've simply got to work in New York? You're too accommodating, dear.

WILLY: If old man Wagner was alive I'd been in charge of New York now! That man was a prince, he was a masterful man. But that boy of his, that Howard, *he don't appreciate*[63]. When I went north the first time, the Wagner Company

62. send a wire: 打电报

63. ...he don't appreciate: 口语非正式表达"他不懂行"

didn't know where New England was!

LINDA: Why don't you tell those things to Howard, dear?

WILLY: [encouraged] I will, I definitely will. Is there any cheese?

LINDA: I'll make you a sandwich.

WILLY: No, go to sleep. I'll take some milk. I'll be up right away. The boys in?

LINDA: They're sleeping. Happy took Biff on a date tonight.

WILLY: [interested] That so?

LINDA: It was so nice to see them shaving together, one behind the other, in the bathroom. And going out together. You notice? The whole house smells of shaving lotion.

WILLY: Figure it out. Work a lifetime to pay off a house. You finally own it, and there's nobody to live in it.

LINDA: Well, dear, *life is a casting off*[64]. It's always that way.

WILLY: No, no, some people—some people accomplish something. Did Biff say anything after I went this morning?

LINDA: You shouldn't have criticized him, Willy, especially after he just got off the train. You mustn't lose your temper with him.

WILLY: When the hell did I lose my temper? I simply asked him if he was making any money. Is that a criticism?

LINDA: But, dear, how could he make any money?

64. 人生就是一场空忙。

WILLY: [*worried and angered*] There's such an undercurrent in him. He became a moody man. Did he apologize when I left this morning?

LINDA: He was *crestfallen*[65], Willy. You know how he admires you. I think if he finds himself, then you'll both be happier and not fight any more.

WILLY: How can he find himself on a farm? Is that a life? A farm-hand? In the beginning, when he was young, I thought, well, a young man, it's good for him to tramp around, take a lot of different jobs. But it's more than ten years now and he has yet to make thirty-five dollars a week!

LINDA: He's finding himself, Willy.

WILLY: Not finding yourself at the age of thirty-four is a disgrace!

LINDA: Shh!

WILLY: The trouble is he's lazy, goddammit!

LINDA: Willy, please!

WILLY: Biff is *a lazy bum*[66]!

LINDA: They're sleeping. Get something to eat. Go on down.

WILLY: Why did he come home? I would like to know what brought him home.

LINDA: I don't know. I think he's still lost, Willy. I think he's very lost.

WILLY: Biff Loman is lost. In the greatest country in the world a young man with such—personal attractiveness, gets lost. And such a hard

65. crestfallen: *a.* 垂头丧气的

66. a lazy bum: 懒虫

worker. There's one thing about Biff—he's not lazy.

LINDA: Never.

WILLY: [*with pity and resolve*] I'll see him in the morning; I'll have a nice talk with him. I'll get him a job selling. He could be big in no time. My God! Remember how they used to follow him around in high school? When he smiled at one of them their faces lit up. When he walked down the street… [*He loses himself in reminiscences[67].*]

LINDA: [*trying to bring him out of it*] Willy, dear, I got a new kind of American-type cheese today. It's whipped.

WILLY: Why do you get American when I like Swiss?

LINDA: I just thought you'd like a change…

WILLY: I don't want a change! I want Swiss cheese. Why am I always being contradicted?

LINDA: [*with a covering laugh*] I thought it would be a surprise.

WILLY: Why don't you open a window in here, for God's sake?

LINDA: [*with infinite patience*] They're all open, dear.

WILLY: The way they boxed us in here. Bricks and windows, windows and bricks.

LINDA: We should've bought the land next door.

WILLY: The street is lined with cars. There's not a breath of fresh air in the neighborhood. The grass don't grow any more, you can't raise a carrot in the back yard. They should've had a

67. reminiscence: *n.* 回忆

law against apartment houses. Remember those two beautiful elm trees out there? When I and Biff hung the swing between them?

LINDA: Yeah, like being a million miles from the city.

WILLY: They should've arrested the builder for cutting those down. They massacred the neighbourhood. [*lost*] More and more I think of those days, Linda. This time of year it was lilac and wisteria. And then the peonies would come out, and the daffodils. What fragrance in this room!

LINDA: Well, after all, people had to move somewhere.

WILLY: No, there's more people now.

LINDA: I don't think there's more people. I think—

WILLY: There's more people! That's what's ruining this country! Population is getting out of control. The competition is *maddening*[68]! Smell the stink from that apartment house! And another one on the other side... How can they whip cheese?

[*On Willy's last line, Biff and Happy raise themselves up in their beds, listening.*]

LINDA: Go down, try it. And be quiet.

WILLY: [*turning to Linda, guiltily*] You're not worried about me, are you, sweetheart?

BIFF: What's the matter?

HAPPY: Listen!

LINDA: You've got too much *on the ball*[69] to worry about.

WILLY: You're my foundation and my support, Linda.

68. maddening: *a.* 令人恼火的

69. on the ball: 勤奋(此处指操心过度)

LINDA: Just try to relax, dear. *You make mountains out of molehills.*[70]

WILLY: I won't fight with him any more. If he wants to go back to Texas, let him go.

LINDA: He'll find his way.

WILLY: Sure. Certain men just don't get started till later in life. Like Thomas Edison, I think. Or B. F. Goodrich. One of them was deaf. [*He starts for the bedroom doorway.*] I'll put my money on Biff.

LINDA: And Willy—if it's warm Sunday we'll drive in the country. And we'll open the windshield, and take lunch.

WILLY: No, the windshields don't open on the new cars.

LINDA: But you opened it today.

WILLY: Me? I didn't. [*He stops.*] Now isn't that peculiar! Isn't that a remarkable... [*He breaks off in amazement and fright as the flute is heard distantly.*]

LINDA: What, darling?

WILLY: That is the most remarkable thing.

LINDA: What, dear?

WILLY: I was thinking of the Chevy. [*slight pause*] Nineteen twenty-eight ... when I had that red Chevy... [*Breaks off*] That funny? I *coulda*[71] sworn I was driving that Chevy today.

LINDA: Well, that's nothing. Something must've reminded you.

WILLY: Remarkable. *Ts.*[72] Remember those days? The

70. You make mountains out of molehills: 你也未免太大惊小怪了。

71. coulda = could have

72. Ts: 活见鬼。

way Biff used to *simonize*[73] that car? The dealer refused to believe there was eighty thousand miles on it. [*He shakes his head.*] Heh! [*to Linda*] Close your eyes, I'll be right up. [*He walks out of the bedroom.*]

HAPPY: [*to Biff*] Jesus, maybe he smashed up the car again!

LINDA: [*calling after Willy*] Be careful on the stairs, dear! The cheese is on the middle shelf. [*She turns, goes over to the bed, takes his jacket, and goes out of the bedroom.*]

[*Light has risen on the boys' room. Unseen, Willy is heard talking to himself, "Eighty thousand miles," and a little laugh. Biff gets out of bed, comes downstage a bit, and stands attentively. Biff is two years older than his brother Happy, well built, but in these days bears a worn air and seems less self-assured. He has succeeded less, and his dreams are stronger and less acceptable than Happy's. Happy is tall, powerfully made. Sexuality is like a visible color on him, or a scent that many women have discovered.[74] He, like his brother, is lost, but in a different way, for he has never allowed himself to turn his face toward defeat and is thus more confused and hard-skinned, although seemingly more content.*]

HAPPY: [*getting out of bed*] He's going to get his license taken away if he keeps that up. I'm getting nervous about him, y'know, Biff?

BIFF: His eyes are going.

HAPPY: I've driven with him. He sees all right. He just doesn't keep his mind on it. I drove into the city with him last week. He stops at a green

73. simonize: *v.* 打蜡

74. 充满性欲是他的特色,或者说,是许多女人在他身上所发现的一种气质。

light and then it turns red and he goes. [*He laughs.*]

BIFF: Maybe he's color-blind.

HAPPY: Pop? Why he's got the finest eye for color in the business. You know that.

BIFF: [*sitting down on his bed*] I'm going to sleep.

HAPPY: You're not still sour on Dad, are you, Biff?

BIFF: He's all right, I guess.

WILLY: [*underneath them, in the living room*] Yes, sir, eighty thousand miles—eighty-two thousand!

BIFF: You smoking?

HAPPY: [*holding out a pack of cigarettes*] Want one?

BIFF: [*taking a cigarette*] I can never sleep when I smell it.

WILLY: What a simonizing job, heh?

HAPPY: [*with deep sentiment*] Funny, Biff, y'know? Us sleeping in here again? The old beds. [*He pats his bed affectionately.*] All the talk that went across those two beds, huh? Our whole lives.

BIFF: Yeah. Lotta dreams and plans.

HAPPY: [*with a deep and masculine laugh*] About five hundred women would like to know what was said in this room. [*They share a soft laugh.*]

BIFF: Remember that big Betsy something—what the hell was her name—over on Bushwick Avenue?

HAPPY: [*combing his hair*] With the collie[75] dog!

BIFF: That's the one. I got you in there, remember?

HAPPY: Yeah, that was my first time—I think. *Boy,*

75. collie: *n.* 柯利犬

	there was a pig.⁷⁶ [*They laugh, almost crudely.*] You taught me everything I know about women. Don't forget that.	76. Boy, there was a pig:天啊,当年我真是一头猪。
BIFF:	I bet you forgot how *bashful*⁷⁷ you used to be. Especially with girls.	77. bashful: *a.* 害羞的
HAPPY:	Oh, I still am, Biff.	
BIFF:	Oh, go on.	
HAPPY:	I just control it, that's all. I think I got less bashful and you got more so. What happened, Biff? Where's the old humor, the old confidence? [*He shakes Biff's knee. Biff gets up and moves restlessly about the room.*] What's the matter?	
BIFF:	Why does Dad mock me all the time?	
HAPPY:	He's not mocking you, he…	
BIFF:	Everything I say *there's a twist of mockery on his face*⁷⁸. I can't get near him.	78. ……他脸上总带着嘲笑的味儿。
HAPPY:	He just wants you to make good, that's all. I wanted to talk to you about Dad for a long time, Biff. Something's—happening to him. He—talks to himself.	
BIFF:	I noticed that this morning. But he always *mumbled*⁷⁹.	79. mumble: *v.* 含糊地说
HAPPY:	But not so noticeable. It got so embarrassing I sent him to Florida. And you know something? Most of the time he's talking to you.	
BIFF:	What's he say about me?	
HAPPY:	I can't make it out.	
BIFF:	What's he say about me?	

HAPPY: I think the fact that you're not settled, that you're still kind of up in the air...

BIFF: There's one or two other things depressing him, Happy.

HAPPY: What do you mean?

BIFF: Never mind. Just don't lay it all to me.

HAPPY: But I think if you just got started—I mean—is there any future for you out there?

BIFF: I tell ya, Hap, I don't know what the future is. I don't know—what I'm supposed to want.

HAPPY: What do you mean?

BIFF: Well, I spent six or seven years after high school trying to work myself up. Shipping clerk, salesman, business of one kind or another. *And it's a measly manner of existence.*[80] To get on that subway on the hot mornings in summer. To devote your whole life to keeping stock, or making phone calls, or selling or buying. To suffer fifty weeks of the year for the sake of a two-week vacation, when all you really desire is to be outdoors, with your shirt off. And always to have to get ahead of the next fella. And still—that's how you build a future.

HAPPY: Well, you really enjoy it on a farm? Are you content out there?

BIFF: [*with rising agitation*] Hap, I've had twenty or thirty different kinds of jobs since I left home before the war, and it always turns out the

80. And it's a measly manner of existence: 过着低三下四的生活。

same. I just realized it lately. In Nebraska when I herded cattle, and the Dakotas, and Arizona, and now in Texas. It's why I came home now, I guess, because I realized it. This farm I work on, it's spring there now, see? And they've got about fifteen new colts[81]. There's nothing more inspiring or—beautiful than the sight of a mare and a new colt. And it's cool there now, see? Texas is cool now, and it's spring. And whenever spring comes to where I am, I suddenly get the feeling, my God, I'm not gettin' anywhere! What the hell am I doing, playing around with horses, twenty-eight dollars a week! I'm thirty-four years old, I oughta be makin' my future. That's when I come running home. And now, I get here, and I don't know what to do with myself. [*After a pause.*] I've always made a point of not wasting my life, and every time I come back here I know that all I've done is to waste my life.

HAPPY: You're a poet, you know that, Biff? You're a—you're an idealist!

BIFF: No, I'm mixed up very bad. Maybe I oughta get married. Maybe I oughta get stuck into something. Maybe that's my trouble. I'm like a boy. I'm not married, I'm not in business, I just—I'm like a boy. Are you content, Hap? You're a success, aren't you? Are you content?

81. colt: *n.* 小马

HAPPY: Hell, no!

BIFF: Why? You're making money, aren't you?

HAPPY: [*moving about with energy, expressiveness*] All I can do now is wait for the merchandise manager to die. And suppose I get to be merchandise manager? He's a good friend of mine, and he just built a terrific estate on Long Island. And he lived there about two months and sold it, and now he's building an-other one. He can't enjoy it once it's finished. And I know that's just what I would do. I don't know what the hell I'm workin' for. Sometimes I sit in my apartment—all alone. And I think of the rent I'm paying. And it's crazy. But then, it's what I always wanted. My own apartment, a car, and plenty of women. And still, goddammit, I'm lonely.

BIFF: [*with enthusiasm*] Listen, why don't you come out West with me?

HAPPY: You and I, heh?

BIFF: Sure, maybe we could buy a ranch. Raise cattle, use our muscles. Men built like we are should be working out in the open.

HAPPY: [*avidly*[82]] The Loman Brothers, heh?

BIFF: [*with vast affection*] Sure, we'd be known all over the counties!

HAPPY: [*enthralled*[83]] That's what I dream about, Biff. Sometimes I want to just rip my clothes off in the middle of the store and outbox that goddam merchandise manager. I mean I can

82. avidly: *ad.* 热诚地

83. enthralled: *a.* 着迷的

outbox, outrun, and outlift anybody in that store, and I have to take orders from those common, petty sons-of-bitches till I can't stand it any more.

BIFF: I'm tellin' you, kid, if you were with me I'd be happy out there.

HAPPY: [*enthused*[84]] See, Biff, everybody around me is so false that I'm constantly lowering my ideals…

BIFF: Baby, together we'd stand up for one another, we'd have someone to trust.

HAPPY: If I were around you…

BIFF: Hap, the trouble is we weren't brought up to *grub for money*[85]. I don't know how to do it.

HAPPY: Neither can I!

BIFF: Then let's go!

HAPPY: The only thing is—what can you make out there?

BIFF: But look at your friend. Builds an estate and then hasn't the peace of mind to live in it.

HAPPY: Yeah, but when he walks into the store the waves part in front of him. That's fifty-two thousand dollars a year coming through the revolving door, and I got more in my pinky finger than he's got in his head.

BIFF: Yeah, but you just said…

HAPPY: I gotta show some of those *pompous*[86], self-important executives over there that Hap Loman can make the grade. I want to walk into the store the way he walks in. Then I'll

84. enthused: *a.* 热情的

85. grub for money: 捞钱

86. pompous: *a.* 自大的

go with you, Biff. We'll be together yet, I swear. But take those two we had tonight. Now weren't they gorgeous creatures?

BIFF: Yeah, yeah, most gorgeous I've had in years.

HAPPY: I get that any time I want, Biff. Whenever I feel disgusted. The only trouble is, it gets like bowling or something. I just keep knockin' them over and it doesn't mean anything. You still run around a lot?

BIFF: Naa. I'd like to find a girl—steady, somebody with substance.

HAPPY: That's what I long for.

BIFF: Go on! You'd never come home.

HAPPY: I would! Somebody with character, with resistance! Like Mom, y'know? You're gonna call me a bastard when I tell you this. That girl Charlotte I was with tonight is engaged to be married in five weeks. [*He tries on his new hat.*]

BIFF: No kiddin'!

HAPPY: Sure, the guy's in line for the vice-presidency of the store. I don't know what gets into me, maybe I just have an overdeveloped sense of competition or something, but I went and ruined her, and furthermore I can't get rid of her. And he's the third executive I've done that to. Isn't that a *crummy*[87] characteristic? And to top it all, I go to their weddings! [*indignantly, but laughing*] Like I'm not supposed to take bribes. Manufacturers offer

87. crummy: *a.* 肮脏的

me a hundred-dollar bill now and then to throw an order their way. You know how honest I am, but it's like this girl, see. I hate myself for it. Because I don't want the girl, and still, I take it and—I love it!

BIFF: Let's go to sleep.

HAPPY: I guess we didn't settle anything, heh?

BIFF: I just got one idea that I think I'm going to try.

HAPPY: What's that?

BIFF: Remember Bill Oliver?

HAPPY: Sure, Oliver is very big now. You want to work for him again?

BIFF: No, but when I quit he said something to me. He put his arm on my shoulder, and he said, "Biff, if you ever need anything, come to me."

HAPPY: I remember that. That sounds good.

BIFF: I think I'll go to see him. If I could get ten thousand or even seven or eight thousand dollars I could buy a beautiful ranch.

HAPPY: I bet he'd back you. Cause he thought highly of you, Biff. I mean, they all do. You're well liked, Biff. That's why I say to come back here, and we both have the apartment. And I'm tellin' you, Biff, any babe you want…

BIFF: No, with a ranch I could do the work I like and still be something. I just wonder though. I wonder if Oliver still thinks I stole that carton

of basketballs.

HAPPY: Oh, he probably forgot that long ago. It's almost ten years. You're too sensitive. Anyway, he didn't really fire you.

BIFF: Well, I think he was going to. I think that's why I quit. I was never sure whether he knew or not. I know he thought the world of me, though. I was the only one he'd let lock up the place.

WILLY: [below] You gonna wash the engine, Biff?

HAPPY: Shh!

[Biff looks at Happy, who is gazing down, listening. Willy is mumbling in the parlor.]

HAPPY: You hear that? [They listen. Willy laughs warmly.]

BIFF: [growing angry] Doesn't he know Mom can hear that?

WILLY: Don't get your sweater dirty, Biff! [A look of pain crosses Biffs face.]

HAPPY: Isn't that terrible? Don't leave again, will you? You'll find a job here. You gotta stick around. I don't know what to do about him, it's getting embarrassing.

WILLY: What a simonizing job!

BIFF: Mom's hearing that!

WILLY: No kiddin', Biff, you got a date? Wonderful!

HAPPY: Go on to sleep. But talk to him in the morning, will you?

BIFF: [reluctantly getting into bed] With her in the house. Brother!

HAPPY: [*getting into bed*] I wish you'd have a good talk with him.

[*The light of their room begins to fade.*]

BIFF: [*to himself in bed*] That selfish, stupid...

HAPPY: Sh... Sleep, Biff.

[*Their light is out. Well before they have finished speaking, Willy's form is dimly seen below in the darkened kitchen. He opens the refrigerator, searches in there, and takes out a bottle of milk. The apartment houses are fading out, and the entire house and surroundings become covered with leaves. Music insinuates itself as the leaves appear.*]

WILLY: Just wanna be careful with those girls, Biff, that's all. Don't make any promises. No promises of any kind. Because a girl, y'know, they always believe what you tell'em, and you're very young, Biff, you're too young to be talking seriously to girls.

[*Light rises on the kitchen. Willy, talking, shuts the refrigerator door and comes downstage to the kitchen table. He pours milk into a glass. He is totally immersed in himself, smiling faintly.*]

...

Assignment

Ⅰ. Review what you've learned from this chapter and complete the following note-taking with related information.

Facts of Miller's Childhood	
Facts of Miller's Career and Marriage	

Ⅱ. Share your opinion of Willy Loman and his expectation on his sons.

Reason of Miller's Writing of *the Crucible* and *All My Sons*	
Masterpieces of Arthur Miller	

Further Reading

Plot Summary of *Death of a Salesman*

Willy Loman returns home exhausted after a canceled business trip. Worried over Willy's state of mind and recent car accident, his wife Linda suggests that he asks his boss Howard Wagner to allow him to work in his home city so he will not have to travel. Willy complains to Linda that their son, Biff, has yet to make good on his life. Despite Biff's promising showing as an athlete in high school, he flunked senior-year math and never went to college.

Biff and his brother Happy, who is temporarily staying with Willy and Linda after Biff's unexpected return from the West, reminisce (回忆) about their childhood together. They discuss their father's mental degeneration (退化), which they have witnessed in the form of his constant indecisiveness (优柔寡断) and schizophrenic (精神分裂症的) daydreaming about the boys' high school years. Willy walks in, angry that the two boys have never amounted to anything. In an effort to pacify (宽慰) their father, Biff and Happy tell their father that Biff plans to make a business proposition the next day.

The next day, Willy goes to ask his boss, Howard, for a job in town while Biff goes to make a business proposition, but both fail. Willy gets angry and ends up getting fired when the boss tells him he needs a rest and can no longer represent the company. Biff waits hours to see a former employer who does not remember him and turns him down. Biff impulsively steals a fountain pen (钢笔). Willy then goes to the office of his neighbor Charley, where he runs into Charley's son Bernard (now a successful lawyer); Bernard tells him that Biff originally wanted to

do well in summer school, but something happened in Boston when Biff went to visit his father that changed his mind.

Happy, Biff, and Willy meet for dinner at a restaurant, but Willy refuses to hear bad news from Biff. Happy tries to get Biff to lie to their father. Biff tries to tell him what happened as Willy gets angry and slips into a flashback of what happened in Boston the day Biff came to see him. Willy had been having an affair with a receptionist on one of his sales trips when Biff unexpectedly arrived at Willy's hotel room. A shocked Biff angrily confronted his father, calling him a liar and a fraud(骗子). From that moment, Biff's views of his father changed and set Biff adrift(走上歧路).

Biff leaves the restaurant in frustration, followed by Happy and two girls that Happy has picked up. They leave a confused and upset Willy behind in the restaurant. When they later return home, their mother angrily confronts them for abandoning their father while Willy remains outside, talking to himself. Biff tries unsuccessfully to reconcile (和解) with Willy, but the discussion quickly escalates (演变为) into another argument. Biff conveys plainly to his father that he is not meant for anything great, insisting that both of them are simply ordinary men meant to lead ordinary lives. The feud (争执) reaches an apparent climax with Biff hugging Willy and crying as he tries to get Willy to let go of the unrealistic expectations. Rather than listen to what Biff actually says, Willy appears to believe his son has forgiven him, and after Linda goes upstairs to bed, (despite her urging him to follow her), lapses(陷入回忆) one final time into a memory of Biff's football career before exiting the house. Biff and Linda cry out in despair as the sound of Willy's car blares up and fades out.

The final scene takes place at Willy's funeral, which is attended only by his family, Bernard, and Charley. At the funeral Biff retains his belief that he does not want to become a businessman like his father. Happy, on the other hand, chooses to follow in his father's footsteps, while Linda laments (痛惜) her husband's decision just before her final payment on the house…: "…and there'll be nobody home. We're free and clear, Willy… we're free…we're free…"

Chapter Seven

How to Be a Good Actor or Actress

Actor

An actor is someone who acts on stage, television, radio or films. In essence, the actor's involvement in a stage performance consists of three stages: the audition, the rehearsal and the performance. The audition is the way the actor gets a role, the rehearsal is the way the actor learns it, and the performance is the way the actor produces it on stage.

How to Be a Good Actor or Actress

Step one

Read the entire script 2-3 times. You need to know the entire play/movie or episode well, not just your character. Actors exist to drive forward the larger theme and plot of a movie, play or TV show. If you don't understand the larger themes and ideas of the script, then your performance will seem out of place. When reading the script, ask yourself what the main theme of the work is. How does your character fit into the story? Once you've got a grasp on the full story, turn to your parts and read them an extra 1-2 times. Now, focus on your character's role and lines.

Step two

Ask and answer several key questions about your character.

Notes:

Who am I?

Where am I from?

Why am I here?

To really get into your character, *you need to dive past what is on the page*[1] and *start thinking about what makes your character tick*[2]. All of this might not make it to the screen/stage, but these little facts will help you fully portray the character and can lead to important discoveries about how you'll play the role. When coming up with "answers", trust your *gut*[3], or ask the director or writer for help.

Step three

Know your character's defining desire. All characters, in almost all stories, want something. This is the basis of plot. The desire can be to save the world, to get a date, or simply to grab a bite to eat. But you need to know this desire, and why your character has it, in order to accurately portray them. All of your character's actions will *stem*[4] in some way from this desire. It is what drives and fuels them. A character's desires can change, and you need to note when this happens. It is almost always a major scene or moment to portray. As an exercise, try and pick out the desires of your favorite characters/actors. In *There Will Be Blood*[5], for example, the main character is completely driven by the need to find more oil. Every action, look, and emotion springs from this unending, passionate greed, and you can see it on *Daniel Day-Lewis's*[6] face each scene.

Step four

Practice your lines until they become second

1. 跳过文字的内容
2. 开始思考如何使角色发挥作用
3. gut: n. 直觉
4. stem: v. 源于
5. 《血色将至》
6. Daniel Day-Lewis: 丹尼尔·戴·刘易斯, 英美著名演员

nature. You shouldn't ever have to stop and think about what you're about to say. You should be more concerned with how you're saying it. The only way to get to this point is to practice your lines over and over again, doing your best to recite them without consulting the script. Get a friend to play the rest of the parts so that you can realistically *bounce the conversation back and forth*.[7] Experiment with the lines as you read. Try them multiple ways, with different *inflections*[8] or emphasis, and see how it affects your character. Recording yourself and watching it later can help you see small mistakes, or hear new ways to deliver the lines.

Focus on getting the lines down first before worrying about perfecting the lines. You want to be able to recite the words now, then make them perfect later.

Step five

Talk to the director about their vision for the character. If you've already got the role, sit down with the director to see if there is any specific direction they want to go with things. Briefly let them know your ideas about the character and how you see them contributing to the themes in the project, then listen to their ideas as well. Remember that you are there to serve the project as a whole, not just yourself. You need to be able to take constructive criticism and ideas gracefully.

If you don't have the role yet, and are going to an audition, pick a direction for the character and stick with it. Don't try and give people what they want to hear. Instead, read the notes and prepare the lines in the way that feels natural to you.

7. 来来回回地练对话

8. inflection: *n.* 音调变化

Step six

Put yourself in the shoes of your character. You cannot adequately represent a character unless you can get inside their head. Even though your words are scripted out, your actions and blocking aren't always written in stone. In addition, knowing your character well will help you *improvise*[9] in case someone forgets his lines. Preparing for a role is the process of getting into your character's head, embodying them the best you can.

Method acting is when an actor refuses to break character on set. In *between takes*[10], they stay in the role, trying to *fully inhabit the character*[11] so that they are always perfect when playing the role on camera.

Find the parts of the role that *ring true*[12] for you. Have you felt the sorts of emotions your character is going through? Do you know a little bit about the struggle? Find ways to channel your emotions into your character's lines for the best results.

How to Do a Rehearsal

During the rehearsal period the actor learns the role and investigates, among other things, the character's biography; the subtext of the play; the character's thoughts, fears, and fantasies; the character's objectives; and the world *envisioned*[13] in the play by the playwright. The director will lead discussions, offer opinions, and *issue directives*[14].

Externally, rehearsal is a time for the actor to experiment with timing and delivery of lines and

9. improvise: v. 即兴发挥

10. between takes: 场间休息
11. 完全沉浸在角色中

12. 听上去很真实

13. envision: v. 想象

14. 发出指令

movements. It is a time to suggest movement possibilities to the director and to work out details of complicated sequences with the other actors. It is also a time to "get secure" in both lines and movements by constant repetition. And it affords an opportunity to explore all the possibilities of the role—to look for ways to improve actor's original plan for its realization and to test various possibilities with the director.

Below are given some key elements in the rehearsal phase for beginner actors.

Rehearsal etiquette

Even if you were beginner actors, you should be professional in the best sense of the word. Be punctual. Respect each other's valuable time. Never tell each other what to do or what not to do. It's the director's job, not yours. And come prepared to each rehearsal and don't expect others to do your work for you.

Vocabulary preparation

Because you are performing in a foreign language, it's very important to look up unfamiliar words before coming to rehearsals and try your best to get the pronunciation correct. Rehearsals should be about better creating characters, and not correcting pronunciation mistakes.

Director's note and actor's note-taking

During rehearsal, the director will give "notes" to the cast. Sometimes the notes are about individual actors, sometimes they are about the collective group. Listen carefully to the notes that concern you and take them on board. Do not argue with the director (particularly

not in front of the whole cast) and think you know your character better. Remember, the director is speaking from the perspective of the whole play. If you really think the director has a flawed perspective, go find him or her afterwards and explain your points politely.

And it's very important to have a pencil (with an eraser attached to it) in hand. You can mark down directions from the director, particularly entrances, exits and moves. You can also mark down mistakes you have made, or things you want to pay attention to.

<u>Cues</u>

One of the most important aspects to acting is listening. First of all, you should listen, in rehearsal as well as stage performance, to your "cues", which tells you when you are supposed to speak or move.

Cures might be:

Lines spoken by your fellow actors, e. g. "Come here."

An actor's movement, e. g. your fellow actor moves downstage.

A sound or music effect, e. g. a gunshot.

A lighting change or visual effect, e. g. light changes from white to red.

However, you should not just listen for your cues, but also what is being said and how it is being said by your fellow actors. There might be subtle changes in the way and actor says his or her lines in different performances and you must act/react accordingly. You always need to co-operate with fellow actors to make a scene work. Even when you are doing a one-man

show, you still need to establish your character through his reaction to sights or sounds on stage.

Another thing that makes attentive listening absolutely necessary is that many times actors make mistakes on stage: the cue might be missed, or an actor might unknowingly skip lines. You will have to react to those mistakes and find a way to save the scene.

Run-through[15]

Run-through usually happen early in the production process. Typically, a run-through does not contain many of the technical aspects of a performance, and is primarily used to assist performers in learning dialogue and to *solidify*[16] aspects of *blocking*[17].

Technical rehearsal

The technical rehearsal, or "tech" (as it is colloquially known) takes place when the set is complete, all the doors and windows and furniture in place, and when lighting and sound effects are introduced. It is something most actors hate because it is often repetitive and tedious. But it's indispensable, because by fully testing out all the technology being used, it diagnoses and prevents mistakes from occurring during the actual performance, and also enables the actors to find out whether exits and entrances work as expected, how long it takes to walk to the telephone, or whether the time allowed for costume change is long enough etc. Actors should report the problems to the stage manager, who will try to solve the problems.

Dress rehearsal

The dress rehearsal is usually the final run-through

15. run-through: *n.* 排练

16. solidify: *v.* 巩固
17. blocking: *n.* 舞台调度

of the whole play. Everything is done as if it were formal performance. All the technical elements are in operation, and the actor would wear the costume and make-up. The entire performance will be run from beginning to end, exactly as the real performances will be, including pauses for intermissions. It is the last chance for actors to check out problems before the opening night.

How to Prepare for Performance

Amazing things might happen to actors when rehearsal shifts into performance. The actor who has been brilliant in rehearsal can *crumble*[18] before an audience and completely *lose the "edge" of*[19] his performance. However, sudden and dramatic change is not the norm: most actors cross over from final dress rehearsal to opening night with only the slightest shift and as a rule they become better on the second and third nights. Below are given some key elements that beginner actors should be aware of.

Before performance

▶▶ Arrival at the theatre

In professional productions the stage manager would usually *designate*[20] a time by which actors should arrive at the theater. This principle should also apply to student performances. No actor should arrive later than half an hour before *curtain-up*[21]. For those actors who have complicated make-up or layers of costume to get into should arrive earlier accordingly.

18. crumble: *v.* 崩溃
19. lose the edge of: 失去优势
20. designate: *v.* 指定
21. curtain-up: *n.* 启幕

▶▶ Check *costume*, *pros and set*[22]

The very first thing an actor should do upon arrival is to check whether the costume is present and complete, if not, contact members of the wardrobe team immediately.

Actors should then check that all their props are in place, if not, contact members of the props team immediately.

Last but not least, it's wise to re-familiarize yourself with the set before audience are allowed into the auditorium, and check that everything is where it ought to be. If possible, you might even try walking around and very quickly go through your lines.

Preparing for performance

▶▶ Relax

First of all, remember it's perfectly natural to feel nervous before a performance. Practically everyone feels nervous, especially on the opening night, including veteran actors. Lawrence Olivier, one of the greatest actors of the 20th century, sometimes had to be pushed onstage by the stage manager; actress Meryl Streep, who won two Academy Awards and 13 Oscar nominations, says she still "suffers from stage fright".

We all know from our own experiences in life that often times the more you want to stop thinking about something, the more it *pops up*[23] in your mind. There is practically no recipe for nerves and actors have to learn to cope with it in their own way. However, it may be helpful to remember what *Yu Shizhi* (于是之), one of the most famous Chinese actors, used to tell himself

22. 服装、道具和布景

23. pop up: 浮现

before a performance on stage: "play as bad as you can, play as bad as you can." If you can really play as bad as you can and hereby dropping your self-consciousness, you might actually end up finding you've conquered your nerves.

▶▶ Warm-up

Physical and vocal warm-ups are highly recommended because they will help you relax and take your mind off to think about something else.

The physical warm-up should take no more than ten minutes. Find a space to do the warm-up either on your own or with fellow actors. The warm-up should, as if you were preparing to play sport or go jogging, be a series of stretching and shaking exercises which will relieve any tension in your muscles and get the blood flowing about your body.

The vocal warm-up should include the breathing exercises you do at home, a facial stretching exercise such as *an over-the-top chewing action*[24], and perhaps a couple of tongue-twisters.

24. 夸张的咀嚼动作

▶▶ Beginner's call

In professional productions there will be a countdown from about 30 minutes before curtain-up, with the stage-manager—that it is 30 minutes, 20 minutes, 10 minutes and 5 minutes to the start of the show. Finally, "beginners please" will be announced and at that point all the actors in the opening scene need to take their positions ready for the play to begin. Also, many well-equipped theaters have a feedback microphone that broadcast the play via loudspeaker in the dressing

room which enables the actors in subsequent scenes to follow up what is going on onstage. While most student groups don't have these practices or facilities, it's important for student actors to remember it is the actor's responsibility to be in position, not just for the start of the play but for all subsequent entrances throughout the performance.

On Stage

Emergencies

Below are some common events that might happen on stage and how the actors should react.

Distractions—Sometimes in the process of the performance, you will hear cellphone ringing or see camera flashing (which unfortunately is the case in many theaters. Just carry on the best you can).

Drying—This is when an actor forgets his lines. In such circumstances it is important to maintain the momentum of the scene. If you realize you have forgotten, you should ask quickly for a *prompt*[25] and carry on. If one of your fellow actors forgets, you should try and help them out.

Laughter—Never speak through audience laughter but say your line as the laughter is dying down. Never wait for excepted laughter as there is no guarantee it will come. The actual case is: the audience sometimes will laugh at the unexpected moments.

Applause—On occasion audiences might applaud an actor or a scene. As with laughter, wait for the applause

25. prompt: *n.* 提白

to subside before speaking your next line.

Missing prop—This would be a nightmare in performance—in a student production of *Romeo and Juliet*, Romeo forgot to bring the dagger, with which Juliet is supposed to kill herself, and the actress playing Juliet had to alter her lines and pretend to drink from the bottle Romeo left. So, actors, double-check your pros before performance.

Script jump—This is when an actor takes the wrong cue line and leaps several pages in the story. You will have to find a way to get things back on track. The most common practice is to pretend nothing happened and say your immediate next line.

Curtain call[26]

There are many different ways to do curtain call. Blow is one common practice.

Step One: Bring the ensemble cast out onto stage for group bows. If it is a large production, bring them out in two or three groups both from right or left stage, coming center and moving downstage for group bows.

Step Two: Present the supporting roles from right and left stage. They come center stage and move quickly where they take center downstage and bow to the audience.

Step Three: Have the lead actors enter from right and left center stage. Each actor, by themselves, move quickly down center stage, singly take a bow, applause from the audience and move either to the right or left of the stage, making room for the next lead to come down stage and take his single bow. Continue until all *leads*[27]

26. curtain call: 演员谢幕

27. lead: *n.* 主演

have done their individual bows.

Step Four: Take a moment to have the whole cast bow together for one final applause. Keep smiling. With energy.

Step Five: Draw the attention to the special effects or lighting as the actors on stage gesture for applause from the audience.

Step Six: Bring the curtain down immediately or bring the lights down to black. Actors leave the stage quickly. Music up.

Curtain calls should be quick and to the point. You don't want to *drown*[28] a great production by a long and boring curtain call.

28. drown: *v.* 毁掉

After Performance

Clean-up

After the last performance, once you have removed your make-up and costume, it is important that you help out with *dismantling*[29] the set. Remember how many people, who do not seek the *limelight*[30], have worked hard to get you on stage. Helping them out on the final night would be a great way to show your appreciation.

29. dismantle: *v.* 拆卸
30. limelight: *n.* 出风头

Sum-up

Actor Dos:
- Listen to the director
- Learn the lines early
- Learn the cues
- Learn the moves
- Be punctual

- Check costume, props and set
- Remain in character until they are off stage and out of sight of the audience
- Listen to their fellow actors ON an OFF stage
- *Help dismantle the set*[31]

31. 帮忙拆除布景

Actor Don'ts:
- *Talk or whisper in the wings*[32]

32. wing: n. 台侧

- Go outside the theater wearing their costumes
- Invite friends or family backstage
- *Have mobile phones switched on backstage*[33]

33. 在后台开着移动电话

- Play tricks on fellow cast members on stage, such as deliberately changing lines
- *Upstage*[34] a fellow actor

34. upstage: v. 抢戏

- Play to particular members of the audience, such as family and friends

Assignment

Do the following acting exercises in class under the guidance of the teacher.

I. Warming-up exercises.

Red and Blue

Each member of the group gets a chair swiftly, and sits in a circle with a space between each chair. Each person in the circle is given a color, alternating between red and blue. The purpose of the exercise is precise movement, with no fuss and in complete silence. On the order "Red!", all the Reds must rise and find another chair. On the order "Blue!", all the Blues have to find another chair. The movement is to be carried out from lightning reaction to slow motion. No contact may be made and the transfer from one chair to another must be made with the minimum of movement. Start giving the orders slowly and then speed up to get very quick reactions.

The Mirror

The purpose of this exercise is to encourage observation, quick reaction, inventiveness and projection of image and sound. A group of eight students are divided into two lines, everyone sitting on space-out chairs facing a partner. Line A and the other line B should be about twelve feet apart. During the chain are static, but the performers are not.

The teacher calls "A!", all the members of line A jump up from their chairs and put their bodies into any position they choose and hold that position. Each person in line B mentally photographs the posture of the partner opposite. On the order of "B!" all the members of line B jump up from their chairs and copy the posture of their partners. On the order of "C", line A and B relax their postures.

In the second round, line A and line B make the switch. Members of line B put their bodies into any position they choose and hold that position. Members of line A copy the posture of their partners.

A further complication can be added. When all students get very quick reactions, they must invent a sound of some sort to accompany their particular movement.

II. Learning to be sensitive.

This practice aims to help the students to concentrate and to be in touch with the world, themselves and others.

Get in touch with the world around you

Pretend you are a spaceman who will be leaving tomorrow for a hard mission in the outer space. You may never come back. When you go home, look at each room, each piece of furniture, and each picture on the wall. What does each mean to you? Run your hand over the back of the sofa or the arm of the chair. How does it feel to your touch?

Get in touch with yourself

The tutor will time 2 minutes when you simply sit quietly trying to hear as many different sounds as you can—in the room, in the hallway and outside. When your time is up, write down all of those you remember. As a class, begin listing them. Were there any your classmates heard that you didn't? Who heard the

most?

<u>Get in touch with others</u>

Look at this photo, discuss with the class:

1) The things you can tell for certain about the people in the photo.

2) The things you can guess about them.

3) How do others in the class see them differently? Why do you think this is so? Who do you think is right and why?

Ⅲ. Learning to free your imagination.

All students bring colored pens to class. The teacher will play a song or tune. As the students listen to the music, they are asked to paint a picture of how the music makes them feel. Match the lines and forms to the rhythm and melody, the color to the changing moods. Don't even think about how the picture looks, whether it's "good" or not. That doesn't matter. All that does matter is that the students capture their thoughts and feelings about what they hear.

Chapter Eight

Character Analysis

Complete a Blank *Character Profile Sheet* Before the Performance

Fill in a blank *Character Profile Sheet* each time you start work on a new character. Use a pencil so that you can make changes; you'll need a highlighter pen too. Begin by sifting the script you're looking for clues to your character. Then keep the sheet with you as rehearsals progress, adding and altering as you make new discoveries. The sheet is in sections, and, once you've listed *the key Facts* down the left-hand side, the rest of the sheet can be completed in pretty well any order.

Name		Nickname	
Favorite Fantasy			
Facts (include age, family, social position)			
What Others Say about Him/Her (name the person who said it)			
Lifetime Objective			

		Extravert		
Personality (highlight the typical feeling and attitudes)	sociable outgoing talkative responsive	easygoing lively carefree leader	active optimistic impulsive changeable	excitable aggressive restless touchy
	Stable ——————————————————————————— Neurotic			
	calm even-tempered reliable controlled	peaceful thoughtful passive careful	moody anxious rigid sober	pessimistic reserved quiet unsociable
		Intravert		

Further Underlines(要点强调)

Nickname: this is a useful "*aide-memoire*[1]" when acting a character, as a nickname is usually *a descriptive label*[2] for a character's personality, whether it be 'Brains', 'Trouble', 'Sunshine' or whatever. Obviously nicknames which are simply words derived from a person's name rarely have any value in giving you a "feel" for the character. In truth you'll probably need to make up the nickname; if this is the case, leave the nickname until last so that you have all the information you need to create a suitable one. And remember—we don't choose our own nicknames.

Favourite Fantasy: this invites you to identify, or (when you know the character well enough) invent, a secret fantasy for your character. As well as helping you to add depth in understanding your character, this section also provides the basis for an interesting *improvisation*[3]

Notes:

1. aide-memoire: *n.* 备忘录

2. 描述性的标签

3. improvisation: *n.* 即兴创作

if time allows—this being, what would it feel like if your character's fantasy came true? If you were playing a servant who fantasies about being King, the experience of being served and *lauded*[4] by everyone else in the story would be a powerful imagined memory.

Lifetime Objective: this is an *overarching*[5] "want" which drives the character's overall behaviour at this point in his life. This is likely to be something which remains the same unless some massive incident impacts on your character's life to change the lifetime objective. Examples are, "to be famous", "to help others", "to do everything once before I die".

Personality: use a highlighter pen to record the qualities, traits and attitudes which you confidently feel are shown by your character at some point in the play. The behaviour only has to be observed once. You'll almost certainly find interesting conflicts: a character may seem carefree one moment, pessimistic the next; peaceful here but restless two pages on. This section will help you to avoid *stereotyping*[6]; like real people, well-written characters are complex creatures whose moods and thoughts can change radically, and without notice. And their behaviour may well alter in direct response to the company they keep. When you've filled in all the behavior which your character shows in the play, you'll notice that there are more words highlighted in one "quarter" of the diagram than in others. You can conclude from this whether your character is, on balance, say, a stable extrovert, or a neurotic introvert (or a different combination). This gives you a quick-

4. laud: *v.* 赞美

5. overarching: *a.* 首要的

6. stereotyping: *n.* 刻板印象

reference sense of the personality of your character, and of how that personality differs from your own.

Example: Mary Tyrone (A Character of *A Long Day's Journey into Night*)

Name	Mary	Nickname	Mrs. Tyrone
Favorite Fantasy	To be a pianist or a nun.		
Facts (include age, family, social position)	She is: ● the wife of a famous actor James Tyrone. ● fifty-four, about medium height. ● a housewife. ● considered by some to have married below class. ● the mother of Jamie and Edmund. ● addicted to morphine and afraid to be watched by her husband and children.		
What Others Say about Him/ Her (name the person who said it)	"You're a fine armful now, Mary, with those twenty pounds you've gained."　　　　　　　　　　　　　　　　—James Tyrone "Now, now, Mary. That's your imagination. If I've watched you it was to admire how fat and beautiful you looked."　　—James Tyrone "Your hair's all right, Mama. I was only thinking how well you look."　　　　　　　　　　　　　　　　　　—Jamie Tyrone "Now don't start imagining things, Mama. We do trust you."　　　　　　　　　　　　　　　　　　　—Edmund Tyrone		
Lifetime Objective	She doesn't want to be alone.		

		Extravert		
Personality (highlight the typical feeling and attitudes)	sociable outgoing talkative responsive	easygoing (lively) carefree leader	active optimistic impulsive changeable	excitable aggressive (restless) (touchy)
	Stable ——————————————————————— Neurotic			
	calm even-tempered reliable controlled	peaceful (thoughtful) passive careful	(moody) (anxious) rigid sober	pessimistic reserved quiet unsociable
		Intravert		

Assignment

Ⅰ. After the learning of *A Long Day's Journey into Night*, *The Glass Menagerie*, and *Death of a Salesman*, which play impressed you most? Choose one play to do the character analysis and fill in a Character Profile Sheet for each main character. Remember, you are not supposed to choose only one character of the play.

Ⅱ. Give a performance: The whole class will be divided into several groups. Each group will work like a troupe. In each troupe, students can choose to be director, screenwriter, photographer and actor in accordance with preferences. Each group will write a short play based on the one of the following three unfinished scripts, rehearse and perform it after class. Make your performance a video and show it in the class.

Script One: Honeymoon

Characters

HELEN, the wife, 20s

STEVE, the husband, 20s

… (You can create more characters if necessary.)

[*An upscale*(高档的) *Las Vegas hotel room, possibly a bridal suite*(蜜月套房). *Fresh flowers and a champagne bucket stand near a king-size bed. HELEN dejectedly*(沮丧地) *sits on the edge of the bed. STEVE, upbeat and enthusiastic enters from the bathroom.*]

STEVE: Is this a great place, or what! Did you see that tub? Eight jets (浴缸喷水孔)!

HELEN: Um-mm...

STEVE: [*pointing out the window*] Look at that view! Boy, Vegas is really something, isn't it.

HELEN: Um-mm...

STEVE: Hey, lady. Come on, this is your wedding night. Let's see some enthusiasm.

HELEN: Yeah. Sure. Whatever.

STEVE: Okay, what's the problem?

HELEN: Problem? I don't have a problem.

STEVE: You've been Mrs. Steve Williams for four hours and you've had a long face the whole time. What's going on?

HELEN: [*long beat*] You didn't like my wedding gown!

STEVE: What are you talking about? I loved your gown.

HELEN: You didn't even notice it.

STEVE: I did, too! It was white, kind of.

HELEN: There! You don't even know what color it was. It was pale ivory.

STEVE: Isn't that white?

HELEN: NO! Pale ivory is not white. It's pale ivory!

STEVE: Looked white to me.

HELEN: You don't even care. I could have worn torn jeans and curlers(卷发棒) and you wouldn't have even noticed.

STEVE: Helen...what's wrong with you? The truth is, I'd have been thrilled to marry you if all you had on was a smile. In fact, a smile would be very welcome right about now.

HELEN: That's right, make fun of my feelings.

STEVE: I'm not making fun of anything. I loved your dress. You looked great in it.

HELEN: You didn't tell me you liked it. You didn't say anything about it.

STEVE: I'm telling you now. What difference does it make? I love you, we got married, our whole life is ahead of us; who cares about a stupid wedding gown. You're never going to wear it again anyway.

HELEN: Don't bet on it.

STEVE: Now, what does that mean? Look, Helen, I don't want to start off our marriage taking tranquilizers (镇静剂).

HELEN: You noticed Denise's dress.

STEVE: Just because I said she looked good?

HELEN: Oh. So maybe it wasn't her dress you were talking about.

STEVE: No. She looked fine. You know…nice. I thought complimenting your sister would make you happy.

HELEN: She looked good, but you didn't even notice me.

STEVE: FOR GOD'S SAKE, HELEN…YOU WERE STANDING RIGHT THERE IN FRONT OF ME. Of course I noticed you. You looked great!

(to be continued…)

Script Two: In Heaven

Characters

FRED, a gatekeeper in Heaven, an angel

DD Dobkins, an actress, 30s

…(You can create more characters if necessary.)

(At the gate of Heaven.)

FRED: Ms. Dobkins, I'm Fred. I'm your gatekeeper. Apologies for your sudden demise (死亡).

DD: Demise?

FRED: It's a lot to process. Follow me.

DD: So, this is the Pearly Gate (天国之门)?

FRED: You sound disappointed.

DD: It's just... I expected for some puppy clouds and a few angels, maybe even a harp. I really need to get back to earth now. Come on... sweetie.

FRED: Have a seat.

DD: What are you doing?

FRED: Reviewing your life. You know, heaven or hell. Hold on a second. I've never seen this before. Ms. Dobkins, according to my records, you have not done a single good deed or bad act in your entire life. You are my first adult 0/0.

DD: You know, I am a good person, all right? Lots of deeds.

FRED: Ms. Dobkins, I've seen a lot of bad people and you're not one of them. But you're not one of the good ones, either. Based on our brief period of time together, I would conclude that you're simply shallow.

DD: Shallow? Well, who do you think you are, in your dress-for-less shirt（廉价衬衣）and your poly-yesterday pants（过时的裤子）? You are rude, and I am not gonna sit here and take it.

FRED: Yeah, well, what are you gonna do about it, right?

DD: Let's find it out.

(to be continued...)

Script Three: What are Friends for?

Characters

ANDY: college student, 19

BILLY: college student, 20

... (You can create more characters if necessary.)

ANDY: I really appreciate your driving me around.

BILLY: It's no problem. I have time today, and I think it's important that you find a good place.

ANDY: It would be hard for just me to do it. I don't know the city at all.

BILLY: So what do you see in there?

ANDY: This one sounds good. Efficiency with view of the lake.（带湖景的套

房。) Utilities and parking included. Newly remodeled kitchen. $ 470.

BIILLY: Can you afford that much?

ANDY: No, I guess not. But that's what I want, isn't it? An efficiency.

BILLY: Yes, an efficiency is a small apartment. Usually one large room and a small bathroom. There is often a small kitchen too. So it's good for one person.

ANDY: This one. *Two male grad students seeking roommate. Must be quiet. Comfortable downtown apartment.* Does this mean I have to share a room with them?

BIILY: No. It probably means they have a large apartment. Probably a living room, kitchen and three bedrooms. They need someone for the empty bedroom.

ANDY: That sounds alright.

BILLY: Yes, it might be an advantage for you. You are a foreigner, after all. If they're alright roommates, you could learn a lot from them.

ANDY: Here's the number, 256-4367.

BILLY: Got it. Let's call these two and see if we can make appointments to see the apartments.

ANDY: Sounds good to me. I really appreciate your help on this.

BILLY: Don't mention it, Larry. What are friends for anyway?

(to be continued...)

Glossary of Theatrical Terms
(Chapter 1–3)

1. Aeschylus:埃斯库罗斯(古希腊诗人及悲剧作家)

Aeschylus, born 525/524 BC, died 456/455 BC, Gela, Sicily, the first of classical Athens' great dramatists, who raised the emerging art of tragedy to great heights of poetry and theatrical power.

2. Aristophanes 阿里斯多芬尼斯(古希腊早期喜剧代表作家、诗人)

Aristophanes, born c. 450 BC, died c. 388 BC, the greatest representative of ancient Greek comedy and the one whose works have been preserved in greatest quantity. He is the only extant representative of the Old Comedy—that is, of the phase of comic dramaturgy (c. 5th century BC) in which chorus, mime, and burlesque still played a considerable part and which was characterized by bold fantasy, merciless invective and outrageous satire, unabashedly licentious humour, and a marked freedom of political criticism. But Aristophanes belongs to the end of this phase, and, indeed, his last extant play, which has no choric element at all, may well be regarded as the only extant specimen of the short-lived Middle Comedy, which, before the end of the 4th century BC, was to be superseded in turn by the milder and more-realistic social satire of the New Comedy.

3. Dionysus 狄俄尼索斯(古希腊神话中的酒、丰产和植物神)

Dionysus, also spelled Dionysos, also called Bacchus or (in Rome) Liber Pater, in Greco-Roman (受希腊罗马影响的) religion, a nature god of fruitfulness and vegetation, especially known as a god of wine and ecstasy.

4. Sophocles 索福克勒斯(古希腊悲剧诗人及剧作家)

Sophocles, born c. 496 BC, Colonus, near Athens (Greece), died 406, Athens, with Aeschylus and Euripides, one of classical Athens' three great tragic playwrights. The best known of his 123 dramas is *Oedipus Rex*.

5. *Oedipus Rex*《俄狄浦斯王》

Oedipus Rex, play by Sophocles, performed sometime between 430 BC and 426 BC, that marks the summit of classical Greek drama's formal achievement, known for its tight construction, mounting tension, and perfect use of the dramatic

devices of recognition and discovery. It examines the story of Oedipus, who, in attempting to flee from his fate, rushes headlong to meet it.

6. *Antigone*《安提戈涅》

Antigone, in Greek legend, the daughter born of the unwittingly incestuous union of Oedipus and his mother, Jocasta. After her father blinded himself upon discovering that Jocasta was his mother and that, also unwittingly, he had slain his father, Antigone and her sister Ismene served as Oedipus' guides, following him from Thebes into exile until his death near Athens. Returning to Thebes, they attempted to reconcile their quarreling brothers—Eteocles, who was defending the city and his crown, and Polyneices, who was attacking Thebes. Both brothers, however, were killed, and their uncle Creon became king. After performing an elaborate funeral service for Eteocles, he forbade the removal of the corpse of Polyneices, condemning it to lie unburied, declaring him to have been a traitor. Antigone, moved by love for her brother and convinced of the injustice of the command, buried Polyneices secretly. For that she was ordered by Creon to be executed and was immured in a cave, where she hanged herself. Her beloved, Haemon, son of Creon, committed suicide. According to another version of the story, Creon gave Antigone to Haemon to kill, but he secretly married her and they had a son. When this son went to Thebes to compete in athletic contests, Creon recognized him and put him to death, whereupon his parents committed suicide.

7. Euripides 欧里庇得斯(古希腊的悲剧诗人及剧作家)

Euripides, born c. 484 BC, Athens (Greece), died 406, Macedonia, last of classical Athens's three great tragic dramatists, following Aeschylus and Sophocles.

8. Tragedy 悲剧

Tragedy, branch of drama that treats in a serious and dignified style the sorrowful or terrible events encountered or caused by a heroic individual. By extension the term may be applied to other literary works, such as the novel.

9. *Trojan Women*《特洛伊妇女》

Trojan Women, Greek *Trōades*, drama by Euripides, produced in 415 BC. The play is a famous and powerful indictment of the barbarous cruelties of war. It

was first produced only months after the Athenians captured the city—state of Melos, butchering its men and reducing its women to slavery, and the mood of the drama may well have been influenced by Athenian atrocities.

10. *Alcestis*《阿尔刻提斯》

Alcestis, Greek *Alkēstis*, drama by Euripides, performed in 438 BC. Though tragic in form, the play ends happily. It was performed in place of the satyr play that usually ended the series of three tragedies that were produced for festival competition.

11. *Medea*《美狄亚》

A play by Euripides: it was first performed in 431 BC in Athens, winning third prize at the City Dionysia. The play caused controversy because Euripides flouted tradition by allowing Medea, the child-murderer, to escape unpunished; in the play's final scene she even appears to have transcended human status and become a demigod or demon. Aristophanes, who often made jokes about Euripides, wrote a scene in which the women of Athens rebuked the playwright for being a misogynistic child-hater. However, the play is now often seen as a proto-feminist statement. The story depicts the ultimate revenge of a wronged woman on her treacherous lover. Medea's vendetta against Jason culminates in her killing their children in order to make him suffer. She finally escapes in a chariot belonging to her grandfather, the sun god. Medea provides a complex, challenging, and prized role.

12. *Bacchae*《酒神女信徒》

Bacchae, also called *Bacchants*, drama produced about 406 BC by Euripides. It is regarded by many as his masterpiece. In *Bacchae* the god Dionysus arrives in Greece from Asia intending to introduce his orgiastic worship there. He is disguised as a charismatic young Asian holy man and is accompanied by his women votaries, who make up the play's chorus. He expects to be accepted first in Thebes, but the Thebans reject his divinity and refuse to worship him, and the city's young king, Pentheus, tries to arrest him. In the end Dionysus drives Pentheus insane and leads him to the mountains, where Pentheus's own mother, Agave, and the women of Thebes in a bacchic frenzy tear him to pieces.

13. *Elektra*《厄勒克特拉》

Electra (Greek: "Bright One"), in Greek legend, the daughter of Agamemnon and Clytemnestra, who saved the life of her young brother Orestes by sending him away when their father was murdered. When he later returned, she helped him to slay their mother and their mother's lover, Aegisthus. Electra then married Orestes' friend Pylades. The plays of the same name written by Sophocles and Euripides and the Choephoroi by Aeschylus vary the theme in detail.

14. *Agamemnon*《阿伽门农》

Oresteia, trilogy of tragic dramas by the ancient Greek dramatist Aeschylus, first performed in 458 BC. It is his last work and the only complete trilogy of Greek dramas that has survived. The Oresteia tells the story of the house of Atreus. The first play, Agamemnon, portrays the victorious return of that king from the Trojan War and his murder by his wife, Clytemnestra, and her lover, Aegisthus. At the play's end Clytemnestra and her lover rule Árgos. The work has extraordinary, sustained dramatic and poetic power. Particularly notable are the fascinating richness of Clytemnestra's deceitful words and the striking choral songs, which raise in metaphorical and often enigmatic terms the major themes—of theology, politics, and blood relationships—that are elaborated throughout the trilogy.

15. *The Libation Bearers*《奠酒人》

The Libation Bearers, a play written by Aeschylus, is the second play of the trilogy, *Oresteia*.

16. *The Eumenides*《报仇神》

The Oresteia of Aeschylus is the author's only complete surviving trilogy, and includes the plays "Agamemnon", "The Libation Bearers", and "The Eumenides". In *The Eumenides*, Athena convenes a trial for Orestes, in which Apollo and the Furies argue against each other as to whether Orestes should pay for his crimes with death.

17. *Prometheus Bound*《被缚的普罗米修斯》

Prometheus Bound, Greek Promētheus desmōtēs, tragedy by Aeschylus, the dating of which is uncertain. The play concerns the god Prometheus, who in

defiance of Zeus (Jupiter) has saved humanity with his gift of fire. For this act Zeus has ordered that he be chained to a remote crag. Despite his seeming isolation, Prometheus is visited by the ancient god Oceanus, by a chorus of Oceanus's daughters, by the "cow-headed" Io (another victim of Zeus), and finally by the god Hermes, who vainly demands from Prometheus his knowledge of a secret that could threaten Zeus's power. After refusing to reveal his secret, Prometheus is cast into the underworld for further torture.

18. Comedy 喜剧

Comedy, literary work that aims primarily to provovke laughter. Unlike tragedy, which seeks to engage profound emotions and sympathies, comedy strives to entertain chiefly through criticism and ridicule of man's customs and institutions.

19. Aristophanes 阿里斯托芬(古希腊早期喜剧代表作家及诗人)

Aristophanes, born c. 450 BC, died c. 388 BC, the greatest representative of ancient Greek comedy and the one whose works have been preserved in greatest quantity. He is the only extant representative of the Old Comedy—that is, of the phase of comic dramaturgy (c. 5th century BC) in which chorus, mime, and burlesque still played a considerable part and which was characterized by bold fantasy, merciless invective and outrageous satire, unabashedly licentious humour, and a marked freedom of political criticism. But Aristophanes belongs to the end of this phase, and, indeed, his last extant play, which has no choric element at all, may well be regarded as the only extant specimen of the short-lived Middle Comedy, which, before the end of the 4th century BC, was to be superseded in turn by the milder and more-realistic social satire of the New Comedy.

20. Menander 米南德(古希腊剧作家)

Menander (343BC—292 BC), Greek exponent of the New Comedy, whose witty and sophisticated plays had a major influence on the development of the modern comic tradition. Menander's plays gave a reduced role to the chorus and avoided serious treatment of heroic, religious, or political themes. Menander's plays are populated by conniving slaves, wily courtesans, domineering fathers, rebellious children, and other lively and bawdy urban characters. His complex plots often involve mistaken identities and problematic love affairs. These

characteristics of his work influenced the Roman writers Plautus and Terence, and, through them, Molière, Congreve, Wilde, and other writers of the comedy of manners. Menander's popularity earned him invitations to royal courts in Egypt and Macedonia but he chose to remain in Athens, where he is thought to have drowned while swimming in the harbour.

21. *Lysistrata*《利西翠妲》

Lysistrata, Greek Lysistratē, comedy by Aristophanes, produced in 411 BC. Lysistrata depicts the seizure of the Athenian Acropolis and of the treasury of Athens by the city's women. At the instigation of the witty and determined Lysistrata, they have banded together with the women of Sparta to declare a ban on sexual contact until their partners end the Peloponnesian War, which has lasted more than 20 years. The women hold out until their desperate partners arrange for peace, and the men and women are then reunited.

22. Comedy of manners 风俗喜剧

Comedy of manners, witty, cerebral form of dramatic comedy that depicts and often satirizes the manners and affectations of a contemporary society. A comedy of manners is concerned with social usage and the question of whether or not characters meet certain social standards. Often the governing social standard is morally trivial but exacting. The plot of such a comedy, usually concerned with an illicit love affair or similarly scandalous matter, is subordinate to the play's brittle atmosphere, witty dialogue, and pungent commentary on human foibles.

23. William Congreve 威廉·康格里夫(英国剧作家)

William Congreve, born January 24, 1670, Bardsey, near Leeds, Yorkshire, England, died January 19, 1729, London, English dramatist who shaped the English comedy of manners through his brilliant comic dialogue, his satirical portrayal of the war of the sexes, and his ironic scrutiny of the affectations of his age. His major plays were *The Old Bachelour*(1693), *The Double-Dealer*(1693), *Love for Love*(1695), and *The Way of the World*(1700).

24. Situation Comedy 情景喜剧

Situation comedy, also called sitcom, radio or television comedy series that involves a continuing cast of characters in a succession of episodes. Often the

characters are markedly different types thrown together by circumstance and occupying a shared environment such as an apartment building or workplace. Sitcoms are typically half an hour in length; they are either taped in front of a studio audience or employ canned applause, and they are marked by verbal sparring and rapidly resolved conflicts.

25. Seneca 塞内卡(古罗马政治家、哲学家、悲剧作家)

Seneca, Lucius Annaeus (4 BC—65 AD), Roman tragedian, philosopher, and statesman. Seneca's nine surviving tragedies on legendary Greek subjects are the only plays from the Imperial era to have survived. The plays (dates unknown) are *Phaedra*, *Thyestes*, *Troades*, *Medea*, *Agamemnon*, *Hercules Furens*, *Hercules Oetaeus*, *Oedipus*, and *Phoenissae*. They were all written for recitation, rather than stage production.

Seneca's plays are flawed by their artificial language, stereotyped characters, and melodramatic plots. Nevertheless, they had a great influence on the drama of Renaissance Europe.

26. Plautus 普劳图斯(古罗马剧作家)

Plautus, born c. 254 BC, Sarsina, Umbria, Italy, died 184 BC, great Roman comic dramatist, whose works, loosely adapted from Greek plays, established a truly Roman drama in the Latin language.

27. Terence 泰伦提乌斯(古罗马剧作家)

Terence, Latin in full Publius Terentius Afer, born c. 195 BC, Carthage, North Africa (now in Tunisia), died 159 BC, in Greece or at sea, after Plautus the greatest Roman comic dramatist, the author of six verse comedies that were long regarded as models of pure Latin. Terence's plays form the basis of the modern comedy of manners.

28. Renaissance 文艺复兴

Renaissance, (French: "Rebirth") period in European civilization immediately following the Middle Ages and conventionally held to have been characterized by a surge of interest in Classical scholarship and values. The Renaissance also witnessed the discovery and exploration of new continents, the substitution of the Copernican for the Ptolemaic system of astronomy, the decline

of the feudal system and the growth of commerce, and the invention or application of such potentially powerful innovations as paper, printing, the mariner's compass, and gunpowder.

29. Farce 闹剧

Farce, a comic dramatic piece that uses highly improbable situations, stereotyped characters, extravagant exaggeration, and violent horseplay. The term also refers to the class or form of drama made up of such compositions. Farce is generally regarded as intellectually and aesthetically inferior to comedy in its crude characterizations and implausible plots, but it has been sustained by its popularity in performance and has persisted throughout the Western world to the present. Antecedents of farce are found in ancient Greek and Roman theatre, both in the comedies of Aristophanes and Plautus.

30. Mystery play 神秘剧

Mystery play, one of three principal kinds of vernacular drama in Europe during the Middle Ages (along with the miracle play and the morality play). The mystery plays, usually representing biblical subjects, developed from plays presented in Latin by churchmen on church premises and depicted such subjects as the Creation, Adam and Eve, the Murder of Abel, and the Last Judgment.

31. Morality play 道德剧

Morality play, also called morality, an allegorical drama popular in Europe especially during the 15th and 16th centuries, in which the characters personify moral qualities (such as charity or vice) or abstractions (as death or youth) and in which moral lessons are taught.

32. Christopher Marlowe 克里斯托弗·马洛(英国诗人、剧作家)

Christopher Marlowe, baptized Feb. 26, 1564, Canterbury, Kent, Eng., died May 30, 1593, Deptford, near London, Elizabethan poet and Shakespeare's most important predecessor in English drama, who is noted especially for his establishment of dramatic blank verse.

33. Shakespeare 莎士比亚(英国诗人、剧作家)

William Shakespeare, also spelled Shakspere, byname Bard of Avon or Swan of Avon, baptized April 26, 1564, Stratford-upon-Avon, Warwickshire,

England, died April 23, 1616, Stratford-upon-Avon, English poet, dramatist, and actor, often called the English national poet and considered by many to be the greatest dramatist of all time. Shakespeare occupies a position unique in world literature.

34. Ben Jonson 本·琼森(英格兰文艺复兴剧作家、诗人和演员)

Ben Jonson, byname of Benjamin Jonson, born June 11, 1572, London, England, died August 6, 1637, London, English Stuart dramatist, lyric poet, and literary critic. He is generally regarded as the second most important English dramatist, after William Shakespeare, during the reign of James Ⅰ. Among his major plays are the comedies *Every Man in His Humour* (1598), *Volpone* (1605), *Epicoene, or, The Silent Woman* (1609), *The Alchemist* (1610), and *Bartholomew Fair* (1614).

35. Masque 假面剧

Masque, also spelled mask, festival or entertainment in which disguised participants offer gifts to their host and then join together for a ceremonial dance. A typical masque consisted of a band of costumed and masked persons of the same sex who, accompanied by torchbearers, arrived at a social gathering to dance and converse with the guests. The masque could be simply a procession of such persons introduced by a presenter, or it could be an elaborately staged show in which a brief lyrical drama heralded the appearance of masquers, who, having descended from their pageant to perform figured dances, reveled with the guests until summoned back into their pageant by farewell speeches and song. The theme of the drama presented during a masque was usually mythological, allegorical, or symbolic and was designed to be complimentary to the noble or royal host of the social gathering.

36. Puritan 清教徒

Puritanism, a religious reform movement in the late 16th and 17th centuries that sought to "purify" the Church of England of remnants of the Roman Catholic "popery" that the Puritans claimed had been retained after the religious settlement reached early in the reign of Queen Elizabeth Ⅰ. Puritans became noted in the 17th century for a spirit of moral and religious earnestness that informed their whole

way of life, and they sought through church reform to make their lifestyle the pattern for the whole nation.

37. Richard Brinsley Sheridan 理查德·布林斯利·谢里丹(英国社会风俗喜剧作家、政治家和演说家)

Richard Brinsley Sheridan, in full Richard Brinsley Butler Sheridan, baptized November 4, 1751, Dublin, Ireland, died July 7, 1816, London, England, Irish-born playwright, impresario, orator, and Whig politician. His plays, notably The School for Scandal (1777), form a link in the history of the comedy of manners between the end of the 17th century and Oscar Wilde in the 19th century.

38. Oliver Goldsmith 奥利弗·哥德史密斯(英国剧作家)

Oliver Goldsmith, born Nov. 10, 1730, Kilkenny West, County Westmeath, Ire., died April 4, 1774, London, Anglo-Irish essayist, poet, novelist, dramatist, and eccentric, made famous by such works as the series of essays *The Citizen of the World*, or, *Letters from a Chinese Philosopher* (1762), the poem *The Deserted Village* (1770), the novel *The Vicar of Wakefield* (1766), and the play *She Stoops to Conquer* (1773).

39. Satire 讽刺文学

Satire, artistic form, chiefly literary and dramatic, in which human or individual vices, follies, abuses, or shortcomings are held up to censure by means of ridicule, derision, burlesque, irony, parody, caricature, or other methods, sometimes with an intent to inspire social reform.

40. Gothic thriller 哥特式惊悚小说

Gothic thriller refers to the European Romantic pseudo-medieval fiction which has a prevailing atmosphere of mystery and terror. Its heyday was the 1790s, but it underwent frequent revivals in subsequent centuries.

41. Historical play 历史剧

A play that has as its setting a period of history and that attempts to convey the spirit, manners, and social conditions of a past age with realistic detail and fidelity (which is in some cases only apparent fidelity) to historical fact.

42. Melodramatic play 情节剧

Melodramatic play, in Western theatre, sentimental drama with an improbable plot that concerns the vicissitudes suffered by the virtuous at the hands of the villainous but ends happily with virtue triumphant. Featuring stock characters such as the noble hero, the long-suffering heroine, and the cold-blooded villain, the melodrama focuses not on character development but on sensational incidents and spectacular staging.

43. Realism 现实主义

Realism, in the arts, the accurate, detailed, unembellished depiction of nature or of contemporary life. Realism rejects imaginative idealization in favour of a close observation of outward appearances. As such, realism in its broad sense has comprised many artistic currents in different civilizations.

44. Émile Zola 埃米尔·左拉（法国作家、自然主义创始人）

Émile Zola, in full Émile-Édouard-Charles-Antoine Zola, born April 2, 1840, Paris, France, died September 28, 1902, Paris, French novelist, critic, and political activist who was the most prominent French novelist of the late 19th century. He was noted for his theories of naturalism, which underlie his monumental 20-novel series *Les Rougon-Macquart*, and for his intervention in the Dreyfus Affair through his famous open letter, "J'accuse".

45. Gustave Flaubert 古斯塔夫·福楼拜（法国小说家）

Gustave Flaubert, born December 12, 1821, Rouen, France, died May 8, 1880, Croisset, novelist regarded as the prime mover of the realist school of French literature and best known for his masterpiece, *Madame Bovary* (1857), a realistic portrayal of bourgeois life, which led to a trial on charges of the novel's alleged immorality.

46. August Strindberg 奥古斯特·斯特林堡（瑞典戏剧家、小说家、诗人）

August Strindberg, in full Johan August Strindberg, born Jan. 22, 1849, Stockholm, Swed., died May 14, 1912, Stockholm, Swedish playwright, novelist, and short-story writer, who combined psychology and Naturalism in a new kind of European drama that evolved into Expressionist drama. His chief works include *The Father* (1887), *Miss Julie* (1888), *Creditors* (1888), *A Dream*

Play (1902), and *The Ghost Sonata* (1907).

47. Henrik Ibsen 亨利克·易卜生(挪威剧作家、现代现实主义戏剧的创始人)

Henrik Ibsen, in full Henrik Johan Ibsen, born March 20, 1828, Skien, Norway, died May 23, 1906, Kristiania (formerly Christiania; now Oslo), major Norwegian playwright of the late 19th century who introduced to the European stage a new order of moral analysis that was placed against a severely realistic middle-class background and developed with economy of action, penetrating dialogue, and rigorous thought.

48. Broadway, Off-Broadway, and Off-Off-Broadway 百老汇,外百老汇和外外百老汇

Broadway, New York City thoroughfare that traverses the length of Manhattan, near the middle of which are clustered the theaters that have long made it the foremost showcase of commercial stage entertainment in the United States. The term Broadway is virtually synonymous with American theatrical activity.

Off-Broadway, in the theatre of the United States, small professional productions that have served since the mid-20th century as New York City's alternative to the commercially oriented theaters of Broadway.

In New York, the alternative theater that developed in the early 1960s in the coffee houses and other small venues of Greenwich Village and the Lower East Side. The off-off-Broadway scene arose as Off-Broadway productions became more professional and profit-conscious.

49. Thomas Godfrey 托马斯·戈弗雷(美国剧作家,诗人)

American colonial playwright and poet.

50. The American Revolutionary War 美国独立战争

The American Revolutionary War (1775—1783), also known as the American War of Independence, was a war between the Kingdom of Great Britain and thirteen British colonies on the North American continent (as well as some naval conflict). The war was the culmination of the political American Revolution, whereby the colonists overthrew British rule.

51. The Continental Congress 大陆会议

Continental Congress, in the period of the American Revolution, the body of delegates who spoke and acted collectively for the people of the colony-states that later became the United States of America. The term most specifically refers to the bodies that met in 1774 and 1775—1781 and respectively designated as the First Continental Congress and the Second Continental Congress.

52. Timothy Dwight Ⅳ 蒂莫西·德怀特四世(耶鲁大学第四任校长)

Timothy Dwight Ⅳ (1795—1817), the 4th president of Yale College.

53. Thomas Forrest 托马斯·福斯特(美国剧作家)

Thomas Forrest (1747—1825) was an American politician. He was member of the 16th Session of the United States Congress, and first chairman of the United States House Committee on Agriculture. He fought in the Continental Army as an artillery officer during the American Revolutionary War.

54. Robert Munford 罗伯特·芒福德(美国剧作家)

Robert Watson Munford (June 22, 1925—May 28, 1991) was an American artist, educator, and founding member of the artist group Grupo Ibiza in Spain. His artwork is in the permanent collections of the Hirshhorn Museum and Sculpture Garden (Washington, DC), the Museum of Modern Art (New York), the New York Public Library, and the Parrish Art Museum (Southampton, New York). He was a pop art pioneer.

55. Heroism 英雄事迹

A hero (masculine) or heroine (feminine) is a person or main character of a literary work who, in the face of danger, combats adversity through impressive feats of ingenuity, bravery or strength, often sacrificing his or her own personal concerns for some greater good.

56. Hugh Henry Brackenridge 休·亨利·布莱肯里兹(美国剧作家)

Hugh Henry Brackenridge (1748—June 25, 1816) was an American writer, lawyer, judge, and justice of the Supreme Court of Pennsylvania. A frontier citizen in Pittsburgh, Pennsylvania, United States, he founded both the Pittsburgh Academy, now the University of Pittsburgh, and the Pittsburgh Gazette, still operating today as the Pittsburgh Post-Gazette.

57. Royall Tyler 罗亚尔·泰勒(美国文学家、剧作家、法官)

Royall Tyler (June 18, 1757—August 26, 1826) was an American jurist and playwright.

58. William Dunlap 威廉·邓拉普(美国第一个职业剧作家)

William Dunlap (February 19, 1766—September 28, 1839) was a pioneer of American theater. He was a producer, playwright, and actor, as well as a historian. He managed two of New York's earliest and most prominent theaters, the John Street Theatre (from 1796—1798) and the Park Theatre (from 1798—1805).

59. Melodrama 传奇剧

A melodrama is a dramatic or literary work in which the plot, which is typically sensational and designed to appeal strongly to the emotions, takes precedence over detailed characterization. Characters are often simply drawn, and may appear stereotyped.

60. The Walnut 核桃剧团

The Walnut is a theatre in Philadelphia, the oldest US theatre still in use today. Built in 1809 as a circus venue, it was converted to use as a theatre in 1811.

61. Thomas Jefferson 托马斯·杰斐逊(美国第三任总统)

Thomas Jefferson (1743—1826), draftsman of the *Declaration of Independence of the United States* and the nation's first secretary of state (1789—1794) and second vice president (1797—1801) and the third president (1801—1809).

62. *Uncle Tom's Cabin*《汤姆叔叔的小屋》

Uncle Tom's Cabin, or, *Life Among the Lowly*, is an anti-slavery novel by American author Harriet Beecher Stowe. Published in 1852, the novel "helped lay the groundwork for the Civil War", according to Will Kaufman. The sentimental novel depicts the reality of slavery while also asserting that Christian love can overcome something as destructive as enslavement of fellow human beings.

63. Harriet Beecher Stowe 哈里耶持·比彻·斯托(美国作家,又称斯托夫人)

Harriet Elisabeth Beecher Stowe (1811—1896) was an American abolitionist and author. She came from a famous religious family and is best known for her

novel *Uncle Tom's Cabin* (1852). It depicts the harsh life for African Americans under slavery. It reached millions as a novel and play, and became influential in the United States and Great Britain. It energized anti-slavery forces in the American North, while provoking widespread anger in the South. She wrote 30 books, including novels, three travel memoirs, and collections of articles and letters. She was influential for both her writings and her public stands on social issues of the day.

64. William Wells Brown 威廉·威尔斯·布朗（美国黑人剧作家、小说家）

William Wells Brown (1814—1884) was a prominent African-American abolitionist lecturer, novelist, playwright, and historian in the United States. Born into slavery in Montgomery County, Kentucky, near the town of Mount Sterling, Brown escaped to Ohio in 1834 at the age of 20. He settled in Boston, where he worked for abolitionist causes and became a prolific writer. His novel *Clotel* (1853), considered the first novel written by an African American, was published in London, where he resided at the time; it was later published in the United States.

65. Harlem Renaissance 哈莱姆文艺复兴

Harlem Renaissance (c. 1918—1937), a blossoming of African American culture, particularly in the creative arts, and the most influential movement in African American literary history. Embracing literary, musical, theatrical, and visual arts, participants sought to re-conceptualize "the Negro" apart from the white stereotypes that had influenced Black peoples' relationship to their heritage and to each other. They also sought to break free of Victorian moral values and bourgeois shame about aspects of their lives that might, as seen by whites, reinforce racist beliefs. Never dominated by a particular school of thought but rather characterized by intense debate, the movement laid the groundwork for all later African American literature and had an enormous impact on subsequent Black literature and consciousness worldwide. While the renaissance was not confined to the Harlem district of New York City, Harlem attracted a remarkable concentration of intellect and talent and served as the symbolic capital of this

cultural awakening.

66. Minstrel show 吟游表演

Minstrel show, also called minstrelsy, an American theatrical form, popular from the early 19th to the early 20th century, that was founded on the comic enactment of racial stereotypes. The tradition reached its zenith between 1850 and 1870. Although the form gradually disappeared from the professional theaters and became purely a vehicle for amateurs, its influence endured—in vaudeville, radio, and television as well as in the motion-picture and world-music industries of the 20th and 21st centuries.

67. Slapstick Comedy 打闹喜剧

Slapstick is a style of humor involving exaggerated physical activity which exceeds the boundaries of normal physical comedy. The term arises from a device developed during the broad, physical comedy style known as Commedia dell'arte in 16th Century Italy. The Slap Stick is merely two thin slats of wood made from splitting a single long stick, which makes a 'slap' when striking another actor, with little force needed to make a loud—and comical—sound.

68. Hedonism n. 享乐主义

Hedonism is a school of thought that argues that pleasure is the primary or most important intrinsic good. A hedonist strives to maximize net pleasure (pleasure minus pain). Ethical hedonism is the idea that all people have the right to do everything in their power to achieve the greatest amount of pleasure possible to them. It is also the idea that every person's pleasure should far surpass their amount of pain. Ethical hedonism is said to have been started by Aristippus of Cyrene, a student of Socrates. He held the idea that pleasure is the highest good.

69. The United States Civil War 美国内战

The United States Civil War was a civil war fought from 1861 to 1865, to determine the survival of the United States of America as it defeated the bid for independence by the breakaway Confederate States of America. Among the 34 states in January 1861, seven Southern slave states individually declared their secession from the U.S. and formed the Confederate States of America. War broke out in April 1861 when they attacked a U.S. fortress, Fort Sumter, and

ended with the surrender of all the Confederate armies in spring 1865.

70. Abraham Lincoln 亚伯拉罕·林肯（美国第 16 任总统）

Abraham Lincoln (1809—1865), 16th president of the United States (1861—1865), who preserved the Union during the American Civil War and brought about the emancipation of the slaves. Among American heroes, Lincoln continues to have a unique appeal for his fellow countrymen and also for people of other lands.

71. Ford's Theater 福特剧院

Ford's Theatre is a historic theatre in Washington, D. C. , used for various stage performances beginning in the 1860s. It is also the site of the assassination of U. S. President Abraham Lincoln on April 14, 1865. The theatre was later used as a warehouse and office building, and in 1893 part of it collapsed, causing 22 deaths. It was renovated and re-opened as a theatre in 1968. During the 2000s, it was renovated again, opening on February 12, 2009, in commemoration of the bicentennial of Lincoln's birth.

72. Victorian burlesque 维多利亚时期的滑稽剧

In the English theatre of the late 17th and 18th century, a burlesque was a comic imitation of a popular play or type of play. The parody was generally fairly crude, often involving a reversal of expected roles, with heroes acting as buffoons, etc.

73. John Wilkes Booth 约翰·威尔克斯·布斯（美国演员）

John Wilkes Booth (1838—1865) was an American stage actor who assassinated President Abraham Lincoln at Ford's Theatre, in Washington, D. C. , on April 14, 1865. Booth was a member of the prominent 19th-century Booth theatrical family from Maryland and, by the 1860s, was a well-known actor. He was also a Confederate sympathizer, vehement in his denunciation of Lincoln, and was strongly opposed to the abolition of slavery in the United States.

74. Burlesque show 滑稽戏演出

Burlesque show, stage entertainment, developed in the United States, that came to be designed for exclusively male patronage, compounded of slapstick sketches, dirty jokes, chorus numbers, and solo dances usually billed as "daring"

or "sensational" in their female nudity.

75. Nationalism 国家主义

Nationalism is a shared group feeling in the significance of a geographical and sometimes demographic region seeking independence for its culture and/or ethnicity that holds that group together. This can be expressed as a belief or political ideology that involves an individual identifying with or becoming attached to one's nation. Nationalism involves national identity, by contrast with the related concept of patriotism, which involves the social conditioning and personal behaviors that support a state's decisions and actions.

76. John Howard Payne 约翰·霍华德·佩恩(美国剧作家,演员)

John Howard Payne (1791—1852) was an American actor, poet, playwright, and author who had most of his theatrical career and success in London. He is today most remembered as the creator of "Home! Sweet Home!", a song he wrote in 1822 that became widely popular in the United States, Great Britain, and the English-speaking world.

77. Mormonism 摩门教

Mormonism is the predominant religious tradition of the Latter Day Saint movement of Restorationist Christianity. Joseph Smith founded this movement in Western New York in the 1820s.

78. Poetic drama 诗剧

Poetic drama is any drama written as verse to be spoken; another possible general term is verse drama. For a very long period, poetic drama was the dominant form of drama in Europe (and was also important in non-European cultures). Greek tragedy and Racine's plays are written in verse, as is almost all of Shakespeare's drama, Ben Jonson, John Fletcher and others like Goethe's Faust.

79. Romanticism 浪漫主义

Romanticism (also the Romantic era or the Romantic period) was an artistic, literary, and intellectual movement that originated in Europe toward the end of the 18th century and in most areas was at its peak in the approximate period from 1800 to 1850. Romanticism was characterized by its emphasis on emotion and individualism as well as glorification of all the past and nature, preferring the

medieval rather than the classical. It was partly a reaction to the Industrial Revolution, the aristocratic social and political norms of the Age of Enlightenment, and the scientific rationalization of nature. It was embodied most strongly in the visual arts, music, and literature, but had a major impact on historiography, education, and the natural sciences.

80. James Herne 詹姆斯·何恩(美国剧作家)

James Herne (1839—1901), born James Ahearn, was an American playwright and actor. Considered by some critics to be the "American Ibsen", his controversial play Margaret Fleming is often credited with having begun modern drama in America.

81. Thomas Hardy 托马斯·哈代 (英国作家)

Thomas Hardy (1840—1928), English novelist and poet who set much of his work in Wessex, his name for the counties of southwestern England.

82. *The Jazz Singer*《爵士歌手》

The Jazz Singer, American musical film, released in 1927, was the first feature-length movie with synchronized dialogue. It marked the ascendancy of "talkies" and the end of the silent-film era.

83. Vaudeville 歌舞杂耍

Vaudeville is a theatrical genre of variety entertainment. It was especially popular in the United States and Canada from the early 1880s until the early 1930s. A typical vaudeville performance is made up of a series of separate, unrelated acts grouped together on a common bill. Types of acts have included popular and classical musicians, singers, dancers, comedians, trained animals, magicians, female and male impersonators, acrobats, illustrated songs, jugglers, one-act plays or scenes from plays, athletes, lecturing celebrities, minstrels, and movies. A vaudeville performer is often referred to as a "vaudevillian". Vaudeville developed from many sources, including the concert saloon, minstrelsy, freak shows, dime museums, and literary American burlesque. Called "the heart of American show business", vaudeville was one of the most popular types of entertainment in North America for several decades.

84. Revue 讽刺时事的滑稽剧

A revue is a type of multi-act popular theatrical entertainment that combines music, dance and sketches. The revue has its roots in 19th century popular entertainment and melodrama but grew into a substantial cultural presence of its own during its golden years from 1916 to 1932. Though most famous for their visual spectacle, revues frequently satirized contemporary figures, news or literature.

85. *Show Boat*《演出船》

Show Boat is a 1927 musical in two acts, with music by Jerome Kern and lyrics by Oscar Hammerstein Ⅱ. Based on Edna Ferber's best-selling novel of the same name, the musical follows the lives of the performers, stagehands and dock workers on the Cotton Blossom, a Mississippi River show boat, over 40 years, from 1887 to 1927. Its themes include racial prejudice and tragic, enduring love. The musical contributed such classic songs as "Ol' Man River", "Make Believe" and "Can't Help Lovin' Dat Man".

86. Jerome Kern 杰罗姆·克恩(美国作曲家)

Jerome Kern (1885—1945), one of the major U.S. composers of musical comedy, whose Show Boat inaugurated the serious musical play in U.S. theatre.

87. Oscar Hammerstein 奥斯卡·汉默斯坦(美国词作家、制作人)

Oscar Hammerstein (1895—1960), American lyricist, musical comedy author, and theatrical producer influential in the development of musical comedy and known especially for his immensely successful collaboration with the composer Richard Rodgers.

88. Richard Rodgers 理查德·罗杰斯(美国作曲家)

Richard Charles Rodgers (1902—1979) was an American composer of music for more than 900 songs and for 43 Broadway musicals. He also composed music for films and television. He is best known for his songwriting partnerships with the lyricists Lorenz Hart and Oscar Hammerstein Ⅱ. His compositions have had a significant impact on popular music up to the present day, and have an enduring broad appeal.

89. The Great Depression 大萧条时期

The Great Depression was a severe worldwide economic depression that took place during the 1930s. The timing of the Great Depression varied across nations; however, in most countries it started in 1929 and lasted until the late 1930s. It was the longest, deepest, and most widespread depression of the 20th century. In the 21st century, the Great Depression is commonly used as an example of how far the world's economy can decline.

90. The Federal Theatre Project 联邦剧院项目

The Federal Theatre Project, national theatre project sponsored and funded by the U. S. government as part of the Works Progress Administration (WPA). Founded in 1935, it was the first federally supported theatre in the United States. Its purpose was to create jobs for unemployed theatrical people during the Great Depression, and its director was the educator and playwright Hallie Flanagan.

91. New Deal program 新政计划

New Deal, domestic program of the administration of U. S. Pres Franklin D. Roosevelt between 1933 and 1939, which took action to bring about immediate economic relief as well as reforms in industry, agriculture, finance, water-power, labour, and housing, vastly increasing the scope of the federal government's activities.

92. Sinclair Lewis 辛克莱·刘易斯 (美国知名作家)

Sinclair Lewis, in full Harry Sinclair Lewis, born Feb. 7, 1885, Sauk Centre, Minn., U. S., died Jan. 10, 1951, near Rome, Italy, American novelist and social critic who punctured American complacency with his broadly drawn, widely popular satirical novels. He won the Nobel Prize for Literature in 1930, the first given to an American.

93. Marc Blitzstein 马克·布利茨斯坦(美国作家、作曲家)

Marc Blitzstein (1905—1964) is an American pianist, playwright and composer known for his unorthodox operas and plays.

94. Tony Awards 托尼奖(美国戏剧奖)

Tony Awards, annual awards for distinguished achievement in American theatre. Named for the actress-producer Antoinette Perry, the annual awards were

established in 1947 by the American Theatre Wing and are intended to recognize excellence in plays and musicals staged on Broadway. Awards are given for best play, best musical, best play revival, and best musical revival, and in categories such as acting, directing, music, choreography, set design, and costume design.

95. Pulitzer Prize 普利策奖(美国新闻、文学、音乐奖)

Pulitzer Prize, any of a series of annual prizes awarded by Columbia University, New York City, for outstanding public service and achievement in American journalism, letters, and music. Fellowships are also awarded. The prizes, originally endowed with a gift of \$500,000 from the newspaper magnate Joseph Pulitzer, are highly esteemed and have been awarded each May since 1917. The awards are made by Columbia University on the recommendation of the Pulitzer Prize Board, composed of judges appointed by the university. The prizes have varied in number and category over the years but currently number 14 prizes in the field of journalism, 6 prizes in letters, and 1 prize in music.

96. Nobel Prize 诺贝尔奖

Nobel Prize, any of the prizes (five in number until 1969, when a sixth was added) that are awarded annually from a fund bequeathed by the Swedish inventor and industrialist Alfred Nobel. The Nobel Prizes are widely regarded as the most prestigious awards given for intellectual achievement in the world.

97. ANT (American Negro Theater) 美国黑人剧院

American Negro Theatre (ANT), African American theatre company that was active in the Harlem district of New York City from 1940 to 1951. It provided professional training and critical exposure to African American actors, actresses, and playwrights by creating and producing plays concerning diverse aspects of African American life. The American Negro Theatre (ANT) was established by two African Americans, the playwright Abram Hill and the actor Frederick O'Neal.

98. Harry Belafonte 亨瑞·贝拉方特(美国知名演员、歌唱家)

Harry Belafonte, byname of Harold George Belafonte, Jr., born March 1, 1927, New York City, New York, U.S., American singer, actor, producer, and activist who was a key figure in the folk music scene of the 1950s, especially

known for popularizing the Caribbean folk songs known as calypsos. He was also involved in various social causes, notably the civil rights movement.

99. Sidney Poitier 西德尼·波蒂埃(美国知名演员)

Sidney Poitier, born February 20, 1927, Miami, Florida, U.S., Bahamian American actor, director, and producer who broke the colour barrier in the U.S. motion-picture industry by becoming the first African American actor to win an Academy Award for best actor [for *Lilies of the Field* (1963)] and the first Black movie star. He also redefined roles for African Americans by rejecting parts that were based on racial stereotypes.

100. Neil Simon 尼尔·西蒙(美国剧作家)

Neil Simon, in full Marvin Neil Simon, born July 4, 1927, Bronx, New York, U.S., died August 26, 2018, New York City, American playwright, screenwriter, television writer, and librettist who was one of the most popular playwrights in the history of the American theatre.

101. Sam Shepard 山姆·夏普德(美国演员、导演、编剧)

Sam Shepard, byname of Samuel Shepard Rogers, born November 5, 1943, Fort Sheridan, near Highland Park, Illinois, U.S., died July 27, 2017, Midway, Kentucky, American playwright and actor whose plays adroitly blend images of the American West, Pop motifs, science fiction, and other elements of popular and youth culture.

102. David Mamet 大卫·马梅(美国剧作家、导演、制片人、演员)

David Mamet, in full David Alan Mamet, born November 30, 1947, Chicago, Illinois, U.S., American playwright, director, and screenwriter noted for his often desperate working-class characters and for his distinctive, colloquial, and frequently profane dialogue.

103. Terrence McNally 特伦斯·麦克纳利(美国知名剧作家)

Terrence McNally, born November 3, 1938, St. Petersburg, Florida, U.S., died March 24, 2020, Sarasota, Florida, American dramatist whose plays explore human relationships—frequently those of gay men—and are typically characterized by dark humour. He also wrote books for musicals.

104. Stephen Sondheim 斯蒂芬·桑德海姆(美国知名词曲作家)

Stephen Sondheim, in full Stephen Joshua Sondheim, born March 22, 1930, New York City, New York, U.S., American composer and lyricist whose brilliance in matching words and music in dramatic situations broke new ground for Broadway musical theatre.

105. August Wilson 奥古斯特·威尔逊(美国剧作家)

August Wilson, original name Frederick August Kittel, born April 27, 1945, Pittsburgh, Pennsylvania, U.S., died October 2, 2005, Seattle, Washington, American playwright, author of a cycle of plays, each set in a different decade of the 20th century, about Black American life. He won Pulitzer Prizes for two of them: *Fences* and *The Piano Lesson*.

106. *Ma Rainey's Black Bottom*《蕾妮大婶的黑臀舞曲》

Ma Rainey's Black Bottom, drama in two acts by August Wilson, performed in 1984 and published in 1985. It was the first of a series of plays in which Wilson portrayed African American life in the 20th century. The play, set in a recording studio in Chicago in 1927, features Ma Rainey, a popular blues singer, and the members of her band.

107. Andrew Lloyd Webber 安德鲁·劳埃德·韦伯(英国知名作曲家)

Andrew Lloyd Webber, in full Andrew Lloyd Webber, Baron Lloyd-Webber of Sydmonton, also called (1992—1997) Sir Andrew Lloyd Webber, born March 22, 1948, London, England, English composer and theatrical producer whose eclectic rock-based works helped revitalize British and American musical theatre, beginning in the late 20th century.

Bibliography

[1]汪义群. 当代美国戏剧[M]. 上海:上海外语教育出版社,2000.

[2]张耘. 西方戏剧[M]. 北京:外语教学与研究出版社,2011.

[3]Michael Manheim. 尤金·奥尼尔[M]. 上海:上海外语教育出版社,2000.

[4]Matthew C Roudane. 田纳西·威廉斯[M]. 上海:上海外语教育出版社,2000.

[5]Christopher Bigsby. 阿瑟·米勒[M]. 上海:上海外语教育出版社,2000.

[6]戴炜栋、范浩. 英美戏剧:剧本与演出[M]. 上海:上海外语教育出版社,2011.

[7]Jeffrey H Richards, Heather S Nathans. Oxford Handbook of American Drama[M]. UK: Oxford University Press, 2014.

[8]Terry Schreiber, Mary Beth Barber. Advanced Techniques for the Actor, Director and Teacher[M]. New York: Allworth Press, 2005.

[9]Glynne Wickham. A History of the Theater, 2nd Edition[M]. UK: Phaidon Press Limited, 1992.

[10]Theresa Saxon. American Theatre History, Context, Form[M]. UK: Edinburgh University Press, 2011.

[11]Arthur Miller. Death of a Salesman[M]. NC: Chelsea House, 2007.

[12]Eugene O'Neill. A Long Day's Journey into Night[M]. New York: Infobase Publishing, 2007.

[13]Tennessee Williams. The Glass Menagerie[M]. New York: Infobase Publishing, 2007.

[14]Paul Elsam. Acting Characters, 20 simple steps from rehearsal to performance[M]. London: A & C Black Publishers Limited, 2009.